Empire and Art: British India

This book forms part of the series *Art and its Global Histories* published by Manchester University Press in association with The Open University. The books in the series are:

European Art and the Wider World 1350–1550, edited by Kathleen Christian and Leah R. Clark

Art, Commerce and Colonialism 1600–1800, edited by Emma Barker

Empire and Art: British India, edited by Renate Dohmen

Art after Empire: From Colonialism to Globalisation, edited by Warren Carter

Art and its Global Histories: A Reader, edited by Diana Newall

Empire and Art: British India

Edited by Renate Dohmen

Published by Manchester University Press
Altrincham Street, Manchester M1 7JA
www.manchesteruniversitypress.co.uk

in association with

The Open University, Walton Hall, Milton Keynes MK7 6AA
www.open.ac.uk

First published 2017

This publication forms part of the Open University module *Art and its global histories* (A344). Details of this and other Open University modules can be obtained from Student Recruitment, The Open University, PO Box 197, Milton Keynes MK7 6BJ, United Kingdom (tel. +44 (0)300 303 5303; email general-enquiries@open.ac.uk).

Edited and designed by The Open University
Typeset by The Open University

Printed in the United Kingdom by Stephens & George Ltd, Dowlais, Merthyr Tydfil CF48 3TD.

British Library Cataloguing-in-Publication Data
A catalogue record for this book is available from the British Library

Library of Congress Cataloging-in-Publication Data applied for

ISBN 978 1 5261 2294 0 (paperback)
ISBN 978 1 5261 2295 7 (ebook)

Contents

Preface

This is the third of four books in the series *Art and its Global Histories*, which together form the main texts of an Open University Level 3 module of the same name. Each book is also designed to be read independently by the general reader. The series as a whole offers an accessible introduction to the ways in which the history of Western art from the fourteenth century to the present day has been bound up with cross-cultural exchanges and global forces.

Each book in the series explores a distinct period of this long history, apart from the present book, *Empire and Art: British India*, which focuses on the art and visual culture of the British Empire, with particular reference to India. This book offers an in-depth study of the artistic interactions between Britain and India as part of the colonial encounter across the visual spectrum, exploring painting, printmaking, design, photography and architecture by British and Indian practitioners.

All of the books in the series include teaching elements. To encourage the reader to reflect on the material presented, each chapter contains short exercises in the form of questions printed in bold type. They are followed by discursive sections, the end of which is marked by ✍.

The four books in the series are:

> *European Art and the Wider World 1350–1550*, edited by Kathleen Christian and Leah R. Clark
>
> *Art, Commerce and Colonialism 1600–1800*, edited by Emma Barker
>
> *Empire and Art: British India*, edited by Renate Dohmen
>
> *Art after Empire: From Colonialism to Globalisation*, edited by Warren Carter.

There is also a companion reader:

> *Art and its Global Histories: A Reader*, edited by Diana Newall.

Introduction

Renate Dohmen

'Oh, East is East and West is West, and never the twain shall meet' is the first line of Rudyard Kipling's poem 'The Ballad of East and West', which was first published in 1889 in *The Pioneer*, an English-language newspaper based in the north Indian city of Allahabad, which circulated across the subcontinent. Widely considered to be the greatest chronicler of the British Empire, Kipling was born in Britain's colonial territories on the Indian subcontinent, then known as British India, in 1865. Only a few years earlier, in 1858, the British Crown had taken over formal control of these territories from the English East India Company, which had been trading on the subcontinent since the seventeenth century. The British continued to rule India right up until 1947 when the colony gained independence. The period from 1858 to 1947, often referred to as the 'Raj', will be the main focus of this book.

It is hardly surprising that Kipling's poem begins by asserting an unbridgeable gulf. At the time, the overwhelming concern of Britons living in India was to retain their distinct identity by keeping their distance from Indian society and culture, which they regarded as racially inferior and morally corrupting. What is more surprising perhaps is that Kipling's ballad evolves into an unlikely story of friendship and respect between an Afghan horse thief and a British soldier that transcends the differences of their backgrounds. The poem thereby hints that the aloof British stance did not altogether tally with the realities of colonial life. British households in India, for example, required a substantial number of native servants, giving rise to close interaction with

Indians in the domestic environment. This kind of intimate contact is demonstrated in a lithograph by the renowned amateur artist Charles D'Oyly, which shows British diners surrounded by a throng of Indian servants (Plate 0.1). Moreover, Indian culture increasingly reached Britain, thereby becoming integral to 'British' life.

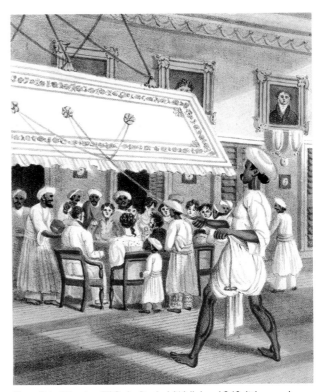

Plate 0.1 Charles D'Oyly, *Punkah Wallah*, c.1840, lithograph. Photo: Chronicle/Alamy.

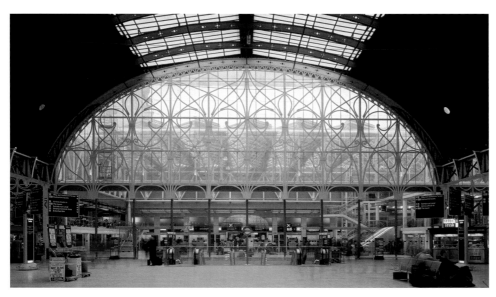

Plate 0.2 Matthew Digby Wyatt (architect), decorative wrought ironwork at Paddington Station, London, c.1850–53. Photo: VIEW Pictures Ltd/ Alamy.

During the nineteenth century it became common for British households to be decorated with Indian artefacts and families began to adopt Indian dishes such as curry. They were largely introduced to Britain by 'memsahibs', as British women living in India were called, on return visits home, even though colonial prejudices meant that they shunned such artefacts and dishes when in India.[1] The influence of India on Britain extended well beyond the realm of the domestic, however. When the architect Sir Matthew Digby Wyatt assisted the engineer Isambard Kingdom Brunel with the design of Paddington Station in London in the mid-nineteenth century, for example, he used a variant of the traditional Indian tear-drop motif for the wrought-iron decorative scrolls on the train shed screen above the station's main concourse (Plate 0.2). As will be discussed in Chapter 2, this motif had come to prominence in Britain during the late eighteenth century through shawls imported from Kashmir, or 'Cashmere' as it was then spelled in English, and was further popularised and adapted in the nineteenth century through their cheaper British-made imitations from the Scottish town of Paisley.

These are just a few examples of the visual and cultural material to be discussed in this book, which explores the histories of artistic interactions between Britain and India from the late eighteenth to the first half of the twentieth century through case studies that range across the media of painting and printmaking, design, photography and architecture. The complex processes of cultural engagement that they entailed are examined in relation to the changing context of Britain's presence in India, and to shifts in British cultural attitudes that occurred during this time. The asymmetric nature of colonial power relations and the pivotal role of art history in legitimating British rule will also be considered.

A point to bear in mind is that India during this period constituted a complex political entity characterised by great linguistic, religious and cultural diversity. This book therefore makes no attempt at comprehensive coverage. Its four chapters rather present a sampling of Indian contexts to provide informative case studies of Anglo-Indian artistic encounters. Their contents also reflect the state of the literature, which offers more in-depth research in some areas than in others. Furthermore, an effort has been made to balance the prevalence of elite perspectives in the writing of histories of Indian art with more vernacular approaches and to range as widely as possible across the visual spectrum to gather a representative collection of artistic interactions in British India.

Chapter 1 charts the cultural encounter between Britain and India in paintings and prints by Indian as well as British artists. Most of the examples discussed are from Bengal, reflecting the importance of its capital, Calcutta (Kolkata), as the seat of the colonial administration, the early development of a middle class that had received a European education in the English language and, subsequently, the rise of modern Indian art and the independence movement there. A

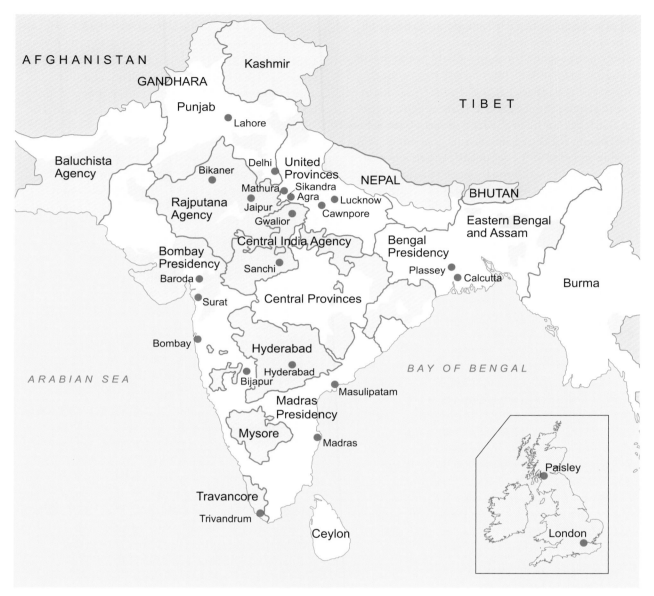

Plate 0.3 British India, adapted from map of India in *Imperial Gazetteer of India*, Oxford, Oxford University Press, 1909, vol. 26, p. 20.

case study dealing with southern India, however, also offers a degree of geographical balance. In Chapter 2 the focus shifts to questions of Indian craft, design and display, which are explored in relation to the Great Exhibition of 1851 and the 1886 Colonial and Indian Exhibition as well as the 1883 Jaipur Exhibition. (The city and state of the same name were referred to as Jeypore by the British at the time, but this book will follow the spelling adopted in 1898.) This chapter also offers examples of Anglo-Indian architectural experiments in Bombay (Mumbai), Madras (Chennai), Jaipur and Bikaner (see Plate 0.3). Chapter 3 explores

photographic representations of India, and how they contributed to the colonial project by documenting Indian racial types, professions and monuments. Examples range widely across the Indian subcontinent, with one sub-section looking closely at photographs of the princely state of Hyderabad. Chapter 4 presents an in-depth case study of the architecture of New Delhi, the new capital of British India that was planned and built as a modern, imperial city after the decision was taken in 1911 to remove the colonial administrative centre from Calcutta. It examines how the Neo-classical architectural language of empire was adapted to India.

Before going any further, it is important to note that at the time the term 'India' was used more or less synonymously with 'British India', which also included the territories of today's Pakistan and Bangladesh. Unless specified otherwise, 'India' will be used in this historical sense throughout the book rather than the regional label 'South Asia', which came into circulation after the end of British imperial rule. In a similar vein, place names used in the eighteenth and nineteenth centuries will be used throughout. Furthermore, the term 'Anglo-Indian' will be used in the sense that prevailed in the nineteenth century, that is with reference to British people living and working in India, rather than its post-1911 usage to mean people of mixed English and Indian ancestry.

Last, but not least, a note on religions in British India is necessary. As the 1891 census demonstrated, around 70 per cent of the population were Hindu and 20 per cent Muslim, with followers of animistic traditions comprising just over 3 per cent and Buddhists roughly 2.5 per cent (the ancient Indian religious tradition of Jainism was misinterpreted as either a Hindu sect or a Buddhist heresy at the time, and is therefore not included in these figures).[2] The Muslim religion, furthermore, is divided into Sunni and Shia branches, with Sunnis in the majority worldwide. Muslim rulers in British India were mostly, but not exclusively, Sunni. In European discussions of Islamic culture, and certainly in the nineteenth century, the difference between these factions has been mostly subsumed under a blanket reference to 'Muslim' or 'Islamic'.

1 Histories of encounter

The British first arrived in India in the early seventeenth century as traders employed by the East India Company (EIC). The company had been founded in 1600 with the aim of breaking the hold of Portuguese merchants on the lucrative spice trade in South-East Asia, but found direct access to the Spice Islands (Malaku Islands or the Moluccas) blocked by the Dutch East India Company. The EIC, therefore, had to procure the coveted spices through regional trade within Asia. It soon discovered that Indian cloth was the most profitable barter in South-East Asia and began to focus on India to source textiles. Its first 'factories' (trading posts) were set up in Masulipatam (also Masulipatnam, now Machilipatnam) on the east coast of India in 1611, and on the west coast in Surat, the outlet port of the textile manufacture of

Gujarat in 1612. A further factory was set up on the east coast in Madras in 1639, and yet another in the 1690s on the Hooghly (one of the mouths of the Ganges), which later developed into the city of Calcutta. Bombay, which came to the British Crown in 1661 as part of the dowry of Charles II's Portuguese bride, was granted to the EIC in 1668.

It took until 1616 before the EIC secured official permission to trade from the most powerful ruler in India at the time, the Mughal Emperor Jahangir (r.1605–27) (see Chapter 1, Plate 1.9). The Mughals were Muslims of central Asian origin who had adopted Persian cultural traditions and conquered parts of northern India in the early sixteenth century. Gradually expanding their empire to encompass, under the Emperor Aurangzeb (r.1658–1707), almost the entire subcontinent, they remained in power until 1857, though from the mid-eighteenth century their authority was increasingly nominal. They ruled over a population that was multi-ethnic and adhered to a range of different faiths. The Mughals were not, however, the first Muslim rulers in India, but had wrested power from a Muslim kingdom in northern India, the so-called Delhi Sultanate (1206–1526). Its rulers, who were also of central Asian origin, initiated the first form of Indo-Islamic architecture, thereby providing a precedent for the Mughals to follow. Even under Mughal rule, other Indo-Islamic styles of art and architecture that differed from Mughal visual culture flourished, for example in the central Indian Sultanate of Bijapur (Vijayapura) (1490–1686) in today's Karnataka. India thus had a long history of cross-cultural encounters before the arrival of the British.

The extent of such encounters under the Mughal Empire is usually credited to Jahangir's father, Emperor Akbar (r.1556–1605), who consolidated Mughal rule in India. Akbar understood that the longevity of his empire depended on inclusivity and religious tolerance; facing down orthodox Sunni Muslim opposition, he had married the Hindu princess Heer Kunwari from the state of Amber (today's Jaipur) in Rajputana (also called Rajasthan). The marriage, which brought considerable Hindu influence to the Mughal court, made the royal Mughal line 'mixed blood' as the princess was the mother of Emperor Jahangir, a trend that continued, since Jahangir's successor, Emperor Shah Jahan (r.1628–58), also had a Rajput mother.

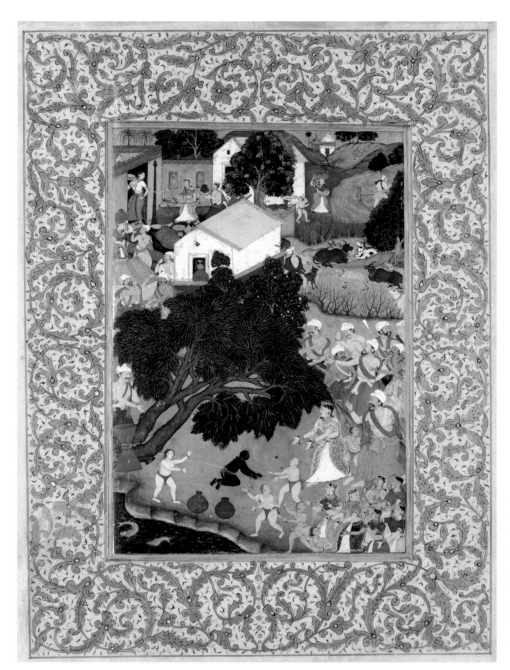

Plate 0.4 Unknown artist, illustration of Krishna as a child, uprooting the Arjuna trees, *c*.1590 (border added in the eighteenth century), opaque watercolour and gold on paper, 38 × 19 cm, from the *Harivamsa* (the story of Lord Krishna). Victoria and Albert Museum, London. Photo: © Victoria and Albert Museum, London.

Furthermore, when expanding Mughal territory through conquest, Akbar offered positions of rank in his army and government to defeated chieftains as well as allowing them to retain their customs and rituals in exchange for accepting Mughal rule.

Likewise, when Akbar expanded the royal atelier which hitherto had solely employed Persian artists, he gave instructions to source Indian talent, thereby introducing local painting traditions to the Mughal court.[3] Scandalising the *ulama* (Sunni Muslim clerics) at the court even further, he also had Hindu myths translated into Persian, the language of the Mughal court, and illustrated. One example depicts a scene from the life of the Hindu deity Krishna, recognisable by his blue skin, from the Mughal *Harivamsa* or story of Krishna (Plate 0.4). Furthermore, court artists copied European images, which, for the most part, arrived in

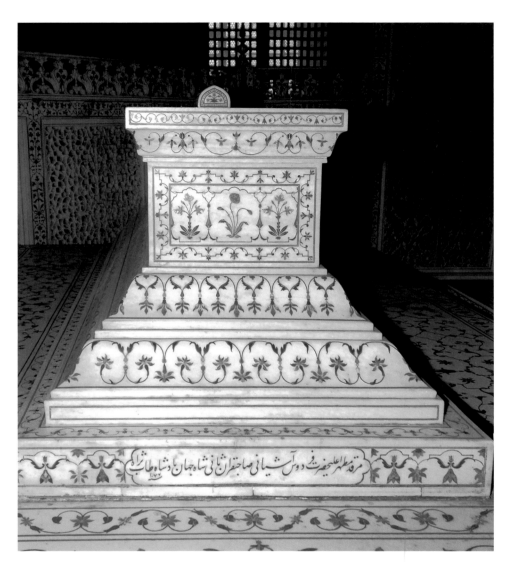

Plate 0.5 The cenotaph of the Mughal Emperor Shah Jahan with *pietra dura* or stone inlay floral decorations. Taj Mahal, Agra. Photo: Dinodia Photos/ Alamy.

India in the form of prints or book illustrations, either through trade, or as gifts from Jesuits who sought to convert the emperor to Christianity. Both Akbar's son Jahangir and his grandson Shah Jahan (who famously commissioned the Taj Mahal) continued his strategies and likewise patronised the arts. The close attention Jahangir and his court artists paid to European iconography is evident from an example illustrated in Chapter 1 (Plate 1.9). These contacts also initiated a form of botanical painting that drew on European precedents (see Chapter 1, Plate 1.10), which in turn led to floral motifs becoming a dominant Mughal architectural decorative element as shown, for example, in the stone inlay work on the cenotaph of Shah Jahan (Plate 0.5).

Mughal court painters were therefore skilled at adapting different visual traditions, including European artistic models, well before British traders arrived in India.

The decline of Mughal power began with the reign of Aurangzeb, which saw a return to Sunni Islamic orthodoxy in the form of a series of highly unpopular measures: he prohibited the Hindu religion, ordered the destruction of Hindu temples and reintroduced the *jizya*, a special tax on non-Muslim males required by Islamic law that Akbar had abolished. Aurangzeb thereby undermined the alliances that had ensured the stability of Mughal power and instigated near continuous revolts, embroiling the empire in relentless

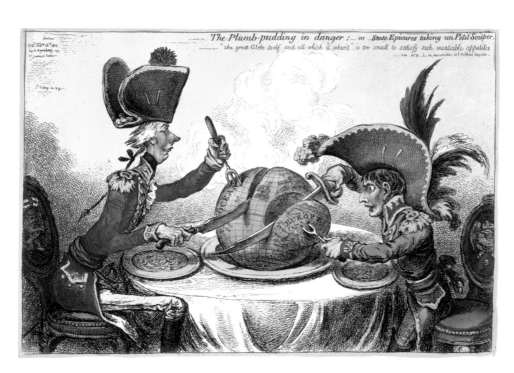

Plate 0.6 James Gillray, *The Plumb Pudding in Danger; -or- State Epicures Taking Un Petit Souper*, 1805, hand-coloured etching, 26 × 36 cm. Photo: Pictorial Press Ltd/Alamy.

military campaigns that brought it to the brink of bankruptcy. In the struggle for the succession that followed his death, the Mughal Empire began to lose its commanding influence. As provincial governors broke away and competed with one another for control over territory, they sought alliances with Europeans to shore up their positions. The ensuing political instability was exacerbated by the sacking of Delhi in 1739 by Nadir Shah (r.1736–47), the ruler of Persia (now Iran). Another contributing factor was the competition between Britain and France for global influence, as shown in a satirical print by James Gillray (Plate 0.6). With both these European powers backing different Indian regional powers, the Anglo-French rivalry increasingly affected Indian politics, playing a major role in the EIC's shift from trade to rule; as once the company had helped its chosen party to the throne through military intervention, it demanded loyalty, tax revenue and the acceptance of EIC overlordship as payback.

A case in point is the Battle of Plassey (1757), a watershed event for the EIC, when the forces of the company under Robert Clive 'defeated' the army of Siraj ud-Daulah, the Mughal governor of Bengal, Bihar and Orissa, and his French allies. In fact, Clive

had bribed Mir Jafar, one of his opponent's generals, to switch sides during the battle, thereby tipping the balance in Britain's favour. Having been declared (puppet) ruler of Bengal in recompense, Mir Jafar duly granted the right to collect taxes in the state to the EIC, a concession often cited as the beginning of British rule in India, as now, for the first time, the company generated revenue through means other than trade. The true balance of power is apparent from a picture of the aftermath of the battle by the British painter Francis Hayman (Plate 0.7). It presents Clive, now the de facto ruler of Bengal, extending a welcoming hand to Mir Jafar, whose inclined body and hand gestures signal supplication. Britain's global dominance was also strengthened by the Treaty of Paris (1763) which marked the end of the Seven Years War, a large-scale conflict that drew in most of the European powers. It saw the French, Portuguese and Dutch defeated, and brought French influence in India largely to an end.

However, it was not only Indian politics and military campaigns that changed the status of the company. During the eighteenth century the British government became increasingly involved in the EIC's Indian affairs, seeking to curb the personal enrichment of company officials while the EIC itself approached

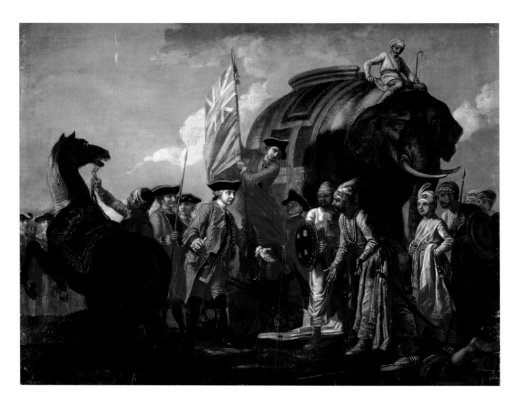

Plate 0.7 Francis Hayman, *Robert Clive and Mir Jafar after the Battle of Plassey, 1757*, c.1760, oil on canvas, 100 × 128 cm. National Portrait Gallery, London. Photo: © National Portrait Gallery, London.

bankruptcy, requiring government bailouts. Successive reform acts passed between 1773 and 1853 steadily increased the influence of and oversight by the British government. A further factor in the development of British imperialism was the arrival of (Protestant) missionaries who had previously been barred from India by the EIC, but gained access in 1813 by government decree. They soon made their influence felt, lobbying relentlessly to reform Indian society and to lift the natives out of 'superstition' through a European-style education based on the Christian faith and taught in the English language. For the social theorist Ashis Nandy, the arrival of the missionaries marks the beginning of colonialism proper, as 'the middle-class evangelical spirit' began to 'ascribe cultural meanings to the British domination' in terms of the civilising effort of a morally superior nation. [4]

Exemplifying this new interventionist spirit is the *Minute on Indian Education* written by the colonial civil servant Thomas Babington Macaulay in 1835. Macaulay famously made the case for introducing English education (meaning the teaching of European arts and science in the English language), breaking with the established model, by which Indians were taught Hindu and Perso-Arabic scriptures, together with rudimentary English skills, at local colleges. [5] Instead, he proposed educating a section of the Indian population to become English in taste and culture on the assumption that they would act as intermediaries between Britain and the colonial population, thereby aiding colonial rule and advancing Britain's civilising efforts (while also working as clerks in the colonial administration at a fraction of the salaries paid to Britons). [6] In time, this 'Anglicist' educational policy largely replaced the previous 'Orientalist' approach of relative cultural non-interference (though in practice the latter too endorsed notions of British superiority and supported British rule by means of an intermediary Indian class). [7] Among the educational institutions founded to impart a European education, in this instance a British art and design curriculum, were four art and design schools: Madras (1850), Calcutta (1854), Bombay (1856) and Lahore (now in Pakistan) (1875). [8] These schools came to play a significant role in the artistic interactions between Britain and India during the Raj, and will feature especially in the first two chapters of this book.

As the EIC shifted from trade to rule, the company initiated fundamental changes at the local level that interfered with established customs, structures

Plate 0.8 Indian presidencies *c.*1851 (showing the Bengal Presidency outlined in green, the Madras Presidency in blue and the Bombay Presidency in yellow), in *Tallis's Illustrated Atlas*, Part 28, London, John Tallis and Company, *c.*1851, Plate [1]. Photo: Antiqua Print Gallery/Alamy.

and administrative procedures.[9] These accumulated interventions are credited with having helped to provoke the single most devastating and consequential event in Anglo-Indian relations, an uprising that began with the revolt of the native soldiers of the Bengal branch of the EIC army in 1857 and spread through vast swathes of northern India. Commonly referred to as the Indian Mutiny in British accounts and the Indian Rebellion in Indian ones, this watershed event brought EIC rule to an end and led to direct governance by Britain. The company's administrative failings,

rapacious territorial annexations and, crucially, the mismanagement of its Bengal army are commonly cited as reasons for the rebellion. The company had long raised and maintained its own military forces to protect trading stations; these consisted of both indigenous and European troops, with Indian soldiers called 'sepoys' commanded by British officers, certainly in the higher ranks. These forces were divided into three separate armies, one for each presidency (as the EIC administrative units were called), centred on Madras, Calcutta and Bombay, respectively (Plate 0.8).

The popular story is that the rebellion was caused by the introduction of new cartridges, which had been greased with pork and cow fat and thus were ritually defiling for both Muslim and Hindu soldiers (the mistake had in fact soon been corrected and cartridges with vegetable grease were issued in India). This was certainly the view adopted by many officials of the Raj, who attributed the uprising to the 'irrational panic' and superstition of the sepoys, deflecting culpability for the mutiny by glossing over more complex, deeper causes.[10] Other commentators identified the rapid rate at which Indian territories were being annexed (Plate 0.9) and the wilful deposition of Indian rulers as contributing factors; liberal reformers such as Lord Dalhousie, governor-general of India from 1848 to 1856, for example, considered Indian rulers to be anachronistic despots who stood in the way of progress and were best removed summarily from office.[11] Dalhousie's annexation in 1856 of the kingdom of Oudh (also Awadh, now Ayodhya) in today's Indian State of Uttar Pradesh, from which about one-third of the sepoys in the Bengal army originated, stoked particular resentment, with the result that, there, by contrast to other Indian regions, all classes rose up to join the rebellion in support of their deposed king.[12]

It took the EIC a year to regain control. Both the rebellion and the subsequent British retaliation were characterised by often extreme and undiscerning violence. British atrocities are now thought to have outweighed acts committed by rebels, yet the latter, notably the massacre of white women and children in Cawnpore (Kanpur) by 'savage' native men (see Chapter 1, Plate 1.4), dominated British media accounts and prompted cries for revenge.[13] The British response was ferocious, indiscriminate and disproportionately brutal, as in the case of the blood bath that followed the recapture of Delhi. Although the majority of the local population in the northern regions of British India had not supported the mutineers, they were massacred alongside the rebellious sepoys – women and children included. Some Britons were appalled by the ferocity of the retribution, however; most prominent among them was Lord Canning, governor-general (1856–58) and first viceroy of India (1858–62). His efforts to restrain the British vengeance earned him the derogatory nickname 'Clemency Canning'.[14]

In the aftermath of the rebellion, debates as to its causes raged in Britain. Conservatives blamed the uprising on the modernising spirit of liberal reformers

and condemned the annexation policy; liberals, by contrast, argued that it was the haphazardness of reforms that had provoked the revolt.[15] The Conservative politician (and future prime minister) Benjamin Disraeli singled out for particular condemnation the administration's Christianising policies, arguing that they had upset the traditional social order.[16] Such views played a decisive role in the post-rebellion reconfiguration of colonial governance in the subcontinent, as Crown rule, which had already been advocated by Conservatives prior to the Indian Rebellion, became political reality. A feudal model was therefore advocated in the belief that it would secure the support of Indian princes by drawing them into a relationship that represented continuity with the Mughal Empire.[17] Accordingly, the Royal Proclamation of 1 November 1858, which ended EIC rule, stated that there would be no further territorial expansion or religious interference. It also held out a vision of equal rights for Queen Victoria's Indian subjects (a declaration the Raj never lived up to). These developments culminated in Queen Victoria being declared Queen-Empress of India in 1877. As the historian David Washbrook has observed, whereas previously her 'symbolic role' was to be 'India's link to a modern future', she was now presented as the heir to the Mughal dynasty, thus standing for the 'changeless and unchangeable ... hierarchical order of traditional Indian society'.[18] In consequence, the Raj now became more autocratic, thereby contributing to the rise of Indian nationalism and the independence movement towards the end of the nineteenth century.[19]

The Queen's assumption of her new title was celebrated with great pomp and circumstance in 1877 in a ceremonial gathering or assembly known as a durbar, which the colonial regime appropriated from Mughal practice and refashioned to suit its own purposes. (Two further durbars were held in 1903 and 1911 respectively; see for example Plate 4.2 in Chapter 4.) The medieval theme adopted for the ceremony, with decorations, uniforms, coats of arms for Indian princes and other details invented for the occasion, served to characterise British rule in feudal terms. Responsibility for the design was entrusted to John Lockwood Kipling, father of Rudyard, an influential British art educator who spent most of his professional career in India, together with other art educators and the civil servant Robert Taylor.[20] For the occasion, the mantle and the

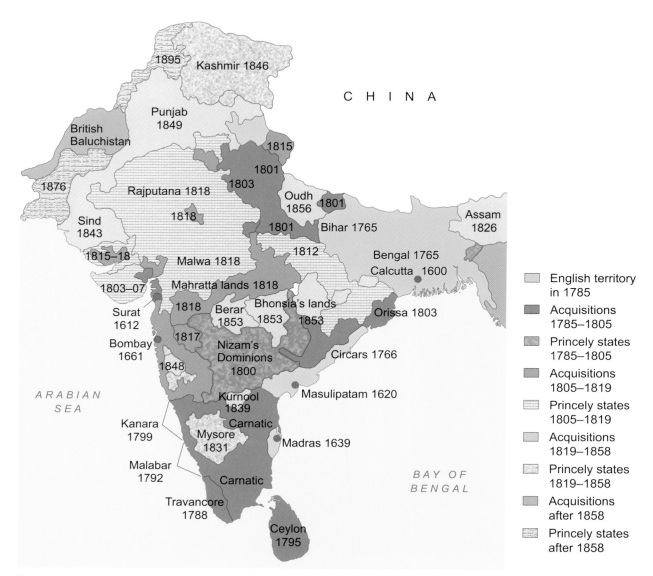

Plate 0.9 Annexations by the East India Company and during the Raj, from 1765, adapted from the map 'The growth of British power in India', in Peter Nathaniel Stearns and William Leonard Langer (eds) 'India 1500–1800', *The Encyclopedia of World History*, sixth edition, Boston, MA, Houghton Mifflin, 2001.

insignia of the Star of India, a chivalric order invented to honour Indian princes and thereby to bind them to the colonial regime, was required to be worn by them.[21] The Muslim Shah Jahan Begum, the female Nawab of Bhopal (r.1868–1901), which was unique among princely states in having a series of women rulers, was photographed at the durbar wearing the accoutrements of the order, over the traditional court dress of Bhopal (fitted trousers, long shirt and angled cap), and English-style leather boots such as were worn by Europeanised men to avoid the indignity of being forced to remove Indian footwear in public places (Plate 0.10).[22] The Begum unusually had only recently adopted the custom of living in seclusion or *purdah*, which was the norm for elite Muslim women. She therefore did not appear unveiled in public, but chose to reveal her face to the camera on this occasion. The durbar was recorded in a painting by the British artist Valentine Prinsep, who depicted Indian rulers paying homage to the viceroy, Lord Lytton (1876–80) (Plate 0.11).

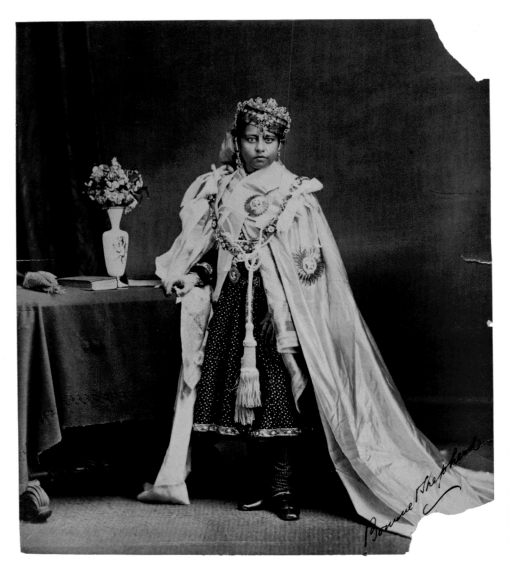

Plate 0.10 *Shah Jahan Begum, Nawab of Bhopal*, 1877. Photographed by Bourne and Shepherd. British Library, London, shelfmark Photo 99/(39). Photo: © British Library Board. All Rights Reserved/ Bridgeman Images.

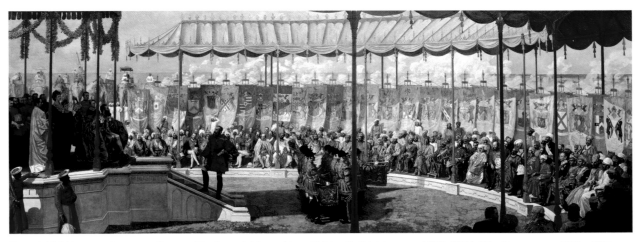

Plate 0.11 Valentine Cameron Prinsep, *The Imperial Assemblage Held at Delhi, 1 January 1877*, 1877–80, oil on canvas, 305 × 723 cm. Royal Collection Trust. Photo: © HM Queen Elizabeth II 2017.

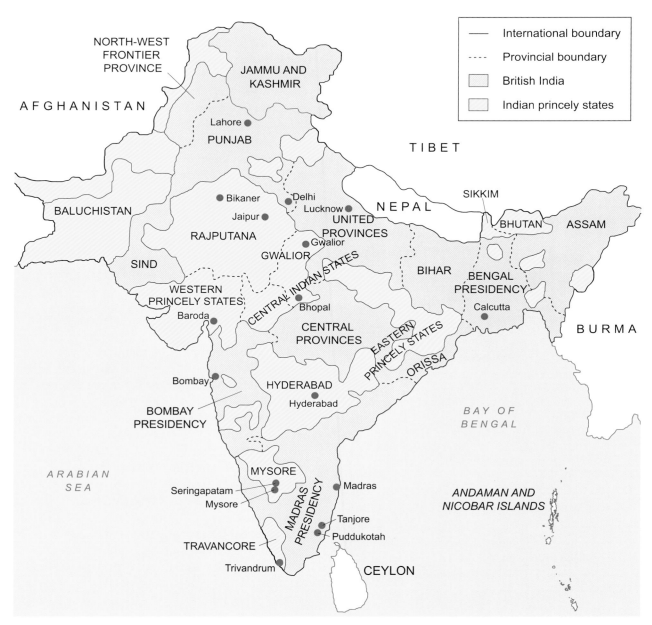

Plate 0.12 Princely states and the territory of British India around 1937 after Burma became a colony in its own right, adapted from a map in Judith Brown and William Roger Louis (eds) *The Oxford History of the British Empire, Volume IV: The Twentieth Century*, Oxford, Oxford University Press, 1999, p. 432.

It is also worth mentioning here that the 500 (or more) princely states scattered all over the subcontinent were not under direct British rule, and therefore, strictly speaking, not part of British India, as the term more properly applies to areas under immediate British governance (Plate 0.12). Together, they covered two-fifths of the Indian subcontinent and accounted for about one-fifth of the overall Indian population under British rule.[23] The local sovereigns who governed these territories included representatives of ancient royal Hindu dynasties such as the Rajputs (Plate 0.13 and Chapter 3, Plates 3.3 and 3.24) and of more recent dynasties such as the Hindu Marathas, a loose confederacy of powerful independent families who emerged in the seventeenth century (Plate 0.14), as well as Muslim rulers who had risen to power during

Plate 0.13 T. Murray, *Ram Singh II, Maharaja of Jaipur*, c.1865, Indian-style 'tinted' photograph. Maharaja Sawai Man Singh II Museum, City Palace, Jaipur, Rajasthan. Photo: Maharaja Sawai Man Singh II Museum.

the eighteenth century, such as the ruling family of Bhopal or the Nizam of Hyderabad, one of the largest princely states. Given the cultural and religious complexities of Indian history, it was not uncommon for Indian populations to live under rulers of foreign origins, culture and religions. Thus, the Muslim faith of the rulers of Bhopal and Hyderabad did not reflect the predominantly Hindu affiliation of their subjects, while in Kashmir, conversely, a Hindu prince ruled over a predominantly Muslim population.[24]

In the new, post-rebellion order, the princes were no longer considered anachronistic despots but rather key allies; as such, they were safeguarded by Britain from internal and external challenges to their rule. They enjoyed varying degrees of sovereignty in their internal affairs, depending on the conditions laid down in the contracts agreed when they came

under British 'protection', but were not allowed to conduct external political relations. In this way, the overarching British interest in exerting control over these territories was satisfied without the burden of administering them. Britain also validated princely successions, reserved the right to depose princes, took charge of princely education and ruled on behalf of minors. Furthermore, a class of colonial administrators oversaw princely conduct; larger states such as Hyderabad received a full-time 'overseer', or British resident, while smaller ones were 'supervised' by an agent responsible for several such territories. This arrangement created a golden age for Indian princes who no longer needed to worry about challenges to their position; effective colonial supervision of the internal affairs of princely states proved difficult, so that an astute, high-ranking prince could do as he pleased as long as no major scandals were caused and a veneer of subservience was maintained.[25]

Although the pomp and circumstance of the imperial durbars projected an image of strength and power, the Indian Rebellion had created a deep sense of distrust between Britons and Indians, with heavy reliance on the army as guarantor of security on the part of the British.[26] Whereas colonial prejudices had previously been tempered by a spirit of liberal optimism, the aloof stance of 'East is East and West is West' now predominated.[27] This shift is made evident by a comparison between a late eighteenth-century portrait by the German-born British painter Johan Zoffany of the Chief Justice of Calcutta, Sir Elijah Impey, and his family (Plate 0.15), and a late nineteenth-century photograph of the children of the colonial officer Surgeon-General Henry Walter Bellew (Plate 0.16). Whereas Zoffany depicts a domestic scene characterised by an informal mixing between Britons and Indians, with one of Impey's children dancing to Indian music in an Indian outfit, Bellew's children are dressed in stiff European clothes. They are primly posed on their ponies while an Indian servant formally stands to attention with no sign of physical interaction, even though he has most likely just lifted them onto their mounts.

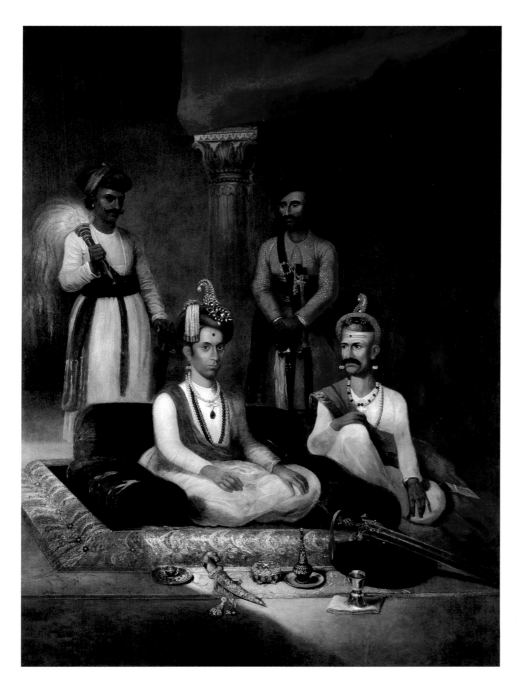

Plate 0.14 James Wales, *Madhu Rao Narayan, Maratha Peshwa and Nana Fadnavis with Attendants*, 1792, oil on canvas, 228 × 186 cm, finished by Thomas Daniell in 1806. Royal Asiatic Society, London RAS 01.014. Photo: Royal Asiatic Society of Great Britain and Ireland, London.

As well as reinforcing colonial prejudices, the rebellion also led to a more cautious attitude towards reform and a new emphasis on 'difference' which sought to preserve Indian traditions, with history, more particularly histories of Indian art and architecture, playing a pivotal role in this endeavour. Anxious to rule India without disrupting its traditions, the British made increasing efforts to understand what they saw as a bewildering array of different cultures, customs and religious traditions. These efforts gave rise to government-sponsored programmes for the exploration and classification of India's history through archaeological excavations and photographic documentation of Indian castes, types and monuments

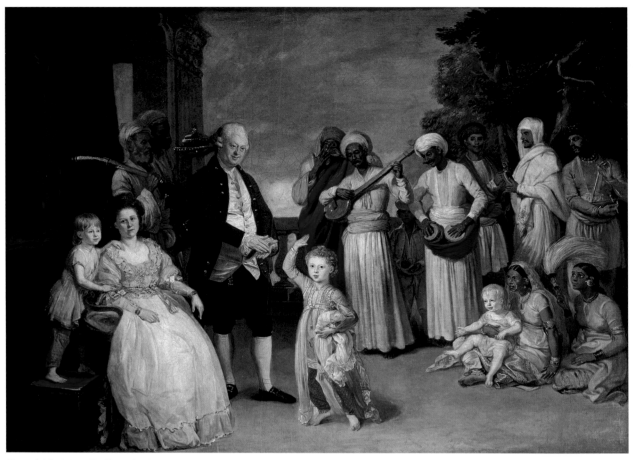

Plate 0.15 Johan Zoffany, *Sir Elijah and Lady Impey and Their Three Children*, *c.*1783–84, oil on canvas, 92 × 122 cm. Museo Thyssen-Bornemisza, Madrid. Photo: © Christie's Images/Bridgeman Images.

(see Chapter 3, Plates 3.14–3.19).[28] It also generated pioneering historical publications by amateur scholars, notably the indigo planter turned architectural historian James Fergusson's *History of Indian and Eastern Architecture* (1876).

Other factors, namely the industrial revolution and the technological innovations it generated, also transformed the relationship between Britain and India. Exemplary of this transformation is the story of chintz, the brightly coloured Indian fabric with exotic floral designs now considered a sign of quintessential Englishness. Large-scale imports of these textiles into Europe in the seventeenth century almost destroyed the European textile industry. In 1750, for example, India produced one-quarter of the world's textile output, exporting cotton and silk fabrics to many countries, including Britain. By the mid-nineteenth century, however, the roles were reversed as industrially manufactured British textiles flooded the Indian market, bringing local production to its knees (see Chapter 2, Plate 2.24).[29] Furthermore, India started to supply raw materials in ever increasing amounts to feed ever more sophisticated machinery in Britain, as industrialisation started to take off. The ensuing transformation of India's agrarian sector turned previously self-sufficient villagers into cash-crop farmers or low-wage workers on large agricultural estates, such as those producing indigo, which were mostly run by Europeans (see Chapter 2, Plate 2.21). When food prices rose beyond what low-paid Indian agrarian workers could afford, famine often resulted.[30]

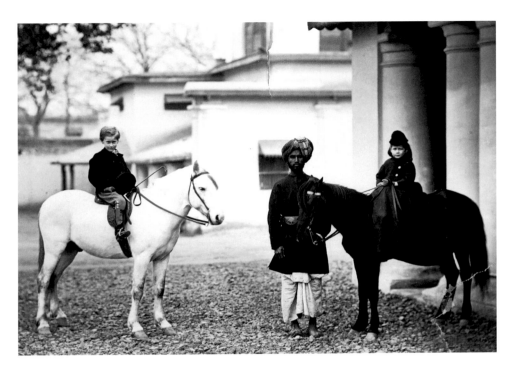

Plate 0.16 Children on ponies, photograph from the album of Surgeon-General Henry Walter Bellew, c.1880. The British Library, London, Bellow Collection. Photo: © British Library Board. All Rights Reserved/ Bridgeman Images.

The transport revolution also made an important contribution to the change in Anglo-Indian relations. Between 1850 and 1900 some 41,000 kilometres of railway track were laid in India, allowing not only for raw materials to be shipped to Britain but also for British goods to penetrate the Indian hinterland. The advent of the steamship was arguably of even greater consequence, reducing the journey time from London to Calcutta from six months to a mere 45 days, which was subsequently halved by the opening of the Suez Canal in 1869. This development led to a reduction in the price of shipping bulk commodities in the 1870s and 1880s, turning the empire into a prime target for British exports. Also noteworthy was the communications revolution resulting from the advent of the telegraph: by the 1870s a direct line between England and India was fully operational, strengthening Britain's control of the colony. [31]

During the nineteenth century, therefore, the relationship between Britain and India was completely transformed. When British traders first arrived in India in the early seventeenth century they had to humour Indian rulers to gain trading concessions; in 1858, by contrast, they tried the 'last Mughal Emperor'

Bahadur Shah Zafar (r.1838–58) for 'treason' since he had (reluctantly) agreed in 1857 to become the nominal leader of the Indian rebels. He was deposed and banished to Burma (now Myanmar). [32] In economic terms too the dynamic had shifted as India had become a supplier of raw materials to British textile mills and a prime export market for British goods.

2 Approaches to the study of empire

Historians have approached the histories of empire from different angles, with so-called 'old' and 'new' imperial history forming two distinct and often opposed schools of thought, a schism that reminds us that the writing of history is not a transparent affair, but entails issues of representation bound up with epistemological choices or, to put it another way, different world-views. [33] The old imperial history, for example, takes an empiricist approach, laying the emphasis on national, diplomatic and economic contexts; focusing as it does on the actions of political and military leaders, it has been described as 'top-down'. [34] It predominated until the 1980s when it was challenged by 'new imperial history', an umbrella term for a range of approaches that added a cultural

dimension to the study of empire.[35] Variously drawing on literary criticism, cultural studies, ethnography and geography, psychoanalysis, feminist theory and philosophy, new imperial history is interested in exploring colonialism in terms of its ideological dimensions, with reference to issues of culture, gender and race. Instead of a 'centre–periphery' model that conceived colonial relations mostly as one-way flows from the colonial centre (also referred to as the metropole) to its colonies, it proposes that 'a matrix of interconnections' is a framework that better reflects the complexity of colonial relations. This approach also extends the study of empire to include the legacy of colonial rule after independence.[36]

New imperial history traces its intellectual lineage to the work of Edward Said, a literary scholar of Christian Palestinian origin. In his book *Orientalism*, published in 1978, Said built on earlier anti-colonial critiques by writers such as the French-Caribbean psychiatrist and political activist Franz Fanon. *Orientalism* provided a major impetus for the development of post-colonial studies, a field that brought a broad range of critical approaches to bear on the study of colonialism and imperialism.[37] New imperial history has in fact been described as history's 'post-colonial' turn. While it is beyond the scope of this introduction to discuss post-colonial studies in depth, some of the perspectives initiated by *Orientalism* need to be outlined here in order to provide a basis for understanding the approaches that inform the discussions in the present book.[38]

In *Orientalism*, Said analysed the highly gendered, stereotypical representations of the 'Oriental East' found in canonical European literature through the lens of 'power-knowledge', a concept forged by the French philosopher Michel Foucault. Foucault argued that the accepted truths in any society are shaped by the interests of those in power, and demonstrated the link between defining a people and having power over them. As Said pointed out, European Orientalist scholarship considered countries such as Egypt and other 'Eastern' cultures without reference to their distinct histories. He argued that it thereby fostered a stereotypical notion of the 'East' that summarily and contradictorily characterised these cultures not only as timeless, sensuous, decadent and effeminate, but

also as despotic and barbaric, as well as mysterious and spiritual. It is worth noting, however, that these clichéd representations were not nineteenth-century inventions, but long-standing notions originating in Greek and Roman conceptions of 'barbarians' and other outsiders that were later reworked through a Christian prism and further adapted in the colonial period.[39]

Orientalism, as it was characterised by Said, therefore offered a rich, paradoxical and malleable reservoir of deeply entrenched stereotypes that could be mobilised according to the requirements of a particular context. The dessert plate illustrated here exemplifies the supposedly 'harmless' and 'amusing' stereotyping of Indian servants (Plate 0.17). It is one of a series of 13 designed and executed by Lockwood Kipling. These 'funny' images caricatured the untrustworthy 'Oriental' nature of Indians who, by implication, were presented as too lazy and dishonest to run their own country.[40] Such representations were not innocent but political; as Said shows, they were based on a complex, hierarchical and deeply gendered set of values that equated European culture, Christianity and masculinity with rationality, modernity and progress, and by default declared representatives of other religions, races and cultures to be inferior, irrational and backward.[41] In British India, this mentality found expression in an exaggerated colonial cult of British manliness and military prowess constructed in contrast to the 'inferior' Indian male, who was thus 'feminised', as with the pervasive stereotype of the 'effeminate Bengali'. This gendering of colonial relations, furthermore, legitimated colonial rule in terms of the 'natural' dominance of 'man' over 'woman'.[42]

Such stereotypes were used to legitimise European authority over 'Eastern' peoples by claiming the right to represent, classify and explain their cultures and histories. These prejudicial attitudes acquired ideological weight since they both reflected and reinforced the imperial rule of the European countries that propagated them.[43] Moreover, as demonstrated by Fanon in his book *Black Skin, White Masks* (1952), these derogatory stereotypes were internalised by colonial subjects to devastating psychological effect. They also, however, informed notions of British identity and culture. As the historian Catherine Hall has pointed

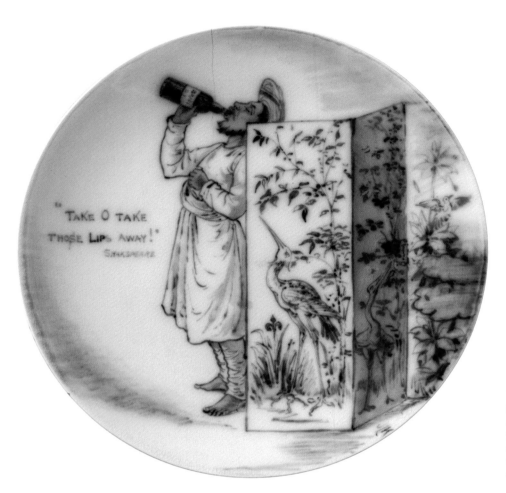

Plate 0.17 John Lockwood Kipling, dessert plate 'Take o take those lips away', *c*.1879, glazed earthenware, diameter 24 cm. Wimpole Hall, Cambridgeshire. Photo: Wimpole © National Trust/John Hammond.

out, British life was not only steeped in the 'fruits of empire', such as tobacco, sugar, tea and textiles, but also enmeshed in ideas about empire that deeply informed its imaginative life. Newspapers reported on colonial affairs; travel narratives recounted heroic and scientific exploits in the colonies; scholarly societies explored the flora, fauna and cultures of distant lands; large-scale panorama paintings commemorated military campaigns, such as the defeat in 1799 of Tipu Sultan (r.1782–99), the Muslim ruler of the Indian kingdom of Mysore (now Mysuru), who fiercely opposed the EIC's rise to power (see Chapter 1, Plate 1.3). For Hall, therefore, notions of imperial Britain and the national identity that it fostered were based on a 'grammar of difference' that defined Britishness in contrast to the 'inferior' cultures of its colonial 'others'.[44] This observation, for example, prompted the anthropologist and historian Norbert Peabody to rephrase Kipling's famous stanza as:

East makes West and West makes East
and, without the Other, the Self is not complete.[45]

Although Said's work has been immensely influential, it has also drawn criticism. In particular he has been accused of constructing too stark a binary between colonial powers and colonial subjects, attributing all power to the former and presenting the latter solely as victim. In his seminal work, *The Location of Culture* (1994), for example, the cultural theorist Homi Bhabha argues that colonial relations were far more complex, and indeed inherently contradictory in character. He emphasises that the 'East' represents a desirable place of fantasy and escapism for the Western imagination as well as an abject space of inferiority and derision, thereby drawing out the fundamental ambivalence that underlies its construction. For Bhabha, it is exactly this double-coding that gave colonialism the dynamism and the flexibility that enabled it to adjust to changing conditions on the ground.[46]

A case in point is provided by British colonial ideology: Indians were thought to be like Europeans with respect to the Aryan ancestry that they supposedly shared, but they were also believed to differ, not least in being representatives of an inferior civilisation that had fallen behind in the development of its Aryan potential. This contrast needed to be sustained in order to justify Britain's colonial presence on the grounds of its supposedly civilising, benevolent paternalism, a need that became more pressing as Indian elites learned English and absorbed English culture. Bhabha describes this diminishing of cultural difference in terms of 'mimicry', referring to English-educated Indians as 'mimic men', who presented too great a resemblance to their rulers' for their comfort. This development threatened to bring about the collapse of the binaries on which Orientalist stereotypes depended, making it necessary to recreate distance by drawing on further aspects of Oriental stereotyping, such as effeminacy. According to Bhabha, stereotypes were thus adjusted and repeated in order to secure and sustain the required colonial distance in response to the changing contexts of encounter.[47] Furthermore, again in contrast to Said, Bhabha emphasises the agency rather than victimhood of indigenous colonial elites, who are no longer presented as passively absorbing colonial ideologies but are recognised to have actively negotiated the colonial encounter, as in the independence movement, for example.

A further approach that has fed into new imperial history is the work of the largely South Asian Subaltern Studies Group, which emerged in the 1980s around the historian Ranajit Guha, who examined peasant uprisings in India. This influential group initiated the writing of South Asian histories from 'below', aiming to correct the dominant focus of imperial histories on colonial elites and thereby to restore history and agency to the subordinated. Questioning whether official texts or images that fill the archives can ever tell us anything about the experiences or values of colonial subjects, the group sought to write a 'history against the grain' of the established accounts of military commanders, colonial leaders and indigenous elites.[48]

New imperial history is also interested in the long-term impact of colonial ideology. As the sociologist Ramón Grosfoguel has pointed out, it recognises that colonialism does not end with the demise of colonial administrations and contends that critical reviews of colonial cultural conceptions are essential to the decolonising of the 'mind', a task that needs to be carried out by all parties to the colonial experience.[49] Moreover, as Nandy has shown, the social and cultural norms introduced by colonial ideology, once internalised by subject peoples, became shared points of reference that subsequently served as the parameters within which indigenous resistance was mounted. This phenomenon is exemplified by the adoption by Indian nationalists of Orientalist frameworks and European conceptions of art and art history for the purpose of defining a distinctively Indian art (this will be discussed in Chapter 1).[50]

3 British art, empire and art history

The recognition that art history played an important role in Britain's colonial enterprise was brought to the fore by the critical perspectives initiated by *Orientalism*. However, the debates that most directly inform the discussions in this book derive from Said's later work, *Culture and Imperialism* (1993), in which he argued that Western culture of late cannot be understood without reference to its often hidden relationship to empire.[51] This book provided the context for the exploration of British art and empire by the art historians Tim Barringer and Geoff Quilley,

who, together with Douglas Fordham, noted that the history of empire had been fundamentally neglected, arguing that this misrepresented Britain's visual culture. In the introduction to their co-edited volume, *Art and the British Empire* (2007), they pointed out that, despite addressing questions of gender, class and race, the 'New Art History' of the 1980s and 1990s had curiously failed to include empire within its remit.[52] They also noted that the forays into British art and empire that did exist, such as the foundational archival and curatorial work of William George Archer and Mildred Archer in the 1950s and 1960s, remained isolated from mainstream discussions of British art.[53]

As scholarship on art and empire has expanded, not only has new attention been devoted to colonial contexts but also, in the process, methodological issues have been raised. A merely additive approach, which retrospectively inserts 'colonial' work into the existing canon, was soon recognised to be unsatisfactory because it fails to address the underlying assumptions that generated these exclusions in the first place. Rather, what is needed is a shift in perspective that revises the conceptions of British art that led to this neglect.[54] Such a critical review of the underlying assumptions that had fostered this insular understanding of British art soon threw a spotlight on nineteenth-century European conceptions of culture more generally, showing them to have been 'essentialist' (a term to be explained below) and linked to nationalism and notions of race.

Before continuing, it is worth tracing some of the ideas that have led to this cluster of conceptions, and their implications for questions of art and empire. A key figure in this context is the eighteenth-century German philosopher Johann Gottfried von Herder, who put forward novel ideas about culture and community that were subsequently appropriated (and misinterpreted) by most European theorists of national identity.[55] What was new and distinctive about Herder's philosophy was the way that he linked notions of language, history and community; for him, the cultural and historical traditions of a people or 'nation' were embedded in their language, which through historic processes of formation had become expressive of the 'inner spirit' of such a group. According to Herder, a 'nation' was therefore a cultural

unit, which had evolved over time and had acquired an inner cohesion. This idea had far-reaching political ramifications since it provided the basis for a novel theory of political legitimacy: no previous philosopher had suggested that identities based on language and culture should be regarded as the primary source for communality and, therefore, by implication, political union and authority.[56] Although Herder remained ambiguous as to precisely how the cultural 'nation' should be expressed in political terms, he did make it clear that he was opposed to any form of political rule that imposed a foreign language on a people and thus staunchly opposed empire: language had now become a source of resistance to invasion and conquest.[57]

Herder's ideas were subsequently adapted by another German philosopher, Georg Wilhelm Friedrich Hegel, who added a developmental, hierarchical dimension that would dominate nineteenth-century thought. Hegel proposed a 'philosophy of history', according to which the civilisations of the world each represented a different stage in the gradual unfolding of a universal 'spirit'; he further posited that Christian European peoples had achieved the most advanced stage in this historical 'grand narrative of progress'.[58] Hegel's interpretation of Herder's notion of a 'cultural nation' also entailed the assumption that a people's art directly expressed its distinctive traits, with the further implication that the work of all artists from the same nation expressed its unique underlying collective character or 'spirit'. Furthermore, a nation's art was thought to offer insights into the developmental stage of civilisation that it occupied, thereby enabling different cultures to be compared and evaluated on the basis of their artistic expression. The supposedly universal standard used for this purpose was that of European classical art, giving rise to a hierarchical ranking of different cultures, as can be seen from a diagrammatic watercolour by the British artist James Stephanoff. It shows art progressing from a primitive stage of development, exemplified by Indian and Mexican sculpture at the bottom of the image, to the perfection of Classical Greece at the top (Plate 0.18).

A point worth noting here is that Hegel did not link cultural leadership and political rule; for him the unfolding of the universal spirit of history was strictly a matter of culture.[59] His ideas, nonetheless, were

Plate 0.18 James Stephanoff, *An Assemblage of Works of Art in Sculpture and in Painting, from the Earliest Period to the Time of Phydias*, 1845, watercolour, 74 × 62 cm. British Museum, London, 1994, 1210.6. Photo: © The Trustees of the British Museum.

interpreted to suggest a causal relationship between cultural and political supremacy. Thus understood, they had far-reaching consequences in so far as they closely intertwined art, art history and politics in a way that would prove crucial for the legitimation of British rule in India. Their usefulness for this purpose was reinforced by the addition of a further element: the linking of culture and biology, which began to gain currency from the early nineteenth century, 'explained' supposed differences in cultural development in terms of race. The French diplomat and writer Joseph-Arthur, Comte de Gobineau, author of *An Essay on the Inequality of Human Races* (1853–55), played a pivotal role here, as did the social and political theorist Herbert Spencer, who coined the phrase 'survival of the fittest' after reading Charles Darwin's *Origin of Species* (1859). Spencer thereby transposed ideas of biological evolution to cultural development, giving rise to so-called 'Social Darwinism'.[60]

By the mid-1860s cultural characteristics were thus increasingly seen as biologically determined and hence inborn and inalienable, initiating the way of thinking known as 'essentialism'. It represented a new departure since race had previously not been considered to be biologically determined; before then, for example, climate had been viewed as a major factor that differentiated European and non-European 'races'.[61] This new, biological approach led to the rise of 'scientific racism', which sought to prove on a purportedly 'scientific' basis that members of a particular race shared certain inborn and inalienable characteristics, such as laziness and despotism in the case of 'Eastern peoples', thereby reinforcing existing Orientalist stereotypes. In other words, what had previously been a cultural prejudice was now declared to be scientific 'truth'. A case in point was the 'science' of anthropometry, which systematically measured the human body, and sought to correlate skull shapes with assumed inborn traits. It was believed to offer 'scientific' proof of theories of racial difference and hierarchy as a result of natural evolution (see Chapter 3, Plate 3.17).[62] The new 'science' also reinforced the conviction of European superiority, creating a greater acceptance of colonial rule among European powers and unleashing a European-wide scramble for colonies that is usually referred to as the 'New Imperialism' (*c.* 1870–1914).

The blending of notions of race and culture also had an impact on the writing of art history. In his *History of Indian and Eastern Architecture*, for example, Fergusson isolated three stylistic strands in Indian art, one of which he considered to be the 'Northern style', which he associated with Aryans; he also, however, thought this style was 'in decline' because of racial mixing. He supported this claim with the 'fact' that the Sanskrit-speaking Aryans, whom he described as being of 'superior mental power and civilization', and who had supposedly created the style after they arrived in India 'at some very remote period in the world's history', had since intermarried with 'inferior' indigenous races, which had led to the dilution of their blood. Since, over time, Aryan blood in Indian veins became 'infinitesimally small', the purity of the style had invariably diminished. As this example demonstrates, cultural and racial mixing became closely intertwined in nineteenth-century art history and both were construed in negative terms as they were thought to weaken the 'pure' essence of any given culture or race.[63]

Such essentialist and racially based conceptions of culture further entrenched the idea that art gave a direct and unmediated expression to the character of an age or a people.[64] From this perspective, art history was regarded as an indispensable tool that could give a more accurate access to the past than written sources; the discipline was thus identified as a means of understanding and hence also of governing British India. These ideas also led to the historical neglect of empire in the field of British art and art history, since, from a nineteenth-century point of view, colonial territories were irrelevant to artistic expressions of Britain's national 'spirit'.

4 The transcultural

Many scholars would argue that the legacies of cultural essentialism are still with us today, even though culture is no longer considered to be biologically determined. In the arts, for example, it can be seen to persist in what the art historian Kobena Mercer has called the 'burden of representation', that is, the way that artists of non-European origins are expected to produce work that reflects their cultural roots and thus to produce work that is visibly 'other'.[65] As Mercer explains, this expectation represents a double standard, given that

the use of non-European models by European artists, as in the 'primitivist' experiments of modern art in the early twentieth century, was considered 'original' and 'authentic'. By contrast, when Indian artists of the same period experimented with European abstraction, their work was considered 'derivative' and 'inauthentic', unless it came along in an ethnic guise, as exemplified by the work of Jamini Roy (see Conclusion, Plate 5.2). The British-Pakistani artist and cultural critic Rashid Araeen thus considers the expectation of work by artists from non-European backgrounds to be visibly 'ethnic' a 'neo-colonial' attitude.[66]

Addressing this lingering essentialism is therefore a central concern of global approaches to art history. In recent years the concept of the transcultural has emerged as a productive framework for taking on this challenge.[67] It is based on the premise that cultures are formed through regular, multi-directional interaction and cultural exchanges with other regions, with particular reference to histories of colonial encounter.[68] The concept of the transcultural builds on a broad range of critical perspectives, such as post-colonial and Subaltern Studies, as well as other approaches associated with new imperial history. A number of pioneering studies from across the globe, which were previously overlooked, are now recognised as early experiments with a transcultural methodology. The Cuban anthropologist Fernando Ortiz, for example, coined the term 'transculturation' in 1947 to describe colonial cultural processes in Latin America from the point of view of the colonised.[69] Another landmark is the literary scholar Mary Louise Pratt's notion of the colonial 'contact zone'. The term refers to a space in which disparate cultural traditions confront one another in colonial conditions marked by unequal power relations, especially where the colonial power imposes its own traditions by violent means.[70]

However, the conceptual basis for the present understanding of the transcultural was most influentially set out by the contemporary German philosopher and cultural theorist Wolfgang Welsch in his essay 'Transculturality: the puzzling form of cultures today' (1999). He argues for a radical break with the inherited nineteenth-century conception of culture in terms of discrete and firmly bounded spheres organised around a nucleus of inner coherence. As he points out, this model allows cultural encounter

to be dismissed as inconsequential on the grounds that it occurs 'in-between' such units and therefore remains exterior to the supposedly inalienable and essential core of a culture. Welsch counters these often unconsciously held assumptions by positing cultural exchange as intrinsic and fundamental to cultural formation, arguing that culture should be recognised as constituted by such interactions.[71] On the basis of this understanding he rejects the notion of the 'intercultural' as unhelpful since it invokes an essentialist understanding of two self-contained entities that engage tangentially but remain sealed off from each other. In a similar vein, he critiques the notion of multi-culturalism as premised on the assumption that cultures have fixed identities, even if they are now acknowledged to co-exist in the same space.[72]

No less problematic is the concept of hybridity, according to the art historian Monica Juneja and other scholars associated with the international research project, 'Asia and Europe in a Global Context: Shifting Asymmetries in Cultural Flows', launched in 2007 at the University of Heidelberg. While acknowledging that the term has been useful in challenging Eurocentric perspectives, they point to its limitations, noting that its very conception presupposes a state of purity prior to 'hybridisation', and thus inadvertently reiterates essentialist assumptions.[73] Seeking to address the legacy of essentialist approaches to Asian history and Europe's interactions with Asia, the research group builds on Welsch's understanding of the transcultural. It emphasises that cultures are not only mutually constitutive, as Welsch suggests, but also in constant flux.[74] This group of scholars also makes the important point that the transcultural is not limited to transformations of concrete cultural practices, but entails temporal, ideological and historical dimensions.[75]

Thus, for example, Juneja proposes an understanding of culture as 'being made and remade', pointing out that such processes often involve the reinvention of an ideal past canonised as a golden age. She highlights the way that the British architect Edwin Lutyens's design for New Delhi (to be discussed in Chapter 4) combined two such canonical historical periods: European classicism, on the one hand, and the Greco-Buddhist art of Gandhara (first to fifth centuries CE, see Chapter 1, Plate 1.17) in today's north-west

Pakistan, on the other.[76] For colonial art historians such as Fergusson, the latter constituted India's 'classical' period, a view rejected by Indian nationalists, who instead posited the Buddhist art of Mathura (first and second centuries CE) as the origin of Indian art and the Gupta period (c.320–550 CE) as its golden age. For Juneja, this example demonstrates that any transcultural inquiry needs to take account of the shifting ideological dimensions of cultures. This approach thus emphasises mobility and tracks objects, practices and ideas as they criss-cross geographical, cultural and temporal border lines. It explores the changes in meaning entailed by such movements, which often occur repeatedly, adding further nuance and reinterpretations each time that such a boundary is (re)crossed. The transcultural also suggests a shift away from the textual bias of historical scholarship to acknowledge the importance of visual cultures across the world as formative cultural forces.[77]

Reflecting these insights and perspectives, the exploration of artistic encounters during the Raj in this book combines discussions of visual practices previously separated into distinct British and Indian histories of art. Building on approaches gathered under the broad umbrella of new imperial history, in particular those associated with post-colonial studies, it seeks to restore empire to the history of British art by critically exploring the legacies and conditions of its neglect in view of the larger project of de-colonising art history's histories and methods. Employing transcultural perspectives, the book conceives artistic interactions in British India as multiple, many-faceted and often contradictory and unruly processes that need to be situated in their respective regional and transnational contexts. A further point to note is that this exploration of artistic encounters in British India offers only one, albeit central, strand of the multiple transcultural exchanges that occurred in British India during the Raj. Transactions with other European countries, as well as with non-European ones, which also informed the complex cultural picture of colonial India, are beyond the remit of this discussion.

Notes

1 Chaudhuri, 1992, pp. 231–3.
2 Baines, 1893, p. 171.
3 Seyller, 2002, p. 44.
4 Nandy, 2010 [1983], pp. 127–8.
5 Viswanathan, 1989, pp. 45–7; Sarkar, 2014, p. 39; Elbourne, 2008, p. 141.
6 Bandyopadhyay, 2015 [2004], p. 144.
7 Viswanathan, 1989, pp. 28–9, 34, 101–4; Bandyopadhyay, 2015 [2004], p. 74.
8 Kantawala, 2012, pp. 211–19.
9 Viswanathan, 1989, p. 35.
10 Metcalf, 1995, pp. 44–5.
11 Markovits, 2002, p. 386.
12 Kaye, 1864; Metcalf, 1995, pp. 43 and 47; Nayar, 2007, p. 51.
13 Putnis, 2013, p. 1.
14 Nayar, 2007, pp. 50, 131 and 182–3.
15 Stubbings, 2016, p. 729; Metcalf, 1995; Hall, 2002; Pitts, 2005; Peers, 2012, p. 25; Nayar, 2007, p. 187.
16 Klein, 2008, p. 562.
17 Stubbings, 2016, p. 743; Nayar, 2007, pp. 218–19.
18 Washbrook, 1997, p. 14.
19 Bandyopadhyay, 2015 [2004], p. 180.
20 Arbuthnott, 2017, pp. 151–2.
21 Cohn, 1996, pp. 119–20.
22 Metcalf, 2011, pp. 1–4.
23 Markovits, 2002, p. 387.
24 Markovits, 2002, p. 388.
25 Markovits, 2002, pp. 393–5.
26 Peers, 2012, especially pp. 24–5.
27 Bandyopadhyay, 2015 [2004], pp. 74–5.
28 Metcalf, 1995, p. 117.
29 Pinney, 2011, pp. 119–20; Arnold, 2011; Clingingsmith and Williamson, 2008.
30 Schweinitz, 1981, pp. 690–2; Spear, 2008, p. 916.
31 Koditschek, 2009, pp. 53–4.
32 Metcalf, 1995, pp. 50–1.
33 Bannerji, 1998, p. 287.
34 Howe, 2010, p. 1.
35 Cooper and Stoler, 1997, p. 3.
36 Peers and Gooptu, 2012, p. 1; Howe, 2010, p. 2.
37 Said, 1979; Fanon, 1952; Howe, 2010, p. 2; McLeod, 2000, p. 23.
38 Bush, 2010.
39 Loomba, 1998, pp. 105–9.
40 Weber, 2017, p. 235; Patterson, 2006, p. 142.
41 Watt, 2011a, p. 6; Watt, 2011b, pp. 272–3.
42 Sinha, 1992; Sinha, 1995, pp. 14–22; Metcalf, 1995, pp. 104–5; Nandy, 2010, p. 127.

[43] Said, 1979, p. 7; Said, 2017 [1978].

[44] Hall, 2008.

[45] Peabody, 1996, p. 187.

[46] Bhabha, 1994; Bhabha, 2017 [1994], p. 22.

[47] Bhabha, 2017, p. 21; Bhabha, 1984.

[48] Guha, 1983; Guha and Spivak, 1988; Spivak, 1985; Spivak, 1988.

[49] Grosfoguel, 2010, p. 73.

[50] Nandy, 2010 [1983], p. 126.

[51] Said, 1993, p. 59.

[52] Barringer, Quilley and Fordham, 2007, p. 8.

[53] Barringer, Quilley and Fordham, 2007, p. 9; and see, for example, Archer, 1953 and Archer, 1959 and Archer, 1969.

[54] Barringer, Quilley and Fordham, 2007.

[55] Benner, 2013, p. 41–3; Coakle, 2012, p. 173.

[56] Benner, 2003, p. 42.

[57] Kennedy and Suny, 2001, p. 8; Avineri, 1962, pp. 483–4.

[58] Mitter, 1992 [1977], pp. 209–20; Avineri, 1962, pp. 480–1.

[59] Avineri, 1962, pp. 480–1.

[60] Clark and Canton, 2009 [1996], pp. 255–6.

[61] Claeys, 2000, pp. 235–38.

[62] Claeys, 2000, p. 238.

[63] Fergusson, 1876, pp. 44, 406–8 and 411.

[64] Preziosi, 2009 [1998], p. 7.

[65] Mercer, 1990, p. 62.

[66] Araeen, 1987, p. 7.

[67] Herren, Rüesch and Sibille, 2012, p. 5.

[68] Hannerz, 2000; Brosius and Wenzlhuemer, 2011, pp. 15–16; Appadurai, 1996.

[69] Ortiz, 1995 [1940]; Herren, Rüesch and Sibille, 2012, p. 45.

[70] Brosius and Wenzlhuemer, 2011, p. 15; Pratt, 1991; Pratt, 1992.

[71] Herren, Rüesch and Sibille, 2012, p. 46.

[72] Welsch, 1999, p. 196.

[73] Herren, Rüesch and Sibille, 2012, pp. 5–6; Juneja, 2011, p. 285.

[74] Herren, Rüesch and Sibille, 2012, p. 48.

[75] Juneja, 2013, pp. 25

[76] Juneja, 2013, pp. 25–6.

[77] Herren, Rüesch and Sibille, 2012, p. 114.

Bibliography

Appadurai, A. (1996) *Modernity at Large: Cultural Dimensions of Globalization*, Minneapolis, MN, University of Minnesota Press.

Araeen, R. (1987) 'From primitivism to ethnic arts', *Third Text*, vol. 1, no. 1, pp. 6–25.

Arbuthnott, C. (2017) 'Designs for the Imperial Assemblage, 1877', in Bryant, J. and Weber, S. (eds) *John Lockwood Kipling: Arts & Crafts in the Punjab and London*, New Haven, CT, Yale University Press, pp. 151–68.

Archer, W. G. (1953) *Bazaar Paintings of Calcutta*, London, Her Majesty's Stationery Office.

Archer, M. (1959) 'India and natural history: the role of the East India Company 1785–1858', *History Today*, vol. 9, no. 11, pp. 736–43.

Archer, M. (1969) *British Drawings in the India Office Library*, London, Her Majesty's Stationery Office.

Arnold, C. (2011) 'Cotton textile production in colonial India', in Andrea, A. J. (ed.) *World History Encyclopedia* [Online], Santa Barbara, CA, ABC-CLIO. Available at Credo Reference (Accessed 2 October 2017).

Avineri, S. (1962) 'Hegel and nationalism', *Review of Politics,* vol. 24, no. 4, pp. 461–84.

Baines, J. A., Sir (1893) *General Report of the Census of India, 1891*, London, Her Majesty's Stationery Office.

Bandyopadhyay, S. (2015 [2004]) *From Plassey to Partition: A History of Modern India*, Hyderabad, Orient Black Swan.

Bannerji, H. (1998) 'Politics and the writing of history', in Roach Pierson, R., Chaudhuri, N. and McAuley, B. (eds) *Nation, Empire, Colony: Historicizing Gender and Race*, Bloomington, IN, Indiana University Press, pp. 287–302.

Barringer, T., Quilley, G. and Fordham, D. (2007) 'Introduction', in Barringer, T., Quilley, G. and Fordham, D. (eds) *Art and the British Empire*, Manchester, Manchester University Press, pp. 1–19.

Benner, E. (2013) 'Nationalism: intellectual origins', in Breuilly, J. (ed.) *The Oxford Handbook of the History of Nationalism*, Oxford, Oxford University Press, pp. 36–55.

Bhabha, H. (1984) 'Of mimicry and man: the ambivalence of colonial discourse', *October*, vol. 28, pp. 125–33.

Bhabha, H. (1994) *The Location of Culture*, London and New York, Routledge.

Bhabha, H. (2017 [1994]) 'The location of culture', in Newall, D. (ed.) *Art and its Global Histories: A Reader*, Manchester and Milton Keynes, Manchester University Press in association with The Open University, pp. 20–3.

Brosius, C. and Wenzlhuemer, R. (eds) (2011) *Transcultural Turbulences: Towards a Multi-Sited Reading of Image Flows*, Berlin, Springer.

Bush, B. (2010) Review of *The New Imperial Histories Reader*, Reviews in History [Online]. Available at http://www.history.ac.uk/reviews/review/989 (Accessed 24 May 2017).

Chaudhuri, N. (1992) 'Shawls, jewelry, curry, and rice in Victorian Britain', in Chaudhuri, N. and Strobel, M. (eds) *Western Women and Imperialism: Complicity and Resistance*, Bloomington, IN and Indianapolis, IN, Indiana University Press, pp. 231–46.

Claeys, G. (2000) 'The "survival of the fittest" and the origins of Social Darwinism', *Journal of the History of Ideas*, vol. 61, no. 2, pp. 223–40.

Clark, C. and Canton, N. (2009 [1996]) '"Race", ethnicity and nationalism', in Marsh, I., Keating, M., Punch, S., and Harden, H. (eds) *Sociology: Making Sense of Society*, Harlow, Longman, pp. 249–99.

Clingingsmith, D. and Williamson, J. G. (2008) 'Deindustrialization in 18th and 19th century India: Mughal decline, climate shocks and British industrial ascent', *Explorations in Economic History*, vol. 45, no. 3, pp. 209–34.

Coakle, J. (2012) *Nationalism, Ethnicity and the State: Making and Breaking Nations*, Los Angeles, CA, Sage Publications.

Cohn, B. (1996) *Colonialism and its Forms of Knowledge: The British in India*, Princeton, NJ, Princeton University Press.

Cooper, F. and Stoler, A. L. (1997) 'Between metropole and colony: rethinking a research agenda', in Cooper, F. and Stoler, A. L. (eds) *Tensions of Empire: Colonial Cultures in a Bourgeois World*, Berkeley, CA, University of California Press, pp. 1–56.

Elbourne, E. (2008) 'Religion in the British Empire', in Stockwell, S. (ed.) *The British Empire: Themes and Perspectives*, Oxford, Blackwell Publishing, pp. 131–56.

Fanon, F. (1952) *Black Skin, White Masks*, New York, Grove Press.

Fergusson, J. (1876) *History of Indian and Eastern Architecture*, London, John Murray.

Grosfoguel, R. (2010) 'The epistemic decolonial turn: beyond political-economy paradigms', in Mignolo, W. D. and Escobar, A. (eds) *Globalization and the Decolonial Option,* London and New York, Routledge, pp. 65–77.

Guha, R. (1983) *Elementary Aspects of Peasant Insurgency in Colonial India*, Oxford, Oxford University Press.

Guha, R. and Spivak, G. C. (eds) (1988) *Selected Subaltern Studies*, Oxford, Oxford University Press.

Hall, C. (2002) *Civilising Subjects: Colony and Metropole in the English Imagination, 1830–1867*, Chicago, IL, University of Chicago Press.

Hall, C. (2008) 'Culture and identity in imperial Britain', in Stockwell, S. (ed.) *The British Empire: Themes and Perspectives*, Oxford, Blackwell Publishing, pp. 199–204.

Hannerz, U. (2000) *Transnational Connections: Culture, People, Places*, London and New York, Routledge.

Herren, M., Rüesch, M. and Sibille, C. (2012) *Transcultural History: Theories, Methods, Sources*, Berlin, Springer-Verlag.

Howe, S. (2010) 'Introduction', *The New Imperialism Reader*, London and New York, Routledge, pp. 1–20.

Inden, R. (1986) 'Orientalist constructions of India', *Modern Asian Studies*, vol. 20, no. 3, pp. 401–46.

Juneja, M. (2011) 'Global art history and the "burden of representation"', in Belting, H., Birken, J. and Buddensieg, A. (eds) *Global Studies: Mapping Contemporary Art and Culture*, Stuttgart, Hatje Cantz, pp. 274–97.

Juneja, M. (2013) 'The making of New Delhi: classical aesthetics, "oriental" tradition and architectural practice: a transcultural view', in Humphreys, S. C. and Wagner, R. G. (eds) *Modernity's Classics*, Berlin, Springer-Verlag, pp. 23–55.

Kantawala, A. (2012) 'Art education in colonial India: implementation and imposition', *Studies in Art Education*, vol. 53, no. 3, pp. 208–22.

Kaye, J. W., Sir (1864) *History of the Sepoy War in India, 1857–58*, London, W. H. Allen.

Kennedy, M. D. and Suny, R. G. S. (2001) *Intellectuals and the Articulation of the Nation*, Ann Arbor, MI, University of Michigan Press.

Klein, I. R. A. (2008) 'Materialism, mutiny and modernization in British India', *Modern Asian Studies*, vol. 34, no. 3, pp. 545–80.

Koditschek, T. (2009) 'Capitalism, race and evolution in imperial Britain, 1850–1900', in Koditscheck, T., Cha-Jua, S. K. and Neville, H. A. (eds) *Race Struggles*, Urbana, IL, University of Illinois Press, pp. 48–79.

Loomba, A. (1998) *Colonialism/Postcolonialism*, Hove, Psychology Press.

McLeod, J. (2000) *Beginning Postcolonialism*, Manchester, Manchester University Press.

Markovits, C. (2002) *A History of Modern India, 1480–1950*, London, Anthem Press.

Mercer, K. (1990) 'Black art and the burden of representation', *Third Text*, vol. 4, no. 10, pp. 61–78.

Metcalf, B. (2011) 'Islam and power in colonial India: the making and unmaking of a Muslim princess', *The American Historical Review*, vol. 116, no. 1, pp. 1–30.

Metcalf, T. R. (1995) *Ideologies of the Raj*, Cambridge, Cambridge University Press.

Mitter, P. (1992 [1977]) *Much Maligned Monsters: A History of European Reactions to Indian Art*, Chicago, IL, University of Chicago Press.

Nandy, A. (2010 [1983]) 'The psychology of colonialism: sex, age and ideology in British India', in Howe, S. (ed.) *The New Imperialism Reader*, London and New York, Routledge, pp. 125–35.

Nayar, P. K. (2007) *The Great Uprising: India, 1857*, New Delhi, Penguin Books.

Ortiz, F. (1995 [1940]) *Cuban Counterpoint, Tobacco and Sugar* (trans. H. de Onis), Durham, NC, Duke University Press.

Patterson, S. (2006) 'Postcards from the Raj', *Patterns of Prejudice*, vol. 40, no. 2, pp. 142–58.

Peabody, N. (1996) 'Tod's Rajast'han and the boundaries of imperial rule in nineteenth-century India', *Modern Asian Studies*, vol. 30, no. 1, pp. 185–220.

Peers, D. M. (2012) 'State, power and colonialism', in Peers, D. M. and Gooptu, N. (eds) *India and the British Empire*, Oxford, Oxford University Press, pp. 16–43.

Peers, D. M. and Gooptu, N. (2012) 'Introduction', in Peers, D. M. and Gooptu, N. (eds) *India and the British Empire*, Oxford, Oxford University Press, pp. 1–15.

Pinney, C. (2011) 'Response', in Adamson, G., Riello, G. and Teasley, S. (eds) *Global Design History*, London and New York, Routledge, pp. 119–22.

Pitts, J. (2005) *A Turn to Empire: The Rise of Imperial Liberalism in Britain and France*, Princeton, NJ, Princeton University Press.

Pratt, M. L. (1991) 'Arts of the contact zone', *Profession*, pp. 33–40.

Pratt, M. L. (1992) *Imperial Eyes: Travel Writing and Transculturation*, London and New York, Routledge.

Preziosi, D. (2009 [1998]) 'Art history: making the visible legible', in Preziosi, D. (ed.) *The Art of Art History: A Critical Anthology*, Oxford, Oxford University Press, pp. 7–12.

Putnis, P. (2013) 'International press and the Indian uprising', in Carter, M. and Bates, C. (eds) *Mutiny at the Margins: New Perspectives on the Indian Uprising of 1857*, New Delhi and London, Sage Publications, pp. 1–17.

Said, E. W. (1979) *Orientalism*, New York, Vintage Books.

Said, E. W. (1993) *Culture and Imperialism*, London, Chatto & Windus.

Said, E. W. (2017 [1978]) '"Introduction – II", in *Orientalism*', in Newall, D. (ed.) *Art and its Global Histories: A Reader*, Manchester and Milton Keynes, Manchester University Press in association with The Open University, pp. 14–15.

Sarkar, S. (2014) *Modern Times: India 1880s–1950s: Environment, Economy, Culture*, Ranikhet, Permanent Black.

Schweinitz, K. de (1981) 'What is economic imperialism?', *Journal of Economic Issues*, vol. 15, no. 3, pp. 675–701.

Seyller, J. (2002) 'The Hamzanama manuscript and early Mughal painting', *The Adventures of Hamza*, Washington, DC, Smithsonian Institution, pp. 44–51.

Sinha, M. (1992) '"Chathams, Pitts, and Gladstones in petticoats": the politics of gender and race in the Ilbert Bill controversy, 1883–84', in Chaudhuri, N. and Strobel, M. (eds) *Western Women and Imperialism: Complicity and Resistance*, Bloomington, IN and Indiana, IN, Indiana University Press, pp. 98–116.

Sinha, M. (1995) *Colonial Masculinity: The 'Manly Englishman' and the 'Effeminate Bengali' in the Late Nineteenth Century*, Manchester, Manchester University Press.

Spear, J. L. (2008) 'A South Kensington gateway from Gwalior to nowhere', *Studies in English Literature*, vol. 48, no. 4, autumn, pp. 911–21.

Spivak, G. C. (1985) 'The Rani of Sirmur: an essay in reading the archives', *History and Theory*, vol. 24, no. 3, pp. 247–72.

Spivak, G. C. (1988) 'Can the subaltern speak?', in Nelson, C. and Grossberg, L. (eds) *Marxism and the Interpretation of Culture*, Champaign, IL, University of Illinois Press, pp. 271–313.

Stubbings, M. (2016) 'British Conservatism and the Indian Revolt: the annexation of Awadh and the consequences of liberal empire, 1856–1858', *Journal of British Studies*, vol. 55, no. 4, pp. 728–49.

Viswanathan, G. (1989) *Masks of Conquest: Literary Study and British Rule in India*, New York, Columbia University Press.

Washbrook, D. (1997) 'After the Mutiny: from Queen to Queen-Empress', *History Today*, vol. 47, no. 9, pp. 10–15.

Watt, C. A. (2011a) 'Introduction: the relevance and complexity of civilizing missions *c*.1820–2010', in Watt, C. A. and Mann, M. (eds) *Civilizing Missions in Colonial and Postcolonial South Asia: From Improvement to Development*, London, Anthem Press, pp. 1–34.

Watt, C. A. (2011b) 'Philanthropy and civilizing missions in India *c*.1820–1960: states, NGOs and development', in Watt, C. A. and Mann, M. (eds) *Civilizing Missions in Colonial and Postcolonial South Asia: From Improvement to Development*, London, Anthem Press, pp. 271–316.

Weber, S. (2017) 'Kipling and the exhibitions movement', in Bryan-Wilson, J. and Weber, S. (eds) *John Lockwood Kipling: Arts & Crafts in the Punjab and London*, London, Yale University Press; New York, Bard Graduate Center, pp. 205–80.

Welsch, W. (1999) 'Transculturality: the puzzling form of cultures today', in Featherstone, M. and Lash, S. (eds) *Spaces of Culture: City, Nation, World*, Thousand Oaks, CA, Sage Publications, pp. 194–213.

Chapter 1

Painting, prints and popular art in British India

Renate Dohmen

Introduction

British art has traditionally been understood to consist of works produced in and relating to Britain. Despite the centrality of empire to British history, images concerned with its global expansion are considered largely irrelevant to the history of British art.[1] Whereas such works are prominently displayed in public galleries and museums of Commonwealth nations such as Australia and New Zealand, similar pictures in the national art collections based in London have remained hidden in storerooms and basements, or have been farmed out to special interest collections, such as the National Maritime Museum, the National Army Museum, the Royal Botanic Gardens at Kew and the Natural History Museum.[2] There, distanced from the world of art, they serve merely as colourful illustrations of naval narratives, historical battles or botanical and geographic exploration. Otherwise, the only opportunities for viewing such works of art in Britain are provided by regional museums, where occasional examples can be seen.

Recently, however, British art's global connections through trade and empire have begun to be acknowledged. *Artist and Empire: Facing Britain's Imperial Past*, a major exhibition staged at Tate Britain in 2015–16, for example, brought together works related to empire from collections across Britain. It featured canonical examples of British art together with neglected images related to empire. As can be seen from a gallery view of the exhibition, a large-scale oil painting of a cheetah and its handlers by the renowned animal painter George Stubbs was presented alongside illustrations of Indian and South-East Asian flora and fauna by the amateur artist Anna Maria (Lady) Jones, the Indian painter Shaikh Zain ud-Din and the scientific illustrator and engraver Edward Smith Weddell (Plate 1.2). The exhibition thus offered an unusual combination of works across artistic genres by artists of different professional status and reputation not normally displayed together.

In setting out to explore the range of art produced in the context of empire, *Artist and Empire* followed a series of earlier initiatives, including conferences, publications and smaller exhibitions that had begun to reflect on British art and questions of empire. These efforts have highlighted the paradoxical situation that, even during the heyday of empire, the British art establishment considered art on imperial themes to be of minor significance. Instead, the British public's keen appetite for such images during the nineteenth century was satisfied by the illustrated press (see Chapter 3, p. 111), as well as by commercial spectacles, such as the panorama. In 1800, for example, the artist and travel writer Robert Ker Porter put on show at the Lyceum in London a semi-circular panorama over 36 metres wide of the

Plate 1.1 (Facing page) Unknown Kalighat artist, *The Sheep Lover* (detail from Plate 1.20).

Plate 1.2 Gallery view of the *Artist and Empire* exhibition, Tate Britain, 23 November 2015–10 April 2016. Artworks on display (left to right): Shaikh Zain ud-Din, *Common Crane*, 1780, gouache; Anna Maria (Lady) Jones, *Cuchäi*, 1785, watercolour (top); Shaikh Zain ud-Din, *Melia ezederach L*, 1780, watercolour (bottom); George Stubbs, *Cheetah and a Stag with Two Indians*, *c*.1765, oil on canvas; Shaikh Zain ud-Din, *Elephant Yam*, *c*.1780, watercolour; Edward Smith Weddell, *Rafflesia Arnoldii*, after John Frederick Miller, 1826, hand-coloured engraving. Photo: © Tate, London 2017.

storming of Seringapatam (Srirangapatna), which had taken place the previous year, in order to capitalise on the enthusiastic response that the defeat of Tipu Sultan had generated in Britain (see Introduction, p. 19).[3] It was accompanied by a printed 'key' that identified the events and personalities shown for the benefit of the viewing public, and in this instance also broke new ground by 'democratising' the image of warfare through the inclusion of named subaltern officers (Plate 1.3).[4] The association of imperial themes with commercial spectacle meant that many British artists are likely to have regarded them as 'secondary' themes, unworthy of artistic attention.

Nevertheless, remarkable events such as the defeat of Tipu Sultan were occasionally depicted in what was then regarded as the highest of the pictorial genres, namely history painting (see, for example, Plate 1.11). Artists not only commemorated victories, however,

but also more troubling events, notably the Indian Rebellion. *In Memoriam* by the Scottish painter Joseph Noel Paton, for example, commemorates one of the most infamous episodes of the rebellion, the massacre of British women and children at Cawnpore (Kanpur), which prompted a public outcry and calls for revenge. Paton, who depicted the victims in poses suggestive of Christian heroism and martyrdom, exhibited his painting at the Royal Academy only one year later. It caused a sensation, not least because in the original version it was not the kilted Highlanders coming to the rescue shown to the left in the background of the image, but rather the Indian rebels presumed to be bent on rape and murder. This version proved so unpalatable to the British public that the artist subsequently changed the composition; it was this altered version that subsequently circulated in engraved form (Plate 1.4). The actual painting was included in the Tate Britain exhibition in 2015.

Plate 1.3 John Lee after Robert Ker Porter, *The Storming of Seringapatam*, 1800, woodcut and letterpress, ink, 35 × 43 cm. Victoria and Albert Museum, London, E.572-1926. Photo: © Victoria and Albert Museum, London.

The reception of *Artist and Empire* was mixed.[5] Although the fact that it brought together scattered works was greeted with enthusiasm, questions were asked about the extent to which the exhibition invited a nostalgic rather than a critical view. What it undoubtedly demonstrated, however, is that art of the British Empire is a rich and worthwhile subject that clearly deserves further attention. This is particularly the case in relation to the art of British India, 'the jewel in Britain's imperial crown', a vast territory with a complex history, striking visual traditions and a sustained colonial interaction with Britain. This chapter examines the history of the artistic interactions between British and Indian

visual cultures from the late eighteenth to the first half of the twentieth century. It explores images by British artists who travelled to India, and considers the new hybrid art of the so-called Company School that evolved when Indian miniature painters were employed by British patrons. This will be followed by a discussion of the role of British and Indian printmakers in negotiating the colonial encounter and the work of the artists Raja Ravi Varma and Abanindranath Tagore who were regarded as pioneers of modern Indian art. Key questions considered include the role of art and art history in legitimising the colonial enterprise and notions of European cultural superiority.

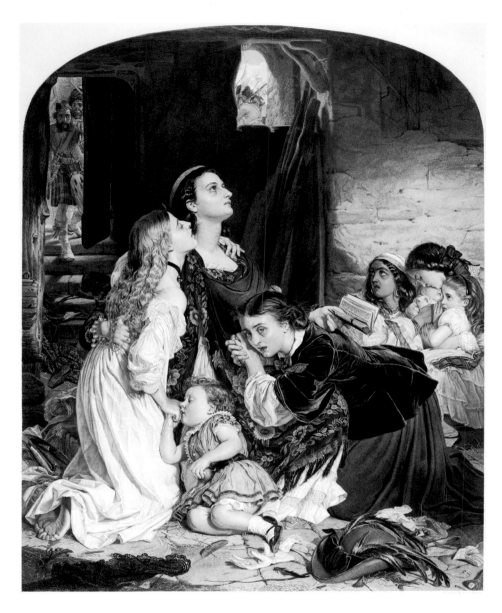

Plate 1.4 William Henry Simmons (engraver), after Sir Joseph Noel Paton (artist), *In Memoriam*, 1862, engraving and stipple engraving, 86 × 69 cm. Victoria and Albert Museum, London, E.164-1970. Given by Mr P. N. McQueen. Photo: © Victoria and Albert Museum, London.

1 Mughal India and the East India Company

When British merchants first established trading posts in India, they relied heavily on existing, local commercial and social networks for their business transactions. This required them to be familiar with Indian customs. Adopting Indian cultural practices and Indian dress, many members of the small, mostly male, British community also took Indian consorts, known as *bibis*. An unfinished family portrait variously attributed to Johan Zoffany or to an Italian artist, Francesco Renaldi,

for example, shows a British army officer who served with the EIC forces in India, Major William Palmer of the Bengal artillery, with his Indian wife and their children (Plate 1.5).[6] Palmer wears European clothes and is seated on a chair in the European manner while the mother of his children is settled on the floor in Indian dress. As noted in the Introduction (p. 14), the easy cultural co-existence evident here was to become increasingly inconceivable during the nineteenth

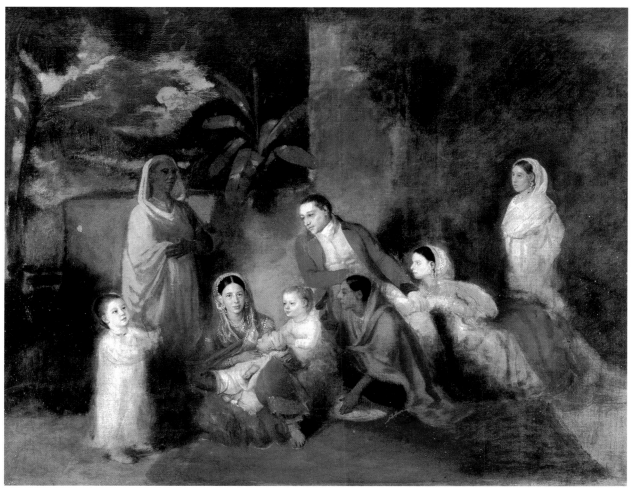

Plate 1.5 Johan Zoffany or Francesco Renaldi, *Major William Palmer with his Second Wife, the Mughal Princess Bibi Faiz Bakhsh*, 1785, oil on canvas, 102 × 127 cm. The British Library, London, shelfmark Foster 597. Photo: © British Library Board. All Rights Reserved/Bridgeman Images.

century. Even during the eighteenth century, however, it was exceptional for EIC men to have themselves portrayed with their Indian families in such a tender and respectful manner.

Moreover, British officials more commonly commissioned portraits of themselves by Indian artists. One such portrait is assumed to show Sir David Ochterlony, who was the first British resident at the Mughal court in Delhi (Plate 1.6). Like other EIC officials who served for long periods at Indian courts, Ochterlony was well-accustomed to Mughal culture. In the eyes of the eighteenth-century British public, he fulfilled the stereotype of the nabob or orientalised British official

who had been 'corrupted' by the 'East'.[7] The painting demonstrates the extent to which he had adapted to local customs; he is shown in his house in Delhi seated Indian-style on the floor smoking a hookah (water pipe), enjoying a traditional dance performance called *nautch*. He wears a fine white muslin *jama* (long tunic) and striped pajamas (trousers), as well as a *patka* (cummerbund) and a red turban. The picture is an example of the so-called Company school of painting, an umbrella term for the mixed styles that evolved when Indian artists, mostly from Mughal ateliers, were employed by EIC officials. In this instance, the artist has introduced European perspectival conventions, such as in the tilting of the portraits and the candle

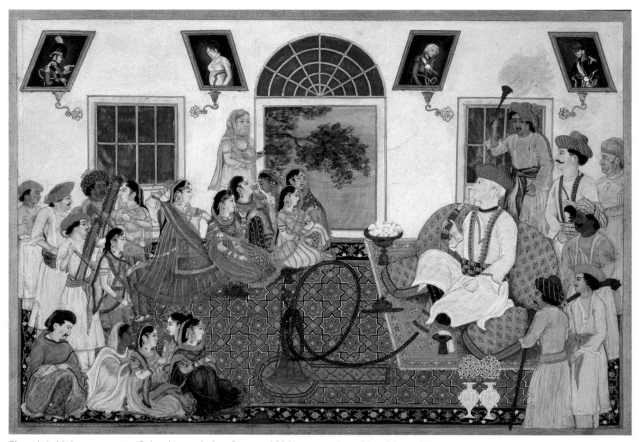

Plate 1.6 Unknown artist, *Ochterlony in Indian Dress*, *c.*1820, watercolour, 22 × 32 cm. The British Library, London, shelfmark AddOr2. Photo: © British Library Board. All Rights Reserved/Bridgeman Images.

holders on the back wall, into a Mughal miniature format invested in decorative detail, as demonstrated by the commanding geometric patterning of the carpet that takes up the image's fore- and middle ground.

Company painting was not the first instance of the blending of different artistic approaches to have developed in India, however. Mughal art was largely derived from Persian miniature traditions, but had also adopted visual elements from other cultures. As the art historian Ebba Koch has explained, the complex syncretism of Mughal art 'successfully fused traditions of various origins (Central Asian, Timurid, Iranian, Indian and European) to create a specific Mughal form of artistic expression'. She also points out that 'Mughal painters consistently studied the arts of Europe, in particular Flemish, Dutch, and German ... from about the middle of the sixteenth to the middle

of the seventeenth centuries'.[8] Their partial adoption of European image conventions can be demonstrated by comparing a fifteenth-century miniature by the Persian artist Bihzad (Plate 1.7), whose work was much admired by the Emperor Akbar, and a late sixteenth-century Mughal miniature from the *Akbarnama*, the chronicle of Emperor Akbar's rule (Plate 1.8). Bihzad's elegant miniature is painted in a fluid style that sets out the physical space presented in the image in a linear fashion, contrasting flat, geometric, architectural elements with open, unpatterned areas in which the action unfolds. Although it clearly builds on this tradition, the Mughal miniature also demonstrates an interest in giving weight and volume to spaces and figures that suggests European models: the rendition of the wall that is being built in this image, for example, has acquired some thickness, and the artisans' bodies have greater volume than Bihzad's sinuous figures.

Mughal appropriations of European image conventions have sometimes been represented as the adoption of a 'superior' pictorial language. However, when the British first arrived in India, Mughal emperors ruled over large parts of the subcontinent and considered Europeans to be inferior. Thus, for example, in a miniature that includes James I of England (r.1603–25) among a group of figures paying homage to the Emperor Jahangir, the English king is placed further from the emperor than a Sufi saint and the Ottoman emperor, and only just ahead of the artist Bichitr (who is holding a picture) (Plate 1.9). The artist has depicted Jahangir seated on an enlarged hourglass that functions as a throne, thereby adopting the European time-keeping instrument to suggest the emperor's divine status, 'above time'. The image demonstrates that Jahangir, whose name translates as 'conqueror of the world', considered himself superior to other rulers; it asserts his command over every aspect of the world, appropriating objects, representational techniques and iconographic references at will. A similar attitude informs other types of images produced at the Mughal court. Mansur, Emperor Jahangir's favourite artist, for example, made over one hundred botanical studies in Kashmir that are clearly based on a European botanical illustration in that they combine front and side views of blossoms, and their progression from bud to full bloom (Plate 1.10).[9]

By contrast, eighteenth-century Britain was not very open-minded about cultural influences from India. At the time, Asia was, for the most part, negatively associated with luxury, immorality and corruption. Such blanket assumptions are likely to have been encouraged by the behaviour of EIC officials, many of whom amassed vast wealth during a short time in India, often by highly dubious means. Accusations against so-called nabobs were fuelled by widespread awareness among the British public that this was the case. The company therefore turned to artistic patronage in order to improve its image and presented its commercial dealings in a high-minded, public-spirited light. As the art historian Geoff Quilley has pointed out, the impact of the EIC on British art was immense, encompassing every aspect of eighteenth-century visual culture, from 'paintings, prints, architecture, sculpture, illustrated books' to 'scholarly works, maps, [and] medals'.[10]

Typical of this kind of window dressing is a picture commissioned by the EIC to commemorate the defeat of Tipu Sultan in the Third Anglo-Mysore War (1790–92). After his defeat, Tipu was required not only to cede half of his kingdom, but also to hand over two of his sons as hostages until he had paid crippling war reparations. The artist, Robert Home, who had received official permission to accompany the campaign, presents the military conquest in glorified, familial terms: Britain, represented by Governor-General Lord Cornwallis, is seen to bestow paternal care upon Tipu Sultan's two sons (Plate 1.11). The painting, which was exhibited at the Royal Academy in 1797 under the title *Lord Cornwallis Receiving Tipu Sahib's Sons as Hostages at Seringapatam*, follows the academic conventions of history painting, except that the figures are shown in contemporary rather than classical dress: it shows an important event with a moral import, while the composition centres on the most important personages in an idealised way. Home's composition thus harnesses the highest genre of European painting to present a propagandist vision of empire.

Whereas Home's painting is devoid of Mughal influence, other works of art produced by British artists in India are thought by some scholars to demonstrate an engagement with Indian art. The historian Maya Jasanoff, for example, has made such a claim in relation to Zoffany's painting *Colonel Mordaunt's Cock Match* (Plate 1.12). As a founding member of the Royal Academy, which had been established in 1768, Zoffany was the most high-profile British artist of the eighteenth century to venture to India. He had set off in 1783 expecting 'to roll in gold dust', but arrived just as the nabobs' world of quickly made fortunes and opulent display was coming to an end: new government legislation, in particular the 1784 India Act, brought the EIC under close parliamentary supervision.[11] Zoffany soon gravitated to Lucknow, the capital of Oudh, an Indian territory under British 'protection' with a British resident (in today's state of Uttar Pradesh). Its ruler, Asaf ud-Daulah (r.1775–97) sought to outdo Delhi and Calcutta with his extravagant building programme and spent lavishly on his art collection. At his cosmopolitan court, Indians mixed with Britons much more freely than in territories under EIC control. Jasanoff argues that India not only features as subject matter in Zoffany's *Cock Match* but has affected its mode of representation; she points to the image's 'microscopic detailing, its flattened perspective and its narrative density', seeing in them reminiscences of Mughal miniatures.[12] Zoffany's 'centrifugal' composition

Plate 1.7 Attributed to Bihzad, *Sa'd'i and the Youth of Kashgar*, 1486, opaque watercolour, ink and gold. Folio from Muslih-uddin Sa'di Shirazi, *The Gulistan* (rose garden), Herat (now in Afghanistan. At Bihzad's time it was part of the Timurid Empire that encompassed Iran and areas in central Asia). Art and History Trust, LTS 1995.2.33. Photo: Courtesy of Freer Gallery of Art and Arthur M. Sackler Gallery, Smithsonian Institution, Washington, DC.

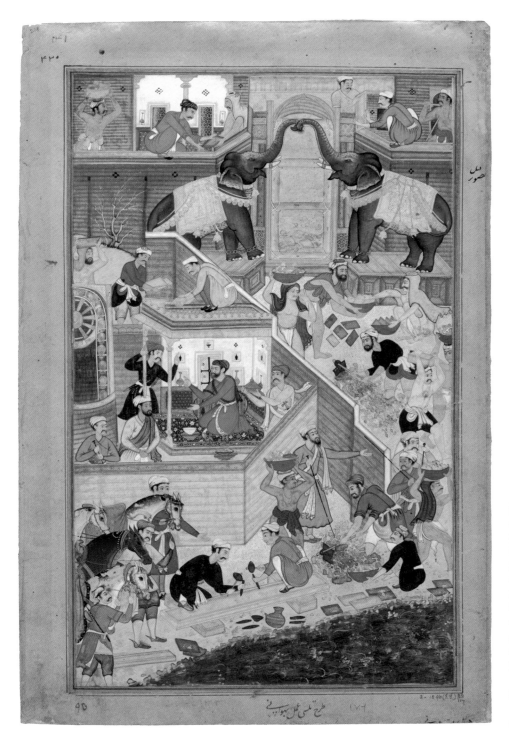

Plate 1.8 Tulsi (artist, composition) and Bhawani (artist, colour), *Workmen Building Fathpur* (Fatehpur Sikri), *c.*1592, opaque watercolour and gold, 33 × 20 cm. From the first illustrated *Akbarnama* written by Emperor Akbar's court historian and biographer Abu'l Fazl between 1590 and 1596. Victoria and Albert Museum, London, IS.86-1986. Photo: © Victoria and Albert Museum, London.

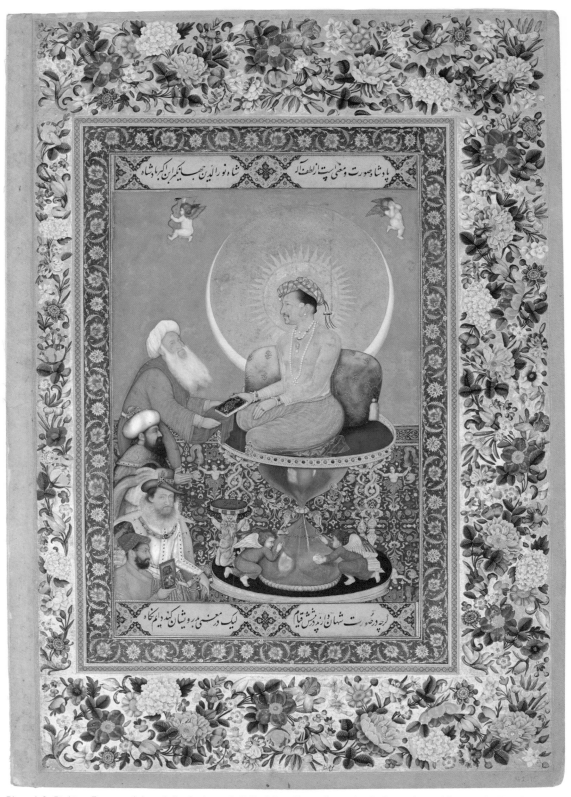

Plate 1.9 Bichitr, *Emperor Jahangir Preferring a Sufi Shaikh to Kings*, from the St Petersburg Album, *c.*1615–18, opaque watercolour, gold and ink, 25 × 18 cm. Freer Gallery of Art and Arthur M. Sackler Gallery, Smithsonian Institution, Washington, DC. Purchase – Charles Lang Freer Endowment F1942.15a. Photo: Freer|Sackler: The Smithsonian's Museums of Asian Art.

Plate 1.10 Mansur, *Tulips*, c.1620, opaque watercolour. Maulana Azad Library, Aligarh Muslim University, Aligarh. Photo: Aligarh Muslim University.

certainly defies the rules of academic art, which called for order, balance and harmony as well as for a central narrative focus, such as can be seen in Home's painting (Plate 1.11). In the *Cock Match*, in contrast, the main action is framed by several sub-plots. Other scholars have, however, explained these features with reference to the work of the eighteenth-century artist William Hogarth, who also depicted a cock fight.[13] What is certain, however, is that the painting's cluttered pictorial organisation is unusual for Zoffany, and it may well have been the encounter with the world of Lucknow that prompted the artist to depart from academic convention.

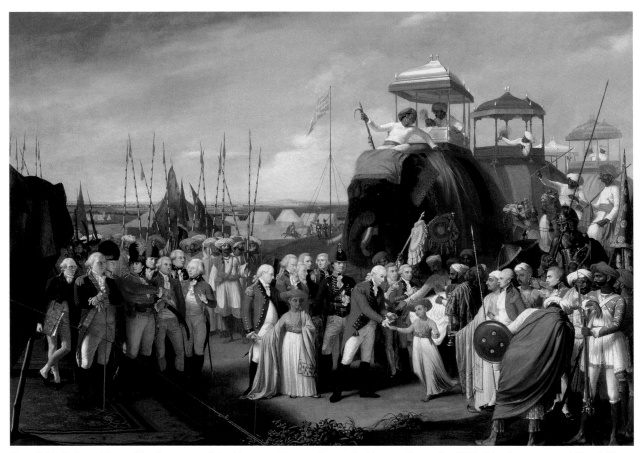

Plate 1.11 Robert Home, *The Reception of the Mysorean Hostage Princes by Marquis Cornwallis*, 1793–94, oil on canvas, 149 × 203 cm. National Army Museum, London. Photo: Bridgeman Images.

Neither Home's nor Zoffany's paintings are, however, typical of the work produced by British artists in India. The majority painted portraits of both Indian and British patrons, while a few specialised in landscape. Notable among the latter was William Hodges, whose approach to India may have been shaped by his prior experience of non-European scenery. He had made a name for himself with his landscapes of remote and unfamiliar places after he accompanied the second voyage of James Cook to the South Pacific (1772–75). He travelled to India in 1779 and, in 1789, after his return to England, gained membership of the Royal Academy with depictions of Indian scenery. His *Tomb and Distant Views of the Rajmahal Hills* (Plate 1.13), for example, draws on classical traditions of pastoral landscapes, as exemplified by the work of the seventeenth-century French artist Claude Gellée (better known as Claude Lorrain), but replaces

Claude's conventional Roman ruins with vestiges of a Mughal tomb. Evoking an Asiatic Arcadia, the painting presents a lush and peaceful vista that suggests that the region enjoys peace and tranquillity under British rule. As Quilley argues, such works by Hodges provide an exemplary case for the investigation of questions of art and empire.[14]

More specifically, this image demonstrates what Quilley has referred to as 'the centrality of history to Hodges', that is the artist's ultimately unsuccessful strategy for making his mark in the competitive art market of London by elevating the genre of landscape art to the higher status enjoyed by history painting. He did so by seeking to address philosophical and moral issues, such as were usually the preserve of the higher genre of history painting. In the example just discussed, for instance, the ruin on the right

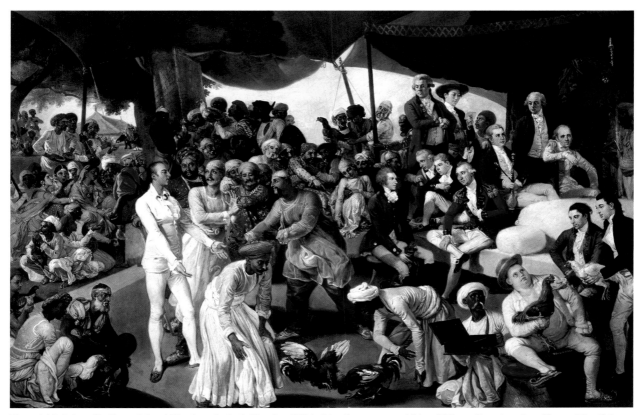

Plate 1.12 Johan Zoffany, *Colonel Mordaunt's Cock Match, c.*1784–86, oil on canvas, 104 × 150 cm. Tate, London. Photo: The Print Collector/Alamy.

can be read as a reference to the Mughal Empire under Emperor Akbar (before its decline under his successors), which the British saw as a golden age. This interpretation draws on well-established ideas rooted in classical antiquity about the corrupting effect of Asian luxury on public life: fears that engagement with the East would undermine British virtue and liberty informed attitudes towards empire for much of the eighteenth century.[15] As the art historian Natasha Eaton has pointed out, the painting therefore served as a history lesson about the fall of empires, but can also be read as holding out a positive vision of the benefits of enlightened overlordship. Since there was, at the time, no precedent for British rule over non-Europeans, Emperor Akbar's regime provided the British with a model for governing India that was conceived in terms of 'enlightened despotism', which was

considered to be the best possible form of Asiatic rule, on the (deeply prejudiced) assumption that rule in Asia was despotic by default.[16] During the second half of the eighteenth century, this model of authoritarian yet 'benevolent' government that claimed to have the best interests of India at heart functioned as a means of legitimising British rule over foreign lands.[17] The link that Hodges' painting makes between the purported golden age under the Emperor Akbar and contemporary British rule in India thus allows it to function as imperial propaganda.

Hodges' ambition to be accepted as an artist who went beyond 'mere' depiction of the visible world by offering high-minded moral and political lessons was underscored by his writings, which included *A Dissertation on the Prototypes of Architecture, Hindoo, Moorish, and Gothic* (1787). In publishing such works,

Plate 1.13 William Hodges, *Tomb and Distant Views of the Rajmahal Hills*, 1782, oil on canvas, 62 × 72 cm. Tate, London. Photo: © Tate, London 2016.

he effectively characterised himself as a learned gentleman artist in accordance with the model of artistic identity promoted by the Royal Academy. He also, however, challenged academic orthodoxy: in *Travels in India During the Years 1780, 1781, 1782, and 1783* (1793), for example, he contends that the notion that 'Grecian architecture comprizes all that is excellent in the art' is 'erroneous and servile', and that such architecture should not therefore be admired 'in an exclusive manner'. Moreover, he argues, one should not be 'blind to the majesty, boldness, and magnificence of the Egyptian, Hindoo, Moorish and Gothic, as admirable wonders of architecture', simply because

'they are not reducible to the precise rules of the Greek hut, prototype, and column'.[18] This unconventional approach, however, was not well received by the British art establishment, and was doubly controversial coming from a 'mere' landscape painter who was from a modest background and could not lay claim to the classical education of a gentleman.

Hodges' interventions were also ill-timed. At a geographical remove from the market-place upon which his career depended, he may not have been aware of recent cultural shifts that affected perceptions of art and empire in ways that did not support his interests.

As Quilley has pointed out, 'the cosmopolitanism of late eighteenth-century art and culture exemplified by Hodges' practice' was being replaced by 'more insular cultural models rooted in national custom and a peculiarly British character'.[19] Furthermore, for much of the eighteenth century Britain had found it difficult to reconcile its liberal ideals with autocratic rule, which was considered un-British.[20] Towards the end of the century, however, these reservations were appeased by the rebranding of empire as a civilising mission, thereby presenting Britain's overseas conquests in a more positive light. At the same time, the reception of Hodges' work was affected by a growing tendency for depictions of the non-European world to be regarded as a specialist category of scientific exploration and documentation rather than appropriate subject matter for high art.[21] Overall, therefore, British painters of Indian subjects were not only for the most part bound to the norms of European art and, unlike Mughal painters, shied away from experimenting with Indian artistic styles, but also increasingly were considered a lesser kind of artist by their compatriots, whatever style they painted in.

2 Prints of India's monuments

Eighteenth-century Britain saw an immense development in the infrastructure of art. Whereas, at the beginning of the century, there were no specialist institutions or dedicated spaces in which artists could exhibit their work, the period from around 1760 onwards witnessed the foundation of several artists' organisations in Britain, including a royally sanctioned art academy, and public art exhibitions emerged as a regular part of urban life. Moreover, the dissemination of contemporary British art beyond the elite was facilitated by a burgeoning print market that saw the arrival of print shops in every major British town by the last quarter of the eighteenth century. Printmaking became the most profitable segment of the art market, with reproductive prints estimated to have outnumbered original works by at least fifty to one.[22] Among the images displayed in British print-shop windows were engravings depicting colonial scenes, which fed what the art historian John Bonehill terms the 'seemingly insatiable appetite of metropolitan culture for knowledge of its colonial interests'.[23] Such prints were valued as images of

travel and exploration, and were appreciated for the perceived accuracy of observed detail, with eyewitness experience conceived as guarantor of authenticity.

Another key development towards the end of the eighteenth century was the rise of the picturesque, a new aesthetic primarily associated with the appreciation and depiction of landscape. It valorised such features as irregularity, roughness and variety, which were thought to be best exemplified by the scenery in uncultivated areas of Britain, such as the Lake District or Scottish Highlands. Crumbling forms, such as ruins, heaped stones and rotting logs, were regular visual features employed in picturesque views. It is important, however, to register that this commitment to depicting a distinctively British landscape did not entail a strictly naturalistic approach. On the contrary, the first theorist of the picturesque, William Gilpin, suggested that the artist might rearrange elements of a scene to improve it, declaring that 'nature is most defective in composition; and must be a little assisted'.[24] In this respect, the picturesque is closely related and, indeed, indebted to the classical tradition of ideal landscape exemplified by Claude. The term, for example, can be applied to Hodges' Claude-inspired Indian landscapes, particularly when they contain such features as crumbling buildings, unrestrained vegetation and craggy mountains.

As this example demonstrates, the picturesque soon found its way to the outer reaches of the British Empire and was to have a powerful and long-lasting impact on the representation of imperial landscapes across a range of visual media. It was, for example, widely taken up by photographers in the second half of the nineteenth century (see Chapter 3, Plate 3.5). In fact, it has been argued that the picturesque took on a special currency in colonial spaces, where it was applied to produce visually appealing and reassuringly familiar images that glossed over the often harsh realities of colonial conquest and imperial domination. The picturesque thus served to 'domesticate' empire, homogenising the disparate territories under British control by subjecting them to a single set of pictorial conventions.[25] Some scholars have adopted the terms 'imperial', 'colonial' or indeed 'Indian' picturesque to distinguish such views from equivalent British landscape scenes, while others have pointed out that the trope also had imperial associations within

Plate 1.14 John Browne, after a painting by William Hodges, *A View of the Gate of the Tomb of the Emperor Akbar, at Secundru* (Sikandra), 1786, engraving, 48 × 63 cm. Yale Center for British Art, Paul Mellon Fund, B1979.22.2. Photo: Yale Center for British Art.

Britain: picturesque travel, way of seeing and sketching transformed Scotland and Wales into naturalised parts of the new imperial nation of Britain.[26] However, the picturesque was broadly conceived, especially when applied to colonial landscapes, as demonstrated by the work of the painter and printmaker Thomas Daniell and his nephew William.

The Daniells spent the period from 1786 to 1793 in India, arriving slightly after Hodges, which enabled them to visit regions that had only very recently come under British domination. They began their journey by following in Hodges' footsteps, however, guided by the aquatints published in his *Select Views of India*, which they consulted not just as an inspiration but also with the aim of outdoing him. They succeeded in doing so, even though Hodges was an artist with an established reputation, who had gained renown for

his Indian views. In order to understand the reasons for which the Daniells' views came to eclipse Hodges', it is useful to consider the different ways in which he and they depicted the same architectural motif, the gate of the tomb of the Emperor Akbar at Secundru (now Sikandra). It is important to note that both of the works to be discussed are prints, which, as already mentioned, would have been much more widely available than oil paintings. Print thus became the principal medium for depicting overseas territories.

Exercise

Compare the two prints of Akbar's tomb reproduced here (Plates 1.14 and 1.15). Consider both how they correspond and how they differ in their representational strategies.

Plate 1.15 Thomas Daniell, *Gate of the Tomb of the Emperor Akbar at Secundru, near Agra*, 1795, aquatint, 46 × 59 cm. Victoria and Albert Museum London, I.S.242:9-1961. Photo: © Victoria and Albert Museum, London.

Discussion

The engraving after Hodges presents a foreshortened view that makes the gate appear colossal and dramatic. Hodges has also exaggerated the size of the arches' apertures and has given them an added pinch. The gloomy, fictitious ruin in the foreground on the left casts a deep shadow, adding further drama to the scene. The scattered, classical-looking fragments on the ground make allusions to Rome, and suggest the past grandeur and mystery of an empire awaiting discovery beyond the gate. Hodges' work foregrounds the mighty, partly ruined, monument (note the signs of decay on the building's surface). In this respect, the image can be seen to combine historical significance with picturesque appeal.

In contrast, Daniell's engraving evidently locates the view in the specific moment in time when the artists visited the site. The tents of their military escort are marked by a British flag, and sepoys, soldiers and European civilians are engaged in casual everyday activities. Like Hodges, Daniell also frames his image with a shadow on the left, but its effect is much less pronounced and hence less atmospheric. In fact, the scene offers quite a sober, matter-of-fact view, one that speaks not to the Mughal Empire of the past but to the contemporary British military presence, which mediates the viewer's visual access to the gate. The potentially enigmatic gate is further demystified by the inclusion of the tomb itself in the distance, offering the scene to the viewer for ready visual consumption and possession by proxy.

As this comparison has demonstrated, the Daniells' approach to Indian scenes differed from that of their predecessor. They staked their reputation on a claim to offer a more faithful and systematic depiction of Indian architecture than Hodges. Thus, for example, William Daniell reported that one of the latter's views proved 'very incorrect' when compared with the actual monument.[27] The Daniells' claims to accuracy were supported by their use of a camera obscura (a darkened enclosed space with a convex lens or aperture for projecting the image of an external object on to a screen inside) and a perambulator (an instrument for measuring distance).[28] In fact, Hodges too insisted on the documentary fidelity of his work, but, in his case, he validated his project with his historical writings about Indian architecture; for him, however, the ultimate aim was to draw out the 'essence' of India, together with the awe-inspiring qualities of its monuments. His high-minded philosophical approach thus contrasted with the down-to-earth one of the Daniells, whose self-promotion was based squarely on their claims to strict visual accuracy.

By the early nineteenth century, the Daniells were considered the foremost artists depicting the Indian scene. Prints after their work were widely disseminated and appropriated for decorative purposes (see, for example, Chapter 2, Plate 2.4). More broadly, the success of their work can be related to the emergence of a new set of aesthetic norms for representing imperial space. Although the picturesque remained popular throughout the colonial period and indeed the Daniells often used the term in the promotional texts that accompanied their works, the pleasures of a landscape that invited a walk or a picnic now needed to be balanced against the requirement to depict India in a rigorous, detailed fashion that provided accurate information about the place depicted. In this respect, colonial depictions of landscape can be compared to maps, statistics and other techniques used by the British authorities to convey knowledge and assert mastery over India.[29] As the historian Gyan Prakash has argued, colonial rule required a new form of knowledge, one based on empirical science.[30] The work of the Daniells can thus be seen to subject the profusion and diversity of India to the mastering gaze of colonial power that came to be associated with the imperial picturesque. Their success, moreover, demonstrates that they had a sound grasp of the

requirements of the art market, both among the colonial elite in India and the British public back home.

The Daniells' work was not the last word in visual veracity, however. Between 1835 and 1842, the Scotsman James Fergusson travelled across the length and breadth of the Indian peninsula. Armed with a diary, a draughtsman's pad and a camera lucida (a portable sketching aid that projects a scene to be drawn on to a surface with the help of a mirror or prism), he followed in the footsteps of the Daniells and their *Oriental Scenery*. Dissatisfied with the accuracy of their depictions of Indian monuments, Fergusson set out to improve on their work. His obsession with the factual detail of the image further attests to the shift from an artistic to a scientific approach to depicting Indian scenes that had already favoured the Daniells' work over Hodges'. Fergusson, however, took this preoccupation in a scholarly rather than artistic direction, since the drawings he made during his years of travel served as the empirical base for his immensely influential art-historical writing. These publications inaugurated the field of Indian architectural history by virtue of being the first on the subject.

Fergusson's preoccupation with accuracy is evident from the engravings that illustrate his publication *Picturesque Illustrations of Ancient Architecture in Hindostan* (1848), such as the one entitled 'Gateway to the Temple at Chillambrum' (Chidambaram) (Plate 1.16). According to the art historian Tapati Guha-Thakurta, this image combines a residual picturesque aesthetic with a 'drive for order and history' that renders the monument 'historically and architecturally legible'.[31] It shows the monument dramatically lit, surrounded by bushes and trees, and strewn boulders, with a few strategically placed Indian figures to enliven the scene. Nevertheless, it is not shown at an angle, as was standard in picturesque views, but in a frontal manner that makes it possible to discern each of its constitutive parts; thus, as the writer and art critic Lee Lawrence puts it, 'from bottom to top, viewers read plinth, doorway, colonnade, frieze, another set of columns', etc.[32] For Fergusson, these details provided the key to unlocking a building's history, such that seeing became the key to knowing. He viewed architecture 'as a great stone book, in which each tribe and race wrote its annals and recorded its faith'.[33] He and many of his contemporaries believed that visual objects in general and buildings in particular offered an objective historical

Plate 1.16 Thomas Colman Dibdin, 'Gateway to the Temple at Chillambrum' (Chidambaram), engraving in James Fergusson, *Picturesque Illustrations of Ancient Architecture in Hindostan*, London, J. Hogarth, 1848. Photo: © Victoria and Albert Museum, London.

record that could be extracted by means of careful observation: hence the emphasis on accuracy in the visual rendering of Indian monuments.

The illustrations in Fergusson's book and their emphasis on architectural detail underscored the overarching theory of architecture that he developed, in which India featured prominently. Fundamental to his approach was a differentiation between mere utilitarian and high-ranking artistic architecture; he argued that a building qualified as fine art if ornament was properly applied, by which he meant integrated, subordinated and complementary to its structure. As he explains in *The Illustrated Handbook of Architecture* (1855), 'true art' had once been prevalent in architecture around the world. Even the 'indolent and half civilised inhabitants of India', along with other 'savage' peoples, had succeeded in creating an architecture that harmonised ornament with construction, in contrast to the 'vulgar' illusionism of contemporary Western design.[34] For Fergusson, ancient Indian monuments thus constituted a worthy case study in world architecture since, as Guha-Thakurta puts it, they constituted a 'living repository of a purity and antiquity that the West had long forfeited'.[35] Reflecting the Aryan myth prevalent at the time (see Introduction, p. 20), Fergusson further

suggested that India had undergone a decline in architecture and hence also in civilisation from the era of unadulterated Aryanism, which he associated with Buddhist art, to the 'decadence' of later Hindu art. India had, therefore, lost its architectural excellence, even if crumbling examples of 'true' architecture could still be found there.

Fergusson's work also provides further evidence of the way that representations of India and associated conceptions of its history were tied to the need to legitimate British rule. A crucial development here was the discovery in 1833 of figurative representations of Buddha with finely detailed drapery reminiscent of Greco-Roman art, which seemed to confirm the prevalent assumption that the Buddhist period had been India's golden age (Plate 1.17). These figurative sculptures were found in the region of Gandhara (now in Pakistan), an area conquered by Alexander the Great in the fourth century BCE. Their discovery inspired what the art historian Partha Mitter has referred to as a 'fully fledged racial theory of culture':[36] Fergusson, for example, argued that Indian art had peaked in the so-called Gandharan period (first to fifth centuries CE). He held that Greek influence in the wake of Alexander's northern Indian conquest had initiated this flowering

Plate 1.17 Unknown artist, statue of Buddha, second to third century, carved hornblende schist (rock), India (Gandhara). National Museums of Scotland, Edinburgh, 000-180-244C. Photo: © National Museums Scotland.

legitimating the colonial project, the documentation of Indian architecture assumed crucial importance, giving rise to large programmes of archaeological exploration and, later, state-sponsored photographic surveys (see, for example, Chapter 3, Plate 3.18). Moreover, Fergusson's classification of architectural styles on the basis of the different religions to which they were believed to give expression, such as Buddhist, Hindu and Muslim, became foundational for the history of Indian art. His work thus exemplifies the long-lasting contribution of colonial rule to the construction of knowledge about India, and would, in the long run, inadvertently help to shape the new, nationalist conceptions of Indian art, which developed in reaction to his arguments, as will be discussed below.

3 Painting, prints and the bazaar

As Mughal power and patronage declined during the eighteenth and the first half of the nineteenth centuries, European art became a model for emulation. Indian artists who had mastered modelling in the round and single-point perspective held a competitive edge in catering to the demand from both British and Indian patrons for images in European styles. But where did these artists learn these skills? There is some evidence of informal instruction, by engineers, for example, which explains the at times schematic appearance of some images, which seem to be drawn, in part at least, with a ruler, as in this early nineteenth-century watercolour by an unknown Indian artist (Plate 1.18). However, institutional avenues for acquiring this knowledge also existed: European art institutions were established in a number of Indian cities during the nineteenth century, starting with Madras in 1850 (see Introduction, p. 8). Generally, however, European visual conventions were picked up informally, through exposure to European images, especially prints, which were often sold off from the collections of Europeans who had died in India. Works by Hodges and the Daniells, for instance, ended up in the bazaar, a generic term for the network of Indian market-places that constituted the centre of artisanal production in the city.[37] The travel writer and artist James Baillie Fraser, who depicted the bazaar in Calcutta, described the scene as 'a bewildering mix of Indian and decaying Palladian architecture' (Plate 1.19).[38]

of a true Indian art and architecture, which it failed to sustain once the civilising influence of Greece waned. This argument supposedly proved that India needed the 'outside' influence of a more advanced nation to progress, and that its best hope of regaining its previous level of artistic achievement therefore lay in British colonial rule and artistic guidance.

Fergusson's history of Indian architecture built on the legacy of Britain's travelling artists who explored India. Like them, he deployed images of monuments to give expression to an apparently objective yet in fact fundamentally colonial view of the subcontinent. Now seen as a reliable index of the past and central to

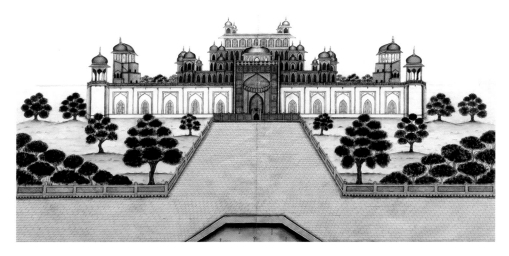

Plate 1.18 Unknown Indian artist, *The Mausoleum of Emperor Akbar, Sikandra*, *c*.1810, watercolour, 57 × 83 cm. Royal Asiatic Society, London, RAS 058.005. Photo: Royal Asiatic Society of Great Britain and Ireland, London.

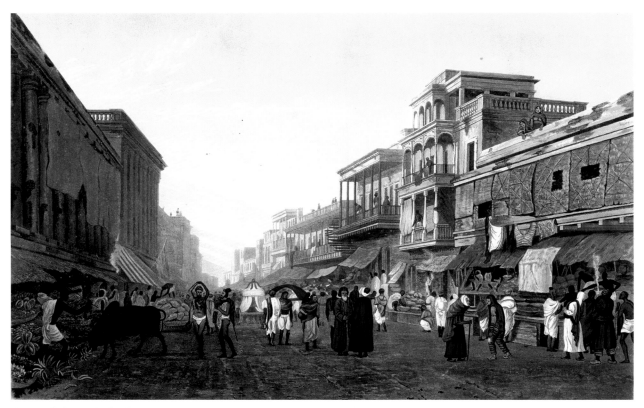

Plate 1.19 James Baillie Fraser, 'A view in the Lal Bazaar leading to the Chitpore Road, on the north side of Dalhousie Square in Calcutta', *c*.1826, coloured aquatint in James Baillie Fraser, *Views of Calcutta and its Environs*, London, Rodwell & Martin, 1824–26, Plate 24. Photo: © British Library Board. All Rights Reserved/Bridgeman Images.

This section will mostly focus on Calcutta, the capital of Bengal, which had been the first region of India to come under EIC territorial control. It served as the seat of the colonial administration until 1911, when the capital was moved to Delhi (see Chapter 4). Calcutta also saw the emergence of a new, English-speaking Indian middle class earlier than anywhere else in British India. Moreover, from 1839, elementary instruction in European artistic practice was available at the Calcutta Art Institute, which became the Calcutta School of Art in 1852. It was in the city's bazaars that European image conventions were appropriated and fused with elements of Indian folk art to form a new vernacular Indian visual language, which gave rise ultimately to the Bengal School of Art, recognised as the first national school of modern Indian art.[39] As a counterpoint to the much discussed contribution of Bengal to the development of Indian art, this section will also consider the work of Ravi Varma, a court artist from the southern, princely court of Travancore, which is representative of what Guha-Thakurta has called an 'alternative stream of Westernisation'.[40] In Travancore, European influences arrived indirectly via other southern Indian courts that had direct contacts with European artists, notably Tanjore (Thanjavur) and Puddukotah (Pudukkotai). The royal household at Puddukotah, moreover, employed a palace artist who had been trained at the Madras School of Art.[41]

A major impetus for these developments was the arrival in the mid-nineteenth century of low-caste *patuas* (itinerant artist-singers), who made their home near the Kalighat temple on the outskirts of Calcutta. Traditionally, *patuas* travelled from village to village with their hand-painted *pats* (scrolls), reciting the stories of gods and goddesses depicted on them in return for money. Once in Calcutta, the *patuas* exchanged their gouache paints and linen supports for European-style watercolours and cheap paper, with which they produced simple pictures that became known as Kalighat paintings (Plates 1.20 and 1.22). These images of gods and goddesses were sold as souvenirs to pilgrims and foreign tourists. The *patuas* also, however, now added social satire to their repertoire, commenting on events in the city such as the exploits of the *babu* (a Westernised *nouveau-riche* Indian), who, from a traditional rural or artisanal

Plate 1.20 Unknown Kalighat artist, *The Sheep Lover*, 1875, watercolour, 45 × 28 cm. Bodleian Library, University of Oxford. Photo: Bodleian Library.

perspective, epitomised the morally corrupt life of the city. This Kalighat painting, for example, satirises the perceived corruption of this new-fangled world, as epitomised by female 'domination', that is, the tendency at the time for women to abandon traditional customs, such as, in the case of upper-class Muslim and Hindu women, living in seclusion, and instead adopt modern Western practices, with some even gaining an English-style education (Plate 1.20). The image makes this point by showing a buxom woman, her sari arranged to outline her ample breasts, keeping her lover, depicted as a sheep, on a leash.

Plate 1.21 Madhab Chandra Sri Das, *Shiva and Parvati*, nineteenth century, woodcut print, 40 × 30 cm. Victoria and Albert Museum, London, E5533-1904. Photo: © Victoria and Albert Museum, London.

Kalighat painting, which flourished especially from the late 1850s to the 1870s, adopted some European elements, such as three-dimensional modelling of figures, while remaining close to inherited rural pictorial conventions characterised by a flat image space and bright, vivid colour. As the historian Sumit Sarkar argues, since they were produced 'entirely for an open market and not at the behest or orders of patrons', these paintings constitute 'perhaps the first modern school of Indian art'.[42] This dynamic indigenous world of image-making forged in the urban bazaar kept evolving, however: Kalighat paintings were soon being pirated in the form of black-and-white woodblock prints or metal engravings with patches of colour at times added by hand (Plate 1.21). These prints, which undercut the hand-painted *pats* on price,

were churned out by the so-called Battala presses, named after the northern part of Calcutta where the city's printing businesses were located.[43] They had a stiffer appearance, since the sense of volume, shade and tone was created by crudely hatched lines rather than the more elegant curvilinear form of the hand-drawn *pats*. The artisans who produced them mostly emerged from communities with skills in carving and cutting metals, who had thrown off traditional caste affiliations and taken advantage of the upward social mobility offered by the new medium of print. By the 1860s and 1870s, they had emerged as the most prominent artisan community in Battala, but did not rise to the status of 'fine artists' (see below for discussion of the reception of this concept in India), and neither did the Kalighat painters.[44] The same can be said of the small number of bazaar artists who, having acquired the skill of oil painting, competed for portrait commissions from the Bengali upper classes, for whom a taste for European-style art had become a major signifier of wealth and status.[45]

Likewise, graduates from government art schools in India struggled to attain the status of fine artist, even though the Calcutta School of Art had by 1864 become a fully fledged government institution with a curriculum devised by the Department of Science and Art in London. (Art school training in India will be discussed in more detail in Chapter 2.) This lack of artistic recognition reflected the fact that the school offered technical, craft-based and employment-oriented instruction in order to train (in the words of one colonial official) 'skilled draughtsmen, architects, modellers, wood-engravers, lithographers and designers for manufacturers'.[46] (It was only towards the end of the century that the instruction became more oriented towards fine art.) Its graduates found employment either as art teachers or as illustrators and printmakers for the colonial government; one prestigious project on which they were employed was the two-volume illustrated work of Rajendralal Mitra, *The Antiquities of Orissa*, which is discussed in Chapter 3. Art school graduates could also fold their new skills back into the production of religious and mythological pictures of the bazaar.[47] Artisanal-level employment, however, was not

to the taste of the middle- and higher-caste students, who were attracted to image-making in increasing numbers by the opportunity it offered for gaining the respectable status of a so-called 'gentleman artist', a new concept in India where previously no distinction between artisanal craft and fine art had been made. As students from these backgrounds began to flock to the Calcutta School of Art, they crowded out the lower-caste students for whom it had been intended.

By the 1870s, some of these better-off graduates had set up their own businesses with the aim of establishing themselves as fine artists. The Calcutta Art Studio was one such enterprise. It was founded in 1878 by Annanda Prasad Bagchi, Nobokumar Biswas and other former art school students. As an advertisement that they placed in *The Bengalee* newspaper reveals, they aspired to gain commissions to 'paint portraits, landscapes and scenes from mythology, history, novels, drama, in an improved and scientific style hitherto unknown to the native Arts in Bengal'.[48] Such work, however, proved difficult to obtain, with the result that the Calcutta Art Studio and other such firms primarily produced popular prints for the bazaar. They appropriated the subject matter pioneered by *pats*, rendering it in the new medium of chromolithography, in which they had been trained at art school. This technology, which allowed cheap mass colour reproduction, combined with their skills in pictorial illusionism, distinguished these art-school graduates as a group of prestigious printmakers.[49] Their attractive and colourful lithographs soon usurped the market share of Battala prints, ushering in a new wave of transcultural assimilation that forged a new synthesis between European academic conventions and popular Indian iconography.

In order to explore the differences between Kalighat paintings and the lithographic prints of the Calcutta Art Studio, it is helpful to compare examples of each that depict the Hindu mythological story of the goddess Annapurna feeding her husband Shiva (Plates 1.22 and 1.23). In the Kalighat painting, the goddess is seated on a low chair with clawed feet that

reflects the European-style furniture found in wealthy, high-status Bengali interiors. The image of the Calcutta Art Studio adds a female attendant in a richly draped outfit to the scene. She stands on the right, behind the goddess, holding a flywhisk, an Indian symbol of status. In Mughal miniatures high-ranking officials are often depicted with a flywhisk bearer, as were nineteenth-century Indian princes (see, for example, Chapter 3, Plate 3.24). On the goddess's other side, we see a small winged figure reminiscent of European representations of angels.

Exercise

Compare and contrast Plates 1.22 and 1.23. Consider their differences and similarities with regard to how the figures and their settings are represented.

Discussion

Both images centre on the seated figure of the goddess Annapurna, who is shown wearing a red sari and has a halo. Both also present Shiva with a round belly, loose hair and a loin-cloth of animal skin.

In the Kalighat painting, however, the goddess and her husband have a doll-like character. They are delineated in a few, fluid, yet precisely painted, outlines with additional contour lines that suggest a degree of modelling. The figures are set against a neutral background created by the blank spaces of the paper. The image is painted in five colours (red, yellow, blue, black and brown) that are applied unmixed. In this regard, the image testifies to the debt that Kalighat painting owed to Indian pictorial conventions, while the medium used (watercolour on paper) and the rendering of figurative volume were derived from European artistic practice.

In the chromolithograph, the figures are set against a rich and intricately detailed backdrop framed by elaborate architectural features. The goddess's sari falls in an abundance of carefully observed folds that model her limbs in a way that

betrays a training in figure drawing. She is shown wearing a crown and is seated on a European-style gilded throne placed on a richly ornate carpet. Her central position and formal presentation recall the iconography of the 'Madonna enthroned', demonstrating the artist's familiarity with European artistic traditions. The colours are modulated in the European manner, with areas of shading, but their intensity and brilliance go beyond conventional naturalism, testifying to the way that pictorial conventions were 'Indianised' once they entered the world of the bazaar.

However, the chromolithographs of the Calcutta Art Studio soon shared the fate of the *pats* and Battala prints: they were copied by cheaper presses not run by art-school graduates. Moreover, both were soon outdone by 'up-market' competition in the form of prints by Ravi Varma, the first Indian to be nationally recognised as a 'gentleman artist'. Born into a minor aristocratic family in Travancore, Varma was a largely self-taught painter whose skill in portraiture earned him an appointment as court artist of the Maharaja of Travancore. He gained a reputation for his ability to capture the likenesses of people and for his masterful rendering of surface textures in oil, especially the dress and accessories of his sitters, skills evident in his investiture portrait of the Maharaja of Baroda (Plate 1.24). It was, however, Varma's paintings of Hindu mythology that allowed him to relinquish his role at the court to pursue an independent career. These images were admired for the skilfulness of their highly illusionistic and intensely colourful fusion of European history painting and Indian mythology and, more specifically, for their supposed introduction of a uniquely Indian inner mythological sentiment or mood (*bhava*), which the bazaar prints were thought to lack.[50] Varma's mythological painting of a scene from the Hindu epic *The Mahabharata*, for example, shows the mythological princess Hamsa Damayanthi listening longingly to a white swan who acts as messenger of love on behalf of the handsome King Nala (Plate 1.25).

Plate 1.22 Unknown Kalighat artist, *Shiva Begging from Annapurna*, nineteenth century, watercolour with pencil and silver. Wellcome Library, London. Photo: Wellcome.

Plate 1.23 Calcutta Art Studio artist, *The Goddess Annapurna Giving Alms to Shiva*, late nineteenth century, chromolithograph, 43 × 32 cm. Ashmolean Museum, University of Oxford. Photo: © Ashmolean Museum, University of Oxford.

Plate 1.24 Raja Ravi Varma, *Sayajirao Gaekwad III, Maharaja of Baroda*, 1881, oil on canvas. Maharaja Fateh Singh Museum, Vadodara. Photo: Granger Historical Picture Archive/Alamy.

Plate 1.25 Raja Ravi Varma, *Princess Hamsa Damayanthi Talking with Royal Swan*, 1899, oil on canvas, 91 × 61 cm. Sri Chitra Art Gallery, Thiruvananthapuram. Photo: Stock Experiment/ Alamy.

Varma's work thus transformed Indian image conventions by humanising Hindu deities and by drawing on European-style narrative approaches. He went one step further still, however, by replicating his paintings in the form of prints, a development that, according to Guha-Thakurta, reflected the specific conditions of India under colonial rule. Since original European art was hard to obtain, Varma, like most Indian artists, had gained his knowledge of European art largely from prints and coloured reproductions.[51] As his reputation grew, he responded to the demand for his work in a manner that reflects this experience by establishing his own lithographic printing press in Bombay in the 1890s to make copies of his paintings.[52] Varma's print of Lakshmi, the goddess of wealth and prosperity, for example, replicates his painting of the same subject; it presents a lush green landscape with distant mountains, a light turquoise sky and a large pool of water with white swans and a white elephant, betraying the influence of European painting as well as that of Indian miniatures,

Plate 1.26 Ravi Varma Press, *Lakshmi*, *c.*1910, lithograph with varnish, 72 × 51 cm. Photo: Art Collection 2/Alamy.

bazaar art and Indian religious traditions (Plate 1.26). The goddess is depicted in a naturalistic manner, wearing the clothes and jewellery of an affluent lady of Varma's time, except that she has four arms, the sign of her divine status. She is also shown standing on a large pink lotus flower in the centre of the image, facing the viewer. This frontal view is reminiscent of Hindu religious iconography that entails a religious form of seeing called *darshan*, which involves the act of standing in the presence of the deity and seeing the image with one's own eyes.[53] Varma's frontal depiction of Lakshmi therefore refers back to a form of Hindu worship and indigenises the conventions of European naturalism that he employs.

As the anthropologist Christopher Pinney explains, the European naturalism taught in Indian art schools heavily emphasised accurate, analytical drawing. Considered a tool of cultural advancement, it was expected to shatter 'the Hindu dream world'.[54] By contrast, Varma's prints, with their vibrant skies and waterways filled with swans and lotuses, offered a world of mythic exuberance. According to Pinney, their 'magic-realism' fulfilled an important function by offering a vision of an imagined mythic golden (Hindu) past that was widely disseminated and shared across regions and social classes, thereby contributing to the nationalist project of forging an Indian nation.[55] Writing in 1907, the Indian journalist and colonial critic Ramananda Chatterjee, for example, argued that, in a country where more than 150 languages were spoken and written in different scripts, and where people professed many religions, it was art's task to take over this unifying role, especially since it also reached the illiterate sections of the population.[56] The emergence of chromolithographic prints in the *darshan* mode therefore offered a visual arena that helped forge a national imaginary. These images, and the response to the colonial encounter they represent, were nurtured by the world of the bazaar, and reached all sections of Indian society by the end of the nineteenth century. The sensuous heroines, deities and mythic worlds popularised in Varma's prints, moreover, had a lasting influence on Indian visual culture that is still prevalent today, in, for example, calendar art and Bollywood films.

4 The question of modern Indian art

By the end of the nineteenth century, Varma's paintings of Indian mythological scenes had earned him recognition as the 'greatest painter of modern India'.[57] The art critic Balendranath Tagore (a nephew of the artist and poet Rabindranath Tagore, who won the Nobel Prize in Literature in 1913) admiringly described Varma's paintings as a truly Indian art, on the basis of his painterly skill and the emotional resonance of his painted Indian mythological scenes.[58] Yet, by around 1910, his work was considered 'un-Indian' and the artist Abanindranath Tagore (another nephew of Rabindranath) was instead declared the

'true' first modern Indian artist. Varma's paintings were subsequently dropped from the canon of Indian art and were dismissed as sentimentalised popular art or kitsch by the educated Indian elite. Since the 1990s, however, the growth of scholarly interest in the popular arts of the bazaar has returned Varma to public attention. This section will explore the issues that informed these changing evaluations.

Abanindranath Tagore is considered to have been the founder of the so-called Bengal School of Art, which is generally acknowledged to be the first national school of modern Indian art. The development of this school formed part of the so-called Bengali Renaissance, a cultural movement associated with the Indian independence struggle, in which several members of the influential Tagore family were involved. The Tagores belonged to the new class of English-speaking and educated 'gentlefolk', known as *bhadralok*, that emerged during the colonial period. In 1905, Abanindranath Tagore's painting *Bharat Mata*, which presents the goddess Lakshmi in the artistic language of the Bengal School, was used in a procession to demand the revocation of the 1905 partition of Bengal (Plate 1.27). The picture thus became an icon of the independence movement, which promoted the boycotting of British goods and anti-British terrorist activities as part of a politics of Swadeshi or self-reliance. In the same year, Tagore was made vice-principal of the Government School of Art in Calcutta, though (like Varma) he had not himself trained in an art school.

A key figure behind the promotion of Abanindranath Tagore's at the expense of Varma's work was Ernest Binfield Havell, principal of the Calcutta School of Art from 1896 to 1900, who played a leading role in the nationalist movement. He considered Tagore's work more 'authentic' on the grounds that he adopted a style inspired by Mughal miniature paintings, whereas Varma, supposedly, merely copied European artistic techniques. Like many British art school educators in India at the time, Havell subscribed to an Arts and Crafts philosophy, which contrasted a debased, materialist, industrial Britain with an idealised vision of a spiritual medieval world. He and other proponents of such views believed that this earlier,

Plate 1.27 Abanindranath Tagore, *Bharat Mata (Mother India) as Lakshmi Devi*, 1905, watercolour. Rabindra Bharati Society, Kolkata. Photo: Debashish Banerji.

and less materialist, stage of civilisational development was still prevalent in India, albeit under threat from the corrupting influence of Britain's colonial presence. India was considered to be essentially spiritual in its cultural essence, which, for Havell and his fellow nationalists, was exemplified by Hindu traditions. This perspective has been called neo-Orientalist because of the way that it drew on Orientalism's fundamental opposition between a spiritual East and a materialist West. In his book *The New Indian School of Painting* (1908), Havell argued that the Indian artist operated on the basis of a yogic, inner vision, so that teaching European naturalism and accurate drawing to Indian art students not only went against their natural inclinations but was also destructive of their inner spirit. He therefore replaced the copies of European art used for instruction at the art school with Indian paintings, and installed Abanindranath Tagore as a teacher.[59] Distaining the Indian vernacular arts of the bazaar, Havell championed Tagore as the only living truly Indian artist on the grounds that he was unique in working in an Indian style, considering his work to be living proof of the reviving spirit of Indian art.

This new conception of Indian art and culture contradicted Fergusson's characterisation of Hindu art as decadent, which was by this date the generally accepted view. Havell now declared it to be the true expression of Indian culture, arguing that the Gupta period (fifth century CE) was the golden age of Indian art on the grounds that it showed no 'foreign' influence and thus constituted an exclusively Indian achievement. By contrast, the Greco-Roman Buddhist art canonised by Fergusson was dismissed as not truly Indian by the nationalists.[60] Havell's ideas were shared by influential fellow neo-Orientalist nationalists. They included Sister Nivedita (formerly Margaret Noble), an Irish follower of the inspirational Hindu monk Vivekananda, a proponent of a militant Hindu nationalism, who founded the Ramakrishna Mission which promoted social and educational welfare, attracting volunteer-disciples from around the globe. Nivedita was also an ardent promoter of pan-Asianism, a view that saw India as the spiritual Asian 'motherland' of all Asian civilisations. Another was Ananda Coomaraswamy, a geologist of mixed Tamil-English parentage, born in Sri Lanka and educated in Britain, who became the most influential figure in twentieth-century Indian art history. Inspired by the Arts and

Crafts Movement and, more particularly, by a utopian vision of medieval village civilisation, he promoted a spiritual conception of Indian art based on Hindu religious traditions. This view has since been criticised for being ahistorical and essentialist on the grounds that it neglects the non-Hindu influences that shaped Indian culture.[61] At the time, however, these figures together played a decisive role in shaping debates around Indian art, with their new vision of a spiritual, national art that privileged Hindu civilisation as the expression of the spirit of India.

Like Havell, Abanindranath Tagore supported the idea that Indian art was essentially 'spiritual'. He argued that Indian art should express an inner vision, which he sought to exemplify in his work. His outlook differed from Havell's, however, as regards the political implications of the rekindling of India's 'true' artistic spirit. The latter argued that the disaffection and political unrest in Bengal showed that the Pax Britannica had succeeded in reviving Indo-Aryan culture sufficiently for the lost Indian spirit to begin to stir. The unrest should therefore be seen in a positive light, but needed to be 'managed' correctly, on the basis of a 'true' understanding of Indian art and culture that could be gleaned from the 'open book of Indian art'.[62] According to Havell, Indian art showed that the roots of Indo-Aryan civilisation lay in village culture; he noted that the Aryans had instituted a system of village government in which five elders guided communities at the local level, while a king ruled the land.[63] According to Havell, this system constituted the appropriate Indian form of self-government that any successful ruler in the land needed to understand; if this historical precedent was respected, he suggested, no people 'were more willing to accept alien rule'.[64] Havell thus held that India was unsuited to 'Western forms of self-government', a historic lesson that, he argued, many Indian nationalists had failed to understand. It was thus his role as art teacher to advise the colonial administration about the guidance offered by Indian art and the light it shone on how to best govern India.[65] In other words, Havell's brand of nationalism, unlike that of Abanindranath Tagore, Sister Nivedita and Coomaraswamy, did not envisage political independence, but rather a continued colonial relationship with Britain and a village-based model of 'self-governance' for India.

There were also differences of opinion among the advocates of Indian independence, however. As the art historian Debashish Banerji has pointed out, a close analysis of Abanindranath Tagore's art reveals that his attitude towards Indian nationhood differed from that of the 'mainstream' nationalist movement which laid claim to his work. Historically, Tagore's art has been framed as an expression of the neo-Orientalist school of art criticism that became canonical in the twentieth century, with Coomaraswamy as one of its main, and most influential, proponents. According to Banerji, however, Abanindranath Tagore did not subscribe to the exclusive emphasis on Hinduism as the cultural core of India, a difference which may well reflect the fact that the Tagore family were *Pirali* Hindus, who were shunned by orthodox members of the faith and who were not bound by the strictures of the caste system. Arguably, this outcast status lay behind the Tagore family's artistic achievements and, more specifically, their openness to the diverse cultural influences in India, which is reflected in their work. Banerji argues that Abanindranath Tagore articulated a position that represented an 'alternate nationalism' reflecting a 'post-Orientalist' perspective.[66] Noteworthy in this context is Tagore's visual reference to the Taj Mahal in two of his watercolours, in which he combines a Mughal visual idiom and miniature format with European pictorial elements.

According to Banerji, this focus on the Taj presents a critique of the nationalists' exclusive endorsement of Hinduism at the expense of India's Islamic heritage, whilst also challenging the British claim to enlightened rule in the image of Emperor Akbar. A close examination of the first of these watercolours, *The Building of the Taj*, reveals a pluralist vision of India, since it shows a Muslim architect presenting an image of the Taj to the Mughal Emperor Shah Jahan, while a Hindu craftsman holds a mallet directly behind him (Plate 1.28). Although the emperor is seated in an elevated position, the relationship between the Muslim and Hindu figures is not one of hierarchy and dominance. For Banerji, the fact that the figures are not looking at one another, but

are absorbed in inner states, suggests not isolation or alienation but rather that they have each been granted space to engage with their respective worlds on a shared platform. Banerji therefore proposes that Abanindranath Tagore offers a vision of a co-creative community of diverse ethnicities in this work. The second watercolour, *The Passing of Shah Jahan*, shows the dying emperor, in the company of his daughter, gazing at the monument that he built to commemorate his wife (Plate 1.29). Read in the context of *The Building of the Taj*, as Banerji suggests, this image invokes nostalgia for a lost era of religious and cultural tolerance that is presented as a vision of a future Indian nation that would be based on non-hierarchical and inter-cultural creativity.[67]

The idea of modern Indian art that has been examined here was politically charged from the outset. It was tied to conceptions of Indian civilisation forged under the influence of British rule and to the essentialist understanding of culture fostered by colonialism. Reassessing the work of Varma and Abanindranath Tagore in the light of a transcultural perspective offers a new understanding of their work. Considered for most of the twentieth century to be a derivative, 'un-Indian' artist because he employed a European style, Varma is now recognised as the creator of a unique and influential 'Indian' visual idiom that responded to the colonial encounter. Abanindranath Tagore, conversely, is generally acknowledged to be a pioneer of an 'authentic' modern Indian art, but, on closer inspection, his art can be seen to have absorbed European as well as Indian elements. Its very claim to 'fine art' status betrays adherence to an 'un-Indian' concept, since the notion of fine art was introduced to the subcontinent through colonialism. Arguably, therefore, both artists have been shoe-horned into narrow categories that do not do justice to their work. This demonstrates the complex ideological and artistic legacies of British rule in India and the historical entanglement of the discipline of art history in the British imperial project, which further underscores the benefits of re-examining these histories from a transcultural perspective.

Plate 1.28 Abanindranath Tagore, *The Building of the Taj*, 1901, watercolour. Rabindra Bharati Society, Kolkata. Photo: Debashish Banerji.

Plate 1.29 Abanindranath Tagore, *The Passing of Shah Jahan*, 1902, watercolour. Rabindra Bharati Society, Kolkata. Photo: Debashish Banerji.

Conclusion

British responses to India shifted from the eighteenth to the nineteenth century, when the depiction of Indian scenes became predominantly associated with science and exploration rather than fine art, making the journey to India an increasingly unattractive prospect for ambitious British painters. This left the visual field to Indians, with the result that the urban bazaar became the cultural space where popular Indian art met European naturalism to forge unique new visual languages. However, it was not only European styles that made an impact on India. Colonial contact introduced European notions of fine art and the 'gentleman artist' to India, which were readily appropriated and led to the rise of modern Indian art. The colonial encounter also inaugurated the fields of Indian art and architectural history, and shaped the way that Indian art and culture were viewed; in fact, notions of art and civilisation were key to legitimising colonial rule and hence became a site of the struggle for independence. As critical approaches to studying colonial and nationalist views of Indian culture have revealed, they were, however, both premised on an essentialist understanding of culture, which a transcultural approach challenges, along with the standard histories of British and Indian art and the methods of art history to which it gave rise.

Notes

[1] Barringer, Quilley and Fordham, 2007.

[2] Thomas, 2013, pp. 105 and 111–12.

[3] Altick, 1978, p. 135.

[4] Ramsey, 2011, pp. 91–2.

[5] See, for example, a series of articles related to the *Artist and Empire* exhibition at http://thirdtext.org/artist-empire-forum. See also Taylor, 2016.

[6] Tobin, 1999, pp. 112–15; D. Ghosh, 2006, pp. 81–9.

[7] Nechtmann, 2010.

[8] Koch, 2001, p. 153.

[9] Koch, 2009, p. 309.

[10] Quilley, 2002, p. 184.

[11] Paul Sandby quoted in Jasanoff, 2011, p. 125.

[12] Jasanoff, 2011, p. 137.

[13] Pollock, 2003, pp. 154–9.

[14] Quilley, 2004, p. 1

[15] Quilley, 2004, pp. 1–5.

[16] Eaton, 2004, pp. 36–7.

[17] For a discussion of 'benevolent despotism' see, for example, Brantlinger, 2013, p. 82 and Lawson, 1993, pp. 128–9. For the change of attitudes to empire in the 1790s, see Marshall, 1999, p. 11.

[18] Hodges, 1793, p. 64.

[19] Quilley, 2011, quoted in Bonehill, 2012, p. 442.

[20] Metcalf, 1995, pp. ix–x.

[21] Quilley, 2011, quoted in Bonehill, 2012, p. 442.

[22] Bayer and Page, 2016 [2011], pp. 5 and 85–9.

[23] Bonehill, 2004, p. 10.

[24] As quoted in Tillotson, 2000, p. 16.

[25] Chattopadhyay, 2006 [2005], p. 33; Auerbach, 2004.

[26] For the 'colonial picturesque', see, for example, Sampson, 2002; for the 'imperial picturesque' and its application within Britain, see Casid, 2005, pp. 45–6; for the 'Indian picturesque', see Ray, 2013, p. 6.

[27] Tillotson, 2000, p. 42.

[28] de Almeida and Gilpin, 2005, pp. 190–1.

[29] Lawrence, 2004, p. 294.

[30] Prakash, 1999, p. 4.

[31] Guha-Thakurta, 2004, pp. 13–15

[32] Lawrence, 2004, p. 296.

[33] Fraser quoted in Mitter, 1992 [1977], p. 265.

[34] Fergusson, 1855, pp. xxv–vi; Guha-Thakurta, 1998, p. 30.

[35] Guha-Thakurta, 2004, p. 21.

[36] Mitter, 2011, p. 28.

[37] Chattopadhyay, 2006 [2005], p. 59.

[38] Fraser quoted in British Library, 2017.

[39] For an in-depth discussion of the world of popular print in Bengal in relation to elite *bhadralok* literature, see A. Ghosh, 2006.

[40] Guha-Thakurta, 1986, p. 174

[41] Guha-Thakurta, 1986, pp. 172–4.

[42] Sarkar, 2014, p. 410.

[43] A. Ghosh, 2006, p. 16.

[44] Guha-Thakurta, 1992, pp. 24 and 42.

[45] Guha-Thakurta, 1992, pp. 49–55.

[46] A. M. Nash quoted in Guha-Thakurta, 1992, p. 59.

[47] Guha-Thakurta, 1992, p. 42.

[48] Calcutta Art Studio, 1879.

[49] Guha-Thakurta, 1992, pp. 78–81.

[50] Guha-Thakurta, 1992, pp. 130–3; Tagore, 2017 [1893], pp. 193–5.

[51] Guha-Thakurta, 1986, p. 186.

[52] See Sarkar, 2014, p. 417.

[53] Eck, 1999, p. 3.

[54] Pinney, 2002, p. 115; for a discussion of India's posited, inferior, feminine, dream-like thought that is derived from Hegel, see Inden, 1992 [1990], pp. 95–6.

55 Pinney, 2002, p. 124.
56 Chatterjee, 1907, p. 84.
57 Chatterjee, 1907, p. 86.
58 Tagore, 2017 [1893].
59 For Havell's account of his instructional change at the Calcutta School of Art, see Havell, 2017 [1908].
60 Havell, 1915, pp. 130–3; Bannerji, 2010, p. 29; Guha-Thakurta, 1992, p. 177.
61 For example, Guha-Thakurta, 1992 and Mitter, 1994.
62 Havell, 1915, p. xxiv.
63 Havell, 1915, p. xxvii.
64 Havell, 1915, p. xxvii.
65 Havell, 1915, pp. xxxiii–xxxv.
66 Banerji, 2010, p. xxi.
67 Banerji, 2010, p. 37.

Bibliography

Altick, R. D. (1978) *The Shows of London*, Cambridge, MA, Belknap Press.

Auerbach, J. (2004) 'The picturesque and the homogenisation of Empire', *The British Art Journal*, vol. 5, no. 1, pp. 47–54.

Banerji, D. (2010) *The Alternate Nation of Abanindranath Tagore*, Los Angeles, CA, Sage Publications.

Barringer, T., Quilley, G. and Fordham, D. (2007) 'Introduction', in Barringer, T., Quilley, G. and Fordham, D. (eds) *Art and the British Empire*, Manchester, Manchester University Press, pp. 1–19.

Bayer, T. M. and Page, J. R. (2016 [2011]) *The Development of the Art Market in England*, London and New York, Routledge.

Bonehill, J. (2004) '"This hapless adventurer": Hodges and the London art market', in Quilley, G. and Bonehill, J. (eds) *William Hodges, 1744–1797: The Art of Exploration*, New Haven, CT and London, Yale University Press, pp. 9–14.

Bonehill, J. (2012) 'The art of empire', *Eighteenth Century Studies*, vol. 45, no. 3, pp. 440–2.

Brantlinger, P. (2013) *Rule of Darkness: British Literature and Imperialism, 1830–1914*, Ithaca, NY and London, Cornell University Press.

British Library (2017) *A View in the Bazaar, Leading to the Chitpore Road* [Online]. Available at http://www.bl.uk/onlinegallery/onlineex/apac/other/019xzz000000644u00024000.html (Accessed 12 October 2017).

Calcutta Art Studio (1879) Advertisement, *The Bengalee*, 8 November, p. 507.

Casid, J. H. (2005) *Sowing Empire: Landscape and Colonisation*, Minneapolis, MN and London, University of Minnesota Press.

Chatterjee, R. (1907) 'Ravi Varma', *Modern Review*, vol. 1, no. 1, pp. 84–90.

Chattopadhyay, S. (2006 [2005]) *Representing Calcutta*, London and New York, Routledge.

de Almeida, H. and Gilpin, G. H. (2005) *Indian Renaissance: British Romantic Art and the Prospect of India*, Aldershot and Burlington, VT, Ashgate Publishing.

Eaton, N. (2004) 'Hodges's visual genealogy for colonial India, 1780–95', in Quilley, G. and Bonehill, J. (eds) *William Hodges, 1744–1797: The Art of Exploration*, New Haven, CT and London, Yale University Press, pp. 35–42.

Eck, D. (1999) *Darsan: Seeing the Divine Image in India*, New York, Columbia University Press.

Fergusson, J. (1855) *The Illustrated Handbook of Architecture: Being a Concise and Popular Account of the Different Styles of Architecture Prevailing in all Ages and Countries*, London, John Murray.

Ghosh, A. (2006) *Power in Print: Popular Publishing and the Politics of Language and Culture in a Colonial Society, 1778–1905*, Oxford, Oxford University Press.

Ghosh, D. (2006) *Sex and the Family in Colonial India: The Making of Empire*, Cambridge, Cambridge University Press.

Guha-Thakurta, T. (1986) 'Westernization and tradition in south Indian painting in the nineteenth century: the case of Raja Ravi Varma (1848–1906)', *Studies in History*, vol. 2, no. 2, pp. 165–98.

Guha-Thakurta, T. (1992) *The Making of a New 'Indian' Art: Artists, Aesthetics and Nationalism in Bengal, c.1850–1920*, Cambridge, Cambridge University Press.

Guha-Thakurta, T. (1998) 'Tales of the Bharhut Stupa: archaeology in the colonial and nationalist imaginations', in Tillotson, G. (ed.) *Paradigms of Indian Architecture: Space and Time in Representation and Design*, London, Curzon Press, pp. 26–58.

Guha-Thakurta, T. (2004) *Monuments, Objects, Histories: Institutions of Art in Colonial and Post-Colonial India*, New Delhi, Permanent Black.

Havell, E. B. (1915) *The Ancient and Medieval Architecture of India: A Study of Indo-Aryan Civilisation*, London, John Murray.

Havell, E. B. (2017 [1908]) 'The new Indian school of painting', in Newall, D. (ed.) *Art and its Global Histories: A Reader*, Manchester and Milton Keynes, Manchester University Press in association with The Open University, pp. 188–90.

Hodges, W. (1793) *Travels in India During the Years 1780, 1781, 1782, and 1783*, London, J. Edwards.

Inden, R. (1992 [1990]) *Imagining India*, Oxford, Blackwell.

Jasanoff, M. (2011) 'A passage through India: Zoffany in Calcutta & Lucknow', in Postle, M. (ed.) *Johan Zoffany, RA: Society Observed*, New Haven, CT, Yale Center for British Art, pp. 124–39.

Koch, E. (2001) 'The "Moghuleries" of the Millionenzimmer, Schönbrunn Palace, Vienna', in Crill, R., Stronge, S. and Topsfield, A. (eds) *The Art of Mughal India: Studies in Honour of Robert Skelton*, Ahmedabad, Mapin Publishing, pp. 153–67.

Koch, E. (2009) 'Jahangir as Francis Bacon's ideal of the king as an observer and investigator of nature', *Journal of the Royal Asiatic Society (Third Series)*, vol. 19, no. 3, pp. 293–338.

Lawrence, L. (2004) 'The other half of Indian art history: a study of photographic illustrations in Orientalist and Nationalist texts', *Visual Resources*, vol. 20, no. 4, pp. 287–314.

Lawson, P. (1993) *The East India Company: A History*, London and New York, Routledge.

Marshall, P. J. (1999) 'The making of an imperial icon: the case of Warren Hastings', *The Journal of Imperial and Commonwealth History*, vol. 27, no. 3, pp. 1–16.

Metcalf, T. R. (1995) *Ideologies of the Raj*, Cambridge, Cambridge University Press.

Mitter, P. (1992 [1977]) *Much Maligned Monsters: A History of European Reactions to Indian Art*, Chicago, IL, University of Chicago Press.

Mitter, P. (1994) *Art and Nationalism in Colonial India, 1850–1922: Occidental Orientations*, Cambridge, Cambridge University Press.

Mitter, P. (2011) 'Language and race in colonial representations of Indian society and culture', in Seneviratne, H. L. (ed.) *The Anthropologist and the Native: Essays for Gananath Obeyesekere*, London, Anthem Press, pp. 19–34.

Nechtmann, T. W. (2010) *Nabobs: Empire and Identity in Eighteenth-Century Britain*, Cambridge, Cambridge University Press.

Pinney, C. (2002) '"A secret of their own country": or, how Indian nationalism made itself irrefutable', *Contributions to Indian Sociology*, vol. 36, no. 1–2, pp. 113–50.

Pollock, G. (2003) 'Cockfights and other parades: gesture, difference, and the staging of meaning in three paintings by Zoffany, Pollock, and Krasner', *Oxford Art Journal*, vol. 26, no. 2, pp. 141–65.

Prakash, G. (1999) *Another Reason: Science and the Imagination of Modern India*, Princeton, NJ, Princeton University Press.

Quilley, G. (2002) 'Signs of commerce: the East India Company and the patronage of eighteenth-century British art', in Bowen, H. V., Lincoln, M. and Rigby, N. (eds) *The Worlds of the East India Company*, Woodbridge, Boydell Press, pp. 183–200.

Quilley, G. (2004) 'William Hodges: artist of empire', in Quilley, G. and Bonehill, J. (eds) *William Hodges, 1744–1797: The Art of Exploration*, New Haven, CT, Yale University Press, pp. 1–7.

Quilley, G. (2011) *Empire to Nation: Art, History and the Visualization of Maritime Britain, 1768–1829*, New Haven, CT and London, Yale University Press.

Ramsey, N. (2011) *The Military Memoir and Romantic Literary Culture, 1780–1835*, London and New York, Routledge.

Ray, R. (2013) *Under the Banyan Tree: Relocating the Picturesque in British India*, New Haven, CT and London, Yale University Press.

Sampson, G. (2002) 'Unmasking the colonial picturesque', in Sampson, G. and Hight, E. (eds) *Colonialist Photography: Imag(in)ing Race and Place*, London and New York, Routledge, pp. 84–105.

Sarkar, S. (2014) *Modern Times: India 1880s–1950s: Environment, Economy, Culture*, Ranikhet, Permanent Black.

Tagore, B. (2017 [1893]) 'Ravi Varma', in Newall, D. (ed.) *Art and its Global Histories: A Reader*, Manchester and Milton Keynes, Manchester University Press in association with The Open University, pp. 193–5.

Taylor, M. (2016) 'Review of *Artist and Empire: Facing Britain's Imperial Past* (Tate Britain, 25 November 2015–10 April 2016)', *Reviews in History*, review no. 1903 [Online]. Available at http://www.history.ac.uk/reviews/review/1903 (Accessed 1 November 2017).

Thomas, S. (2013) 'The spectre of empire in the British art museum', *Museum History Journal*, vol. 6, no. 1, pp. 105–21.

Tillotson, G. (2000) *The Artificial Empire: The Indian Landscapes of William Hodges*, Richmond, Curzon Press.

Tobin, B. F. (1999) *Picturing Imperial Power: Colonial Subjects in Eighteenth-Century British Painting*, Durham, NC and London, Duke University Press.

Chapter 2

Design reform, Indian crafts and empire

Renate Dohmen

Introduction

In his *Travels in South Kensington*, published in 1882, the American writer Moncure Daniel Conway recounts receiving an invitation by a friend to travel around the world. Imagining a long and expensive journey, he declined. His friend, however, explained that what he had in mind was a visit to the South Kensington Museum (renamed Victoria and Albert Museum in 1899) (Plate 2.2). He argued that leaving London would make such a trip far less successful, declaring that 'there are few greater humbugs than this travelling about to see Objects'. The friend added that if one wanted to see the art and antiquities of the world, London was the best place to be and the South Kensington Museum a prime destination. For him, this 'mode of travel' was not just easier on the purse but also more satisfactory, since 'ten thousand people and a dozen governments have been at infinite pains and expense to bring the cream of the East and of the West' to London.[1]

This chapter takes its cue from this invitation to 'travel in South Kensington'. It explores the prevailing association of India with artisanal production during the colonial period, with reference to the institutional complex related to art and design located south of London's Hyde Park, which has been dubbed the 'South Kensington Juggernaut'[2]. The site, which had been purchased with the profits of the Great Exhibition, held in Hyde Park in 1851, was dedicated to education in history, culture, art and music. The South Kensington Museum, which opened on the site in 1857, adjoined the government art school (now the Royal College of Art), which moved there in 1853, as well as the all-important Department of Science and Art (DSA), founded in 1853. These three institutions worked together to further public education in matters of taste and design: the museum and its staff codified the 'correct' principles of design and displayed objects that embodied these principles, the associated art school taught these principles to artisans, and the role of the DSA was to oversee Britain's artisanal education, including drawing up the curriculum taught to students, and to organise international exhibitions that presented the best of British products to the world. As part of this remit, the department was responsible for the training of

Plate 2.1 (Facing page) William Holman Hunt, *Fanny Holman Hunt* (detail from Plate 2.28).

Plate 2.2 Victoria and Albert Museum, main entrance, London. Photo: Matthew Chattle/Alamy.

art and design teachers in what came to be known as the South Kensington system of drawing and design, which was taught not just in Britain but throughout the British Empire.[3]

Behind this cluster of interconnected institutions loomed the influential civil servant Sir Henry Cole, often referred to as 'Old King Cole'. He had played a prominent part in making the Great Exhibition of 1851 a success, became the first director of the South Kensington Museum and was the DSA's founding spirit as well as its leading official during its first two decades. A key figure involved in both the museum and the DSA was the architect and designer Owen Jones, whose influential *Grammar of Ornament* will be discussed in this chapter. Furthermore, almost all key advocates of

Indian crafts in Britain as well as in India, many of whom were South Kensington-trained art teachers, had substantial links with the DSA.

This chapter explores the close and complex relationship between British design reform, the ideas of the Arts and Crafts Movement, and Indian crafts. It examines the transfer of design principles and practices between Britain and India in a process that can be taken to exemplify the approach known as the transcultural. It also considers questions debated at the time as to what constituted 'authentic' Indian design, together with the display of Indian crafts at national and international exhibitions. The chapter then investigates the architectural response to colonial encounters in British India, and closes with a consideration of the role of market forces and questions of design.

1 Design reform and Indian design

This section discusses the impact of Indian decorative arts on British design education. Indian design first came to public attention at the Great Exhibition of 1851 (formally, the Great Exhibition of the Works of Industry of All Nations), an unprecedented display of manufactured products from many different countries. It served a dual purpose: internationally it promoted Britain as a leading industrial and imperial nation through peaceful competition, while nationally it sought to educate the British public in the values of art and taste, with the aim of rectifying perceived deficiencies in national production. Concerns about the artistic quality of British industrial goods had been highlighted in 1836 by the Select Committee on Arts and Manufactures, which expressed fears about the ability of British industry to compete internationally. The committee recommended the foundation of design schools in order to train artisans; these were duly established, but proved to be ineffective. Once the exhibition opened, concern about the shortcomings of British design were confirmed; the manufactured goods of other European nations put those of Britain to shame, with the superiority of French design causing particular anxiety.[4] The DSA was therefore founded with a mandate to devise an effective approach to design education.

Plate 2.3 Joseph Nash, *The Indian Court*, *c.*1851, lithograph, 44 × 60 cm, published as 'India No. 4' in *Dickinsons' Comprehensive Pictures of the Great Exhibition of 1851*, London, Dickinson Brothers, 1854. London Metropolitan Archives, City of London. Photo: Bridgeman Images.

The search for examples of design excellence focused attention on the Indian designs at the Great Exhibition. The Indian display, which was intended to showcase the best that the subcontinent had to offer, dazzled the British public; the publisher John Cassell, for example, eulogised 'India the glorious, glowing land, the gorgeous and the beautiful', and lauded its 'strange', 'rich' and 'wonderful' treasures (Plate 2.3).[5] What made a lasting impression, however, was not the glamour of the Indian goods, but the quality of their decorations: it was at the Great Exhibition that the superiority of India 'in point of design' became an accepted fact.[6] This 'discovery' was, in part, redemptive. As a result of its imperial connection with Britain, Indian ornament could 'justly' be claimed for the nation, thereby compensating for the failure of British design to gain critical acclaim.

The criteria on which the designs were evaluated were based on principles promoted by the British design reform movement. This umbrella term stands for a range of perspectives that coalesced around the agreed need to reform what was seen as a rampant and indiscriminate use of ornamentation on mass-produced British industrial goods. Leading figures here were the architect and designer Augustus Welby Pugin, who played a pioneering role in the Gothic Revival in Britain in the first half of the nineteenth century, and

the art critic and social reformer John Ruskin, both of whom argued that standards of design affected social conditions (and vice versa). Staunchly opposed to industrialisation, they deplored what they saw as the dehumanisation in the industrial labour process and promoted artisanal, hand-crafted work as an antidote to modern social decay. These attitudes would give rise to the Arts and Crafts Movement towards the end of the century. Central to the design reform movement was the belief that, since design and ornament not only reflected but also influenced the moral values of the wider society, they needed to be 'honest' and to express 'propriety'. But what exactly did this mean?

For 'design purists', as their critics called them, the wallpaper design illustrated here would be considered 'dishonest', as it shows an illusionistic scene (Plate 2.4). The source is in fact an imaginary Indian view based on prints of Indian scenes by Thomas and William Daniell gleaned from their popular six-volume *Oriental Scenery* (1795–1808) (see, for example, Chapter 1, Plate 1.15). 'Honest' wallpaper, in contrast, was considered to be characterised by an emphatically two-dimensional design that was true to the flat 'nature' of the wall to which it adhered. In accordance with these principles, Indian ornamentation was admired for the perfection, 'honesty' and colour harmony of the two-dimensional patterns found on textiles, enamelled vases and other

Plate 2.4 Pierre Mongin, for Zuber & Cie, scene from the panoramic wallpaper 'Hindoustan', designed 1807, colour woodblock print, based on prints from Thomas and William Daniell, *Oriental Scenery*. Photo: Zuber.

products (the actual shapes of three-dimensional objects were of no interest). In this respect, they offered a contrast to the supposed dishonesty of the naturalistic three-dimensional patterns that were seen to overburden British goods. Thus, whereas Indian painting was declared inferior because of its perceived lack of naturalism, this 'shortcoming' was deemed to be a strength of Indian designs.

Cole agreed with Pugin and Ruskin about the need to improve British design. For him, however, the solution did not lie in rejecting industry but in mass education. He therefore stressed the need to instil the fundamentals of good taste and the 'right' principles of design not only into artisans, the target audience of design reformers, but also into manufacturers and consumers. He pursued this agenda vigorously for the rest of his life by means of the institutions at South Kensington that he directed. In so doing, he worked closely with with Jones, whose

celebrated work, *The Grammar of Ornament* (1856), became a mainstay in British design schools, both at home and across the empire.[7] For Jones and his fellow design reformers, ornament was a key artistic indicator. The decoration of a building was thought to reveal the artistic calibre of its architect, for example, and the same principles of decoration were thought to be applicable across all artistic media.[8] This emphasis on design reflects nineteenth-century beliefs in the cultural unity of a given civilisation and age, from which it followed that all art forms in a particular period fundamentally expressed the same 'spirit'. Jones's stated aim was hence to develop a new style of ornament fit for the age of progress, one that could rise to the challenge presented by the 'fatal facility in manufacturing ornament', that is the ease with which any type of ornament could now be industrially produced, whether it suited the object that it was attached to or not.[9]

In *The Grammar of Ornament*, Jones analyses decorative patterns from around the world, ordered chronologically from antiquity to the Renaissance, and illustrated in 112 plates made using what was then the dazzling new technology of chromolithography. He includes several plates devoted to 'Indian ornament', three of which (like the one reproduced here) show ornaments taken 'from Embroidered and Woven Fabrics, and paintings on Vases, exhibited in the Indian Collection in 1851, and now at South Kensington' (Plate 2.5).[10] In the text that accompanies these plates, the samples are more specifically characterised as 'Mohammedan' (Muslim), since a separate section is devoted to 'Hindoo Ornament'. Unlike Fergusson, however, Jones does not denigrate Hindu art, but reserves judgement on it, stating that he has not seen enough to be able to draw conclusions. By contrast, he expresses a very high opinion of 'Indian' (meaning Indo-Islamic) design on the basis of the works exhibited in 1851. They embody, he declares, 'all the principles, all the unity, all the truth' that modern European products lack. Praising them for the consistent use of good design principles, he states that 'there is always the same care for the general form, the same absence of all excrescences or superfluous ornament'.[11] For Jones, designs originating in the Islamic world thus exemplified the best standards, with Indian works providing a case in point; it was, however, the Alhambra in Spain that he considered to be the most perfect example of Islamic design.

In addition to the plates of designs from different periods and cultures, *The Grammar of Ornament* includes a final section of 10 plates 'of leaves and flowers'. The text that accompanies this section explains that good design always featured ornaments that are 'based upon an observation of the principles which regulate the arrangement of form in nature, [rather] than on an attempt to imitate the absolute form of those works ...: true art consisting in idealizing, and not copying, the forms of nature'.[12] Among the plates in this section is a botanical illustration, which is revealingly listed in the table of contents as 'Various Flowers in Plan and Elevation' (Plate 2.6). The rigorous, scientific spirit suggested by this title is confirmed by the text, in which Jones explains that the image demonstrates that 'the basis

of all form is geometry'; despite the seeming variety, the forms of nature are based on 'unvarying principles', namely order, symmetry and regularity.[13] For Jones, therefore, ornaments from any time and place can be understood, analysed and synthesised with reference to these principles, irrespective of the cultural contexts in which they originated. Nevertheless, he believed that good design was informed by a knowledge of history; the purpose of this section, he explains, is to demonstrate that the progress of ornament can best be secured by 'engrafting on the experience of the past the knowledge we may gain from a return to nature'.[14]

Exercise

Now look at the plate of Indian designs from *The Grammar of Ornament* (Plate 2.5) and consider how Jones has adapted his source material in them. To what extent do the designs bear out his emphasis on imitating nature's principles rather than directly copying it?

Discussion

The designs contain no hint of their origin in textiles and vases. They are presented without any reference to their material, cultural and historical contexts. They are set out in a schematic way, in the manner of scientific specimens, with each design occupying a rectangular space in the grid-like structure into which the page is divided. They range from recognisable, if schematised, floral shapes to abstract geometric designs. Apart from the example to the left of the middle section, which shows an abundance of overlapping forms that recall flowers in a vase, the shapes are evenly spaced on flat, uniformly coloured backgrounds. The choice of patterns underscores Jones's edict that good designs abstract from nature, rather than 'copying' it, as was standard in European art (and 'bad' British design), in which plants were rendered naturalistically. The plate thus confirms that, for Jones, any illusionistic representation of nature in design is essentially misguided (though not, of course, in art, which for him would have been distinct from design).

Plate 2.5 Owen Jones, 'Indian No. 4', in Owen Jones, *The Grammar of Ornament*, London, 1865, Plate LII. Victoria and Albert Museum, London, National Art Library, ref. no. ND.91-0040 (vol. II). Photo: Victoria and Albert Museum, London.

Jones's emphasis on discovering the underlying principles of design revealed by the examples of ornament that he illustrated in his book makes clear that he did not intend to promote a mere revival of the past. Rather, the aim was to extract the principles of the world's decorative languages in order to transcend history. In the 'Thirty Seven Propositions' or 'General Principles' that preface the book, he offers guidelines for new decorations appropriate for the industrial age. Moreover, the abstraction evident in the samples of historic designs in the *Grammar*, together with Jones's insistence that nature should not be directly copied, marks a significant shift towards a modern visual language of a scientific character. Similar tendencies

Plate 2.6 Christopher Dresser, original drawing, for Owen Jones, *The Grammar of Ornament*, London, 1865. Victoria and Albert Museum, London, 1671. Photo: Victoria and Albert Museum, London.

can be discerned in international exhibitions and museums of the period, in which objects were no longer displayed and collected for their unique and unusual status, as they had been in cabinets of curiosity. Instead, objects were now presented according to encyclopaedic organising principles, with each serving to represent a given category, for example 'Indian craft'.[15] As such, they were seen to illustrate larger narratives of developmental stages in art and civilisation.

Also exemplary of the modernity of the *Grammar* is the use of a new technique of reproduction, in the form of chromolithography, for the purpose of disseminating knowledge. Illustrated publications such as the *Grammar* were crucial in facilitating Jones's and Cole's project of mass education in matters of taste. However, the most important role here was played by the drawing classes that the DSA established across the nation; by the mid-1860s, over 90 per cent of British school children and a large proportion of working-class adults had been enrolled in such classes.[16] The skills that they taught included disciplined hand–eye coordination and attention to detail, which were considered essential to workers in the machine age. In a similar way to Jones in his *Grammar*, the department promoted a conceptual method of drawing that was held to be superior to 'mere copying'. This rational approach to drawing and the emphasis on modern abstracted forms of seeing promoted by the DSA also informed art-school training in India.[17] There, as in Britain, the success of this programme of instruction for the training of artisans was mixed. The Bombay art school, for example, had a doubtful record of turning out employable artisans; it succeeded, however, in training drawing teachers who worked in schools across the Bombay Presidency; eventually there were enough teachers for every school in the district to be able to offer South Kensington-style drawing classes.[18]

Thus, the British colonial authorities provided Indian artisans with a training in supposedly universal principles of design derived (in part) from ornaments produced by their ancestors. However, the widely held view that India excelled in design was a double-edged compliment, as can be seen from remarks made by Ruskin on the subject. In a lecture that he gave at the South Kensington Museum in 1858, he declared: 'Among the models set before you in this institution ... there are, I suppose, none in their kind more admirable than the decorated works of India'.[19] However, for Ruskin, speaking in the aftermath of the Indian Rebellion, the superiority of India's ornament was a reflection of the barbarism of its people, whereas Europe's naturalistic art testified to the higher moral standards of a civilised people. Speaking in Manchester the following year, he stated:

All ornamentation of that lower kind is pre-eminently the gift of cruel persons, of Indians, Saracens, Byzantians, and is the delight of the worst and cruellest of nations, Moorish, Indian, Chinese, South Sea Islanders, and so on ... they are capable of doing this in a way that civilised nations cannot equal ... The fancy and delicacy of eye in interweaving lines and arranging colours – mere line and colour, observe, without natural form – seems to be somehow an inheritance of ignorance and cruelty. ... Get yourself to be gentle and civilized, having respect for human life, and a desire for good, and ... you will not be able to make such pretty shawls as before.[20]

Ruskin here seems to be objecting precisely to the artistic traditions that were most admiringly treated in *The Grammar of Ornament*.[21] Certainly, his outlook differed from that of Cole and Jones, who shared neither his hostility to abstraction nor his overt racism.

Nevertheless, belief in the excellence of Indian design undoubtedly represented the other side of the coin from the conviction that the colony's backwardness meant that Indians were not capable of producing fine art (see Chapter 1). Praising Indian design was thus 'safe', in so far as it neither threatened Britain's claims to developmental superiority nor challenged its role as colonial guardian. From this perspective, it was only 'natural' to turn to the ornaments of 'less developed' cultures, as Jones had done, to extract principles of good design. These principles could then be taught to British craftsmen, who, belonging as they did to a more advanced civilisation, had lost the intuitive ability to create design and colour harmonies, but could now regain this skill on a higher, that is, rational and scientific, level. Furthermore, the training of Indian artisans in these advanced principles of design could be claimed as fulfilling the legitimating promise of the civilisational 'uplift' that would accrue to India as a result of British colonial rule.

By the 1880s, critiques of mechanised production as dehumanising had become widespread in Britain. It was during this period that the phrase 'Arts and Crafts' was coined in order to define the commitments of those who advocated a revival of traditional handicrafts. Just as the design reform movement had drawn inspiration

from Indian design, so too representatives of the Arts and Crafts Movement turned to India. Their interest, however, was more generally focused on India's 'living' craft traditions that were seen to be preserved in the unchanging life of the Indian village, which was considered to be under threat from contact with Britain and British industrialisation.

A notable proponent of such views was George Birdwood, a former medical officer in India, who was appointed keeper of the Indian collections at South Kensington in 1875. Prominent art educators in India, such as John Lockwood Kipling and Ernest B. Havell, also became vociferous campaigners for the preservation and revival of Indian crafts. Kipling, for example, edited the *Journal of Indian Art* (1884–1900), a richly illustrated periodical that provided information about techniques as well as showcasing objects. The hope and expectation of adherents of the Arts and Crafts Movement was that, once Indian craft traditions had fully recovered from the damage caused by British interference, they could help Britain to deal with the social as well as the artistic problems caused by the dominance of machine production. Such views were articulated, for example, by the architect and designer C. R. Ashbee in his foreword to Ananda Coomaraswamy's *The Indian Craftsman* (1909): 'in this effort of the Western artists, workmen, and reformers for the reconstruction of society on a saner and more spiritual basis, the East can help us even more than we shall help the East'.[22] Thus, Indian artefacts not only presented a standard of 'good' design that could make British industry more competitive; they also served the contradictory end of saving British society from the corrupting effects of that very industrialisation.

2 India exhibited

The tremendous success of the Great Exhibition launched a new era of international exhibitions that extended from the mid-nineteenth to the early twentieth centuries. Across Europe and North America, as well as in other parts of the world, large-scale exhibitions of this type became an important vehicle for the negotiation of national and imperial identities. In the case of Britain, a tripartite model of empire was elaborated at such exhibitions, as the historian Peter Hoffenberg has explained. At the 1886 Colonial and

Indian Exhibition in London, for example, visitors were greeted at the turnstiles by three images which, between them, offered a 'portrait' of the British Empire: India (top) was represented by a potter working at his wheel with a female assistant, Australia (middle) by a farmer and a gold miner, and Britain (bottom) by an engineer and a blacksmith (Plate 2.7).[23] Here, India was presented as the epitome of a British subject colony, characerised by craft production, Australia stood for the white settler colonies, exemplifying the progress they had made under British rule and Britain was associated with industry. Thus, each component of the empire had a distinct and complementary identity. This section will explore the image of India and the display of Indian artefacts presented at such exhibitions.

The Indian artefacts presented at the Great Exhibition were highly admired, as already noted, but they also seemed positively miraculous since it was assumed that they had been produced by an extremely backward people. According to Cassell, for example,

> We gaze upon the myriad objects, rare and beautiful, which she contributes ... and gazing upon the simple instrument and the still simpler people by whom they were produced – for models of the workers themselves are here – we are transported to a strange country, and carried back to the infancy of time ... Here may be studied the industrial habits of nations preserved through centuries without change or progress, yet still wonderful and magnificent in the eyes of modern labour.[24]

As this passage indicates, the Indian displays included demonstrations of production methods in the form of clay models (Plate 2.8). Moreover, Cassell's *Illustrated Exhibitor*, from which this passage is drawn, exemplifies the voluminous accompanying literature which supplemented the displays. Exhibition visitors were thus expected not simply to wonder at the beauty and riches on show, but to examine the displays in a spirit of self-improvement, by reading as well as looking. Typically, however, this literature introduced objects and described craft procedures without making more than cursory references to India's very different regional cultures and histories, positing a blanket lack of progress for the whole of the country. Indian displays were thus seen as live history lessons of developmental stages through which Britain had long since passed.

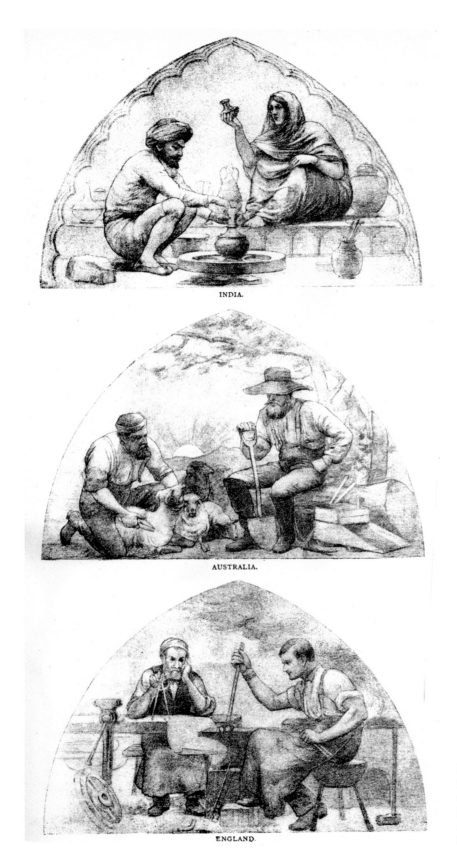

Plate 2.7 Messrs Doulton & Co., impasto panels displayed at the Colonial and Indian Exhibition, South Kensington, 1886, published in *The Builder*, vol. 51, London, 24 August 1886. Photo: RIBA Collections.

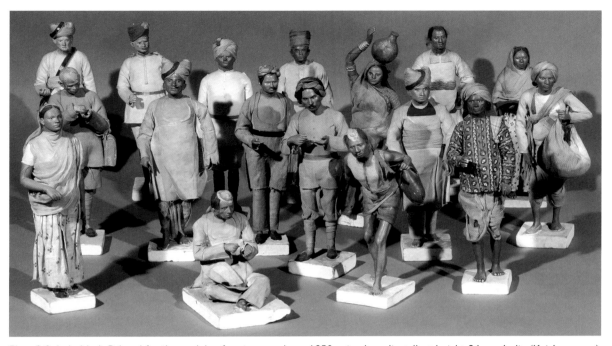

Plate 2.8 Jadu Nath Pal and family, models of various trades, *c.*1850, mixed media, tallest height 26 cm, India (Krishnanagar). In the collection of Indar Pasricha. Photo: Indar Pasricha Fine Arts, London.

The image of India as a backward place characterised by craft production and by the imagined purity of village life was reinforced by the Colonial and Indian Exhibition. Whereas the Great Exhibition celebrated Britain's place in the industrialised world, the 1886 exhibition formed part of the celebrations for Queen Victoria's Golden Jubilee. Attended by over five million people, it offered a showcase for the vast empire over which she presided, with India given pride of place, as can be seen from an engraving published in *The Graphic* (Plate 2.9). It shows Queen Victoria passing between the 'East' on the left, represented by the 'Gwalior Gate' (to be discussed below) and other samples of 'Indian architecture' designed by British officials, with a row of Indian subjects bowing in front it, while to the right a pseudo-medieval stage set that represented 'Old London', with Yeomen of the Guard (or 'Beefeaters') in attendance. India is thus here presented as one of the twin pillars of the empire, alongside Britain. The Indian display, which took up roughly one-third of the exhibition's floor space, included art, artefacts and architecture, as well as 'economic goods' (agricultural products and raw materials) and anthropological displays, such as the one discussed below (see Plate 2.21).

The examples of Indian art were arranged by region in a specially designed area that also housed an 'Indian palace', designed by the architect and archaeologist Caspar Purdon Clarke (later director of the South Kensington Museum). The palace featured an elaborately carved durbar or meeting hall (now in the Hastings Museum), built on-site and decorated by Mohammed Baksh and Mohammed Juma, two skilled wood-carvers brought over from the Punjab (see Plate 2.10, image at bottom right). During the exhibition, the palace was used by the Prince of Wales for official receptions; stalls of Indian food vendors and Indian artisans were also set up in its courtyard (see Plate 2.10). At its entrance stood the Gwalior Gate, a colossus of carved stone weighing approximately 76 tonnes, which had been created for the Calcutta International Exhibition in 1883 (Plate 2.11). It was funded by the Maharaja Jayajirao Scindia of Gwalior (r.1843–86) at the prompting of Major J. B. Keith, Curator of the Monuments of Central India, who argued that it would give employment to 2000 stone carvers while also promoting stone carving as an export industry. Rather than reproducing an actual monument, it was intended as an eclectic showpiece

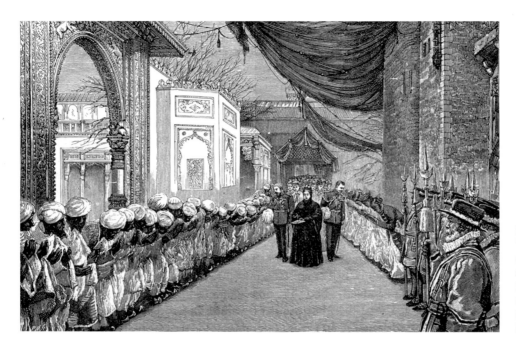

Plate 2.9 Unknown artist, 'The Queen's visit at the opening of the Indian and Colonial Exhibition, London', engraving in *The Graphic*, issue 858, London, 8 May 1886. Photo: The Print Collector/Alamy.

to illustrate the designs of many periods, as well as a mix of both Hindu and Muslim decorative motifs; it was purposely created by carvers of both faiths hired by Keith.[25] Referring to the *Grammar,* Keith stated that while Jones considered the copying of designs of the past anachronistic for the present age, this rule did not apply to the gateway since the designs were representative of living traditions ready to be revived through patronage, even if they were in abeyance.[26]

The 1886 Colonial and Indian Exhibition marked the last occasion when the gate was seen in its full glory. After the exhibition closed, it was moved to the Victoria and Albert Museum where it remains, but is now covered over to provide wall space for a series of tapestry designs by Raphael (known as the Raphael cartoons). As Deborah Swallow, former Keeper of the Asian Department and Director of Collections, has commented, its fate reflects the difficulties that such a gigantic monument poses for a European museum not geared to an architecture on the mammoth scale of Indian buildings (such gates were built to accommodate ceremonial processions with riders atop elephants). It also points to the complex institutional politics of the period after the Second World War when the British Empire disintegrated and India won independence. Writing in 1998, Swallow argued that its hidden location is indicative of the ongoing

Eurocentricity in the arts, which she found ironic in a museum that houses an extraordinary collection of applied art from around the world: 'those working in the studios of the great Renaissance masters, who still moved easily between what later became the "fine" and "applied" arts, might not have found the attitudes or the skills of the Indian craftsman so alien or unworthy of praise'.[27]

However, the Gwalior Gate was not the only example of the British appropriation and reinvention of traditional Indian designs: at the main entrance to the Indian section stood the so-called Jaipur Gate, a 'traditional' wooden construction financed by the Maharaja of Jaipur (Plates 2.12 and 2.13). It was designed by the engineer-turned-architect Samuel Swinton Jacob, who had been employed since 1867 as Executive Engineer to the princely state of Jaipur. The platform above the gateway served as a music gallery, and its central kiosk was based on Jaipuri stone originals. The golden sun indicates the claimed descendance of the Jaipur royal family from the Indian sun god Suraya, while the lettering cites the family's motto: 'Where virtue is – is victory'. The words are carved in Sanskrit with English and Latin translations on either side of the centrally placed inscription. Carved by local craftsmen, the gate was intended to show off Indian design at its best: 'The

COLONIAL AND INDIAN EXHIBITION: THE INDIAN EMPIRE.

WOOD-CARVERS (COURTYARD OF INDIAN PALACE).

GOLD BROCADE-WEAVERS.

MODEL OF NATIVE FRUIT-SHOP.

ARCHWAY, COURTYARD OF INDIAN PALACE.

VESTIBULE OF THE DURBAR HALL.

Plate 2.10 D. R. Warry, scenes from the 'Colonial and Indian Exhibition: Indian Empire', engraving in *The Illustrated London News*, London, 17 July 1886. Private collection. Photo: © Look and Learn/Illustrated Papers Collection/Bridgeman Images.

Plate 2.11 Unknown artist, 'The Gwalior Gateway' on display at the Colonial and Indian Exhibition, London, engraving in *The Builder*, vol. 51, London, 3 July 1886, p. 16. Photo: RIBA Collections.

only instructions issued to the woodcarvers have been that as great a variety of patterns was to be employed as possible; the ornament was to be purely Indian, and no attempt was to be made to work on other than the traditional lines.'[28] Ironically, therefore, these instructions were issued by British officials to Indian craftsmen, who most likely came from artisanal families going back generations, in order to ensure that they worked in a wholly 'authentic' way, that is, in accordance with a fossilised notion of Indian tradition which, historically, had thrived on adaptation and change.

Plate 2.12 Unknown artist, scene from the 'Colonial and Indian Exhibition: Indian Empire', engraving in *The Illustrated London News*, London, 17 July 1886. Photo: World History Archive/Alamy.

Plate 2.13 Unknown craftsmen, detail of carving on Jaipur gate (after restoration), originally constructed 1864, teak with gold leaf sun and lettering with Jaipur's motto 'Where virtue is – is victory' in Sanskrit. Hove Museum and Art Gallery, Hove. Photo: The Green Oak Carpentry Company Ltd.

However, it was the actual, living Indian artisans who could be observed at work in the Indian palace that most enthralled exhibition visitors. They had been carefully selected to represent different races and religions, and were even presented to Queen Victoria at Windsor Castle; she commissioned the Austrian artist Rudolf Swoboda to paint portraits of several of them. Unbeknown to the British public, they were in fact inmates from Agra jail who made the journey to London under the watchful eye of the jail's superintendent.[29] Rather than reflecting artisanal life rooted in idyllic villages, their presence attested to the colonial practice of training prison inmates in craft skills, in order to instil the moral values of hard work into them and thereby to transform unruly subjects into law-abiding ones. Indian jails, in fact, included outlets in which craft products made within them were sold, and prison officials teamed up with British art educators to improve the authenticity of these products. The catalogue of the Colonial and Indian Exhibition, for example, credits the improvement of jail carpets to government schools of art, which provided advice on the correct use of traditional designs and dyes.[30]

Indian crafts could also be seen in exhibitions within India. These were informed by the same objectives and employed the same principles of display as international exhibitions in Europe and America. The objects on display were not always of the same standard, however, as Indian exhibitions had far smaller budgets. Moreover, the best artefacts were reserved for international shows in Europe; the officials who were charged with sourcing items for display, known as 'exhibition wallahs', many of whom were art educators affiliated with South Kensington, often complained that they could not keep up with the demand from London for high-quality artefacts. Most of the Indian craft exhibitions had a regional character; this is true, for example, of the 1883 Jaipur Exhibition, which will be discussed below. An international exhibition was, however, staged in Calcutta in 1883, but this initiative was not supported by officials in Britain. They saw it as a threat to the imperial order, since the staging of such an exhibition served as a marker of India's modernity, proclaiming the subcontinent's ambition to relinquish its 'backwardness' and to take its place among the world's industrial nations. Moreover, the exhibition was held during the controversy over the

Ilbert Bill, a liberal measure that would have allowed senior Indian magistrates to try Europeans living in rural districts in criminal cases. Vehemently opposed by British residents in India, the bill also found a hostile reception in Britain. In this fraught political climate, the exhibition was considered a step too far; it was boycotted by the British government and press. Another international exhibition planned for Bombay was cancelled by its organisers. [31]

By contrast, the much smaller, regional Jaipur Exhibition, held earlier the same year, was discussed favourably and extensively in British newspapers. It was conceived by Surgeon-Major Thomas Holbein Hendley, a British medical officer stationed in the princely state of Jaipur. An Arts and Crafts enthusiast, who took a keen interest in Indian artisanal traditions, Hendley gained the nominal permission of the Maharaja Sawai Madho Singh II (r.1880–1922) via the British officials who ruled on his behalf until he reached regal maturity to stage an exhibition with the aim of improving and promoting Jaipur's crafts. Some 7000 objects, most of them from Jaipur and neighbouring states in Rajasthan, were displayed in the exhibition, for which Hendley had display cases modelled on those in the South Kensington Museum specially made in Bombay.[32] Apart from presenting artefacts worthy of imitation, he also included some bad examples to 'show what should have been avoided, and what mischief has already been done by the contact between Oriental and European art'.[33] The exhibition, which was funded by the maharaja, was held in the recently completed Naya Mahal, or new palace, the exterior decoration of which ironically exemplified the very stylistic hybridity that Hendley deplored, as will be discussed below (see Plate 2.20). The exhibition proved highly popular; during its two months' run, it was visited by a quarter of a million Indians from all sections of Jaipur society. Its success led to the creation of a permanent showcase for Indian artefacts, the Albert Hall Museum, which enjoyed similar sustained levels of popularity (see Plate 2.19). It also earned Jaipur its invitation to participate in the 1886 Colonial and Indian Exhibition.

The Jaipur Exhibition thus begs the question of whether or not Hendley had succeeded in instilling a sense of 'authentic' Indian art in the local people. Were Indian viewers, many of whom were illiterate, eager to educate themselves in what he considered

to be 'correct' principles of design? The historian of Indian art and architecture Giles Tillotson suggests otherwise. He argues that, on the contrary, the maharaja and the people of Jaipur appropriated the colonial agenda for their own purposes. He points out that the Rajput state of Mewar traditionally had the highest ranking in the region, a position that the state and royal house of Jaipur had long wished to usurp. Jaipur also competed with Mewar in the spheres of trade and the manufacture of artefacts. According to Tillotson, it is local pride in Jaipuri identity that explains the spectacular success and popularity of the exhibition and the Albert Hall Museum. He concludes that they tell 'a story not of British colonial curating, but of an Indian state's self-fashioning and self-promotion as a commercial centre of the arts'; Jaipuri interest in craft exhibitions thus has less to do with embracing British notions of 'authentic' Indian design than with 'the deliberate building of a reputation that Jaipur continues to enjoy today'.[34] As this example demonstrates, once transported to India, British notions of Indian crafts and of educational display were subject to transcultural appropriation in accordance with local politics and cultural contexts.

3 Anglo-Indian styles of architecture

In British India, the Public Works Department (PWD), founded in 1854, was in charge of all general construction work. A vast organisation, it inherited its structures, personnel and procedures from the Indian Corps of Engineer established by the East India Company in the late eighteenth century when, with the exception of prestige buildings, questions of architecture hardly arose; the emphasis was on infrastructural development.[35] The PWD was staffed with military engineers who were tasked with the building of all manner of structures. They erected bridges, sewage and irrigation systems, as well as functional buildings based on standard, utilitarian designs, with a basic classical vocabulary employed to dignify the more important ones. The results could appear bleak and dreary, as one contemporary observer emphasised: 'Who does not know the sense of desolation that comes over one at first sight of some of our Indian cantonments, the straight and dusty roads, the rows of glaring white rectangular barracks, the barn-like church'.[36] A prime example of PWD building

was the bungalow, which will be discussed in Chapter 4 (see, for example, Plates 4.26 and 4.27).

After 1857, however, as building work in British India accelerated, civil engineers began to join the ranks of the PWD, soon outnumbering their military counterparts, who, however, continued to dominate the institution.[37] By the mid-1870s, the question of which architectural style was best suited to represent the British Raj was being hotly debated in Britain as well as India, and the PWD's approach was increasingly being found wanting. In the following decade, growing awareness of the need for specialist expertise prompted the appointment of 'consulting architects' to the provinces of British India.[38] From an architectural perspective, the problem with the PWD approach was that buildings of low artistic standard set a bad precedent and undermined colonial prestige, while promoters of traditional Indian arts thought that PWD buildings blunted the spirit of the Indian people. From their point of view, the fact that Indians had to frequent 'un-Indian' municipal buildings suppressed their cultural sensitivities, which inevitably made them rebellious. This claim was based on the idea that architecture constituted the cultural core of any living 'nation', so that its vital presence was essential for its spiritual, cultural and social well-being. By implication, therefore, colonial architecture that reflected Indian traditions would lead to peace in the colony, providing a relatively straightforward solution to British post-rebellion anxieties by safeguarding against political unrest. Experiments with mixed architectural styles hence gained support.[39] This section will discuss two such styles, the Indo-Gothic and the Indo-Saracenic, together with an architectural example from Jaipur, which can be taken to exemplify a transcultural approach.

The Indo-Gothic style derived from the Neo-Gothic, which was adopted as the modern national style in Britain in the latter half of the nineteenth century. The emphasis on decoration characteristic of the Gothic style had the advantage of being able to accommodate Indian building traditions, which similarly emphasised sculptural embellishment.[40] The principal aim of Sir Bartle Frere, the governor of Bombay from 1862 to 1867, who played an instrumental role in creating the Indo-Gothic, was, however, to assert the city's status as a modern metropolis by transforming it in accordance with the latest architectural fashions in Britain.[41] An

adherent of Gothic Revivalism with good connections to British architectural circles, Frere commissioned buildings from British architects of high repute, a new departure in India on both counts since professional architects, let alone prominent practitioners in the field, had never designed a building in India before. Gilbert Scott, one of the leading architects of the Gothic Revival in Britain, was engaged, as were Owen Jones and Matthew Digby Wyatt, among others. Frere sought to foster an 'indigenous school of Anglo-Indian architecture' that would reflect what he saw as the more considerate post-1857 approach to British colonial rule under the Crown.[42]

The building programme formed part of a larger urban regeneration plan, which, as the architectural historian Preeti Chopra has shown, was unique in being a collaborative effort on the part of the colonial authorities and Indian elites. As a result, some Indian engineers were able to rise through the ranks of the PWD in Bombay; one of them, Khan Bahadur Muncherji Coswasji Murzban, was responsible for the design of many buildings in the city and became a fellow of the Royal Institute of British Architects in 1889.[43] This ambitious remodelling of the city reflected Bombay's recent rise to prosperity, due to increased demand for Indian cotton during the American Civil War (1861–65). After the end of the war, Bombay's boom was sustained by the opening of the Suez Canal in 1869, which made it the first point of disembarkation for travellers coming from Europe. Also crucial in this respect was the arrival of the railway, which transformed the city into an economic hub by facilitating the flow of raw materials from its hinterland to Britain. The railway also allowed for the dissemination of British goods in India, not to mention a steady flow of European travellers in both directions. The Indo-Gothic style, however, remained largely confined to the Bombay Presidency and flourished above all in its capital city.

Bombay's pride in its new-found success found expression in the grandeur of its central railway station, the Victoria Terminus, a symmetrical three-storey building consisting of a central section flanked by two wings, which was completed in 1887 (renamed Chhatrapati Shivaji Terminus in 1996, and Chhatrapati Shivaji Maharaj Terminus in 2017) (Plate 2.14). Considered one of the city's foremost Indo-Gothic

buildings, it served as the administrative head-office of the Great Indian Peninsula Railway (GIPR). Frederick William Stevens, a young civilian architect attached to the Bombay PWD, was entrusted with designing the building. He drew inspiration from Gilbert Scott's St Pancras Station in London (completed in 1868), but also from the Venetian Gothic tradition, of which Ruskin was the most celebrated admirer. Stevens's 'tropicalised' these models, however, by adjusting them to Indian climatic conditions: open verandahs, for example, wrap around the building and offer protection from heavy monsoon rains, while also shading the offices from the heat and glare of the sun. The style thus reflected the joint leadership of the city's building programme; so too did the sculpted lion (symbolising Britain) and tiger (representing India), each atop a plinth on either side of the entrance to the forecourt of the central section.

The Victoria Terminus's claim to Anglo-Indian status also rests on the use of local building materials, together with a range of Indian decorative and symbolic features. They include a bas-relief of 16 carved Indian heads representing the city's diverse population on the drum that connects the left wing to the central section. The main façade of the Terminus, moreover, is decorated with 10 terracotta portrait roundels, a speciality of Kipling and of John Griffiths, another British art educator in Bombay; these depict GIPR officials and local community leaders. Among the latter are two Indians, including Jamsetjee Jeejeebhoy, the founder of the art school which was named after him (Plate 2.15). In fact, many of the embellishments mentioned above were executed by the staff and students of the Sir Jamsetjee Jeejeebhoy School of Art in Bombay (Sir JJ School of Art). The building also features a plethora of decorative carvings on capitals, arches, cornices and other stone-masonry elements that show local creatures and regional flora and fauna (Plate 2.16). Reflecting colonial hierarchies, the high-profile sculptural elements of the building were, however, commissioned from the British sculptor Thomas Earp: the allegorical figures of 'Progress', 'Civil engineering', 'Agriculture' and 'Commerce' that top the dome and gables, the statue of Queen Victoria that originally occupied a niche below the dome, and the lion and tiger flanking the entrance to the forecourt were executed by Earp in Britain and shipped to Bombay.

Plate 2.14 Victoria Terminus (now Chhatrapati Shivaji Maharaj Terminus), c.1887–90, albumen print, Taurines Studio. Photo: The Hugh A. Rayner Photograph Collection.

The other major Anglo-Indian architectural style, known as the Indo-Saracenic, was based on Indo-Islamic architecture, which derived from Persia (now Iran), Afghanistan and central Asia as well as regional Indian traditions. The label by which the style is known is thus a misnomer, since the word 'Saracenic' derives from Europe's encounter with the Arabs in the Middle Ages, whether in the eastern Mediterranean or Islamic Spain, and disregards the cultural differences between Indo-Islamic and Mediterranean Islamic cultures. It will, however, be used here, in accordance with the usage at the time, which reflected how the style came to be conceived in the first place. As with the Indo-Gothic in Bombay, the creation of the so-called Indo-Saracenic style was informed by the architectural vision of a British governor, in this instance, Lord Napier, the governor of Madras from 1866 to 1872. He considered India's Islamic architectural tradition to be artistically rooted in European culture, on the grounds that Islamic art had developed in the late seventh century CE

out of Byzantine architectural precedents in the eastern Mediterranean, which in turn had developed from the culture of classical Greece. For Napier, therefore, Indo-Islamic architecture, which combined Hindu and Islamic architectural elements, entailed a historical European Christian dimension.

Indo-Islamic architecture was therefore seen to be ideally suited to represent the Raj, which brought Christians, Hindus and Muslims together in a single political entity. The Indo-Saracenic style flourished in Madras, with Napier's support, but also expanded beyond the city. It flourished throughout the subcontinent, particularly for public buildings frequented by Indians.[44] English-educated Indian princes likewise adopted the style, especially for the 'modern' residences they built (which were also used to entertain British officials), since they well understood the advisability of appearing to be appropriately 'traditional' in compliance with British expectations of them.[45] Indo-Saracenic architecture

Plate 2.15 Façade of the Victoria Terminus (now Chhatrapati Shivaji Maharaj Terminus) showing left corner drum with carved heads and main section with terracotta portrait roundels, Bombay. Photo: Jackie Britton.

was considered the most appropriate architectural style in British India between the 1860s and the 1900s. Its influence waned in the early twentieth century, which witnessed a resurgence of classicism in Britain. This development strengthened the hands of critics of the Indo-Saracenic style, who held that British rule should be proudly marked with a true 'Anglo-Saxon' architecture, unquestioningly identifying Neo-classicism as such.[46]

Nevertheless, the Indo-Saracenic style was only to some degree more Indian in character than the Neo-Gothic. Despite drawing on a much larger array of Indian architectural features, most buildings in the style were fundamentally based on European principles of design,

construction and spatial organisation. Furthermore, the eclectic mix of mostly northern Indian design elements that characterised Indo-Saracenic buildings ignored the different cultures of the rest of the subcontinent and must have seemed incongruous to local populations in other regions. It also ignored differences between historical periods. The style's features were gleaned from architectural publications, of which the most influential were those of Fergusson. In addition however, a collection of designs was assembled by Jacob, the six-volume *Jeypore Portfolio of Architectural Details* (1890) (see Plate 2.18), which served as the basis for his design of the Albert Hall Museum. The portfolio contained scaled drawings of architectural features

Plate 2.16 Carved stonework detail with monkey, lizard and local plants, Victoria Terminus (now Chhatrapati Shivaji Maharaj Terminus), Bombay. Photo: Jackie Britton.

Plate 2.17 Sir Samuel Swinton Jacob, Lallgarh Palace (now the Laxmi Niwas Palace Hotel), 1902–26, Bikaner, India. Photo: David South/Alamy.

from buildings in and around the city of Jaipur, as well as nearby Mughal monuments in Agra, Fatehpur Sikri and Delhi. They were drawn by Indian draughtsmen attached to Jacob's department whom he instructed to document designs of local buildings with the aim of ensuring that the Albert Hall Museum was based on examples of regional architecture.

Jacob's concern to draw on regional architectural traditions can be demonstrated by comparing a drawing of a dome-shaped pavilion or *chatri* from the portfolio with the completed Albert Hall Museum (Plates 2.18 and 2.19). The comparison demonstrates that the drawing served as the basis for the four open kiosks that mark the corners of the museum. With its stepped-back

FIG. 1. PLAN.

FIG. 2 ELEVATION.

(Marble)

FIG. 3. SECTION.

Sukhdev and Ram Pertap, del.

Plate 2.18 Elevation and section of a dome-shaped pavilion or *chatri* commonly found in Rajput and Mughal architecture and featured in the Albert Hall Museum, Jaipur, in Samuel Swinton Jacob, *Jeypore Portfolio of Architectural Details*, Part XI, London, 1890, Plate 12. Photo: © Victoria and Albert Museum, London.

storeys culminating in a central raised dome also topped by a kiosk, Jacob's scheme differs markedly from European museums of the same period, whether classical or Gothic. The overall design draws on Jaipuri sources, such as the maharaja's city palace, together with Mughal ones, including the Panch Mahal Pavilion in Fatepur Sikri and Akbar's tomb in Sikandra (see Chapter 1, Plate 1.18 and Chapter 3, Plate 3.2).[47] Jacob's sensitivity to regional styles is also borne out by his design of Lallgarh Palace, which was built for Ganga Singh, the Maharaja of Bikaner (r.1887–1943) (Plate 2.17). The building displays a recognisable Bikaneri style of ornamentation; the architectural elements specific to the region include the local pinkish-red sandstone, the multi-tier stone lattice screens, or *jalis,* and projecting windows. However, the interior of the palace betrays elements of European spatial organisation.

Not all buildings in British India were designed by British architects or engineers, however. The high degree of independence granted to Jaipur in its treaty with Britain meant that the Maharaja Sawai Ram Singh II (r.1835–80) retained his authority over architecture within the city's walls; he maintained a traditional *Imarat*, or building committee, which was exclusively staffed by Indian master builders. Ram Singh, who had received an English education and was a keen amateur photographer, was adept at negotiating British expectations of an Indian prince by appearing 'Oriental' and 'Other', while also presenting a modern and reform-oriented image when it came to running his state. He initiated irrigation projects, for example, in order to curry favour with British officials. In 1866, he founded an art school, for which a building was constructed within the city walls according to his specification;

OPENING OF THE NEW ALBERT HALL, AT JEYPORE, INDIA.

Plate 2.19 'Opening of the new Albert Hall, at Jaipur, India', engraving in *The Illustrated London News*, London, 24 November 1888. Private collection. Photo: © Look and Learn/Illustrated Papers Collection/Bridgeman Images.

the training it offered differed somewhat from that provided by government art schools, which, he thought, over-emphasised drawing.

Ram Singh also founded the Albert Hall Museum, which was modelled after the one in South Kensington and named after Albert Edward, Prince of Wales (later Edward VII), who laid the foundation stone during a royal visit in 1876. The maharaja challenged British authorities, however, by retaining control over the design of the museum despite its being built outside the city walls; according to the rules set down in his treaty with the British, responsibility for the building should have been handed to the local PWD and thus to Jacob. In so doing, he offered a wholly unpreceded snub to British authority; it has been interpreted as a symbolic 'counter-invasion' on the part of the maharaja, who thereby reclaimed authority over a part of his state where he officially had no jurisdiction (which the British authorities chose to ignore).[48] Ram Singh II died in 1880, however, before the building work had begun. Since his heir, Madho Singh II (r.1880–1922) had not yet come of age, the administration of the state was handed to British officials in the interim, in accordance with Jaipur's treaty. During this period, they restructured the *Imarat* by appointing Indian craftsmen trained in the British manner, thereby gaining control over building work within the city walls. The PWD also took over the building of the Albert Hall Museum, with Jacob leading the project.

Despite the sensitivity towards local traditions for which Jacob was renowned, the eclectic mix of Indian architectural and decorative styles employed in the Albert Hall Museum in fact reflects distinctively

British notions of what constituted 'traditional' Indian design. When the museum opened, for example, Hendley especially commended the interior decoration: 'Almost every pillar and every inch of wall space is a copy of, or an adaptation from some well-known and admired native building'. The masons who worked on the building, he added, had trained at the Jaipur School of Art where they had been instructed to make copies of 'the ornament on the palaces, tombs and other important edifices at Delhi, Agra or Fatehpore Sikri'. This training continued under Jacob, until these hereditary masons 'were so imbued with the spirit of the Indo-Saracenic style that they could produce works which were no longer copies but creations', stating that '[m]uch of the internal decoration of the hall is therefore original'.[49] As Jacob explained to a gathering at the Royal Institute of British Architects in London in 1891, the design of the building was thus integrated into the conception of the museum, since it was 'not only the content of the museum, but the walls themselves' that constituted it.[50]

The entire museum project thus represented a contribution to the larger goal of protecting and reviving 'good' Indian design. Accurate draughtsmanship was seen to play a key role in the reinvigoration of the 'right kind' of Indian architectural and design traditions. For Hendley, drawing constituted a crucial corrective to what he saw as the tendency of Indian craftsmen to copy blindly, without any real understanding of their native artistic traditions.[51] In his eyes, this tendency made them highly susceptible to the corrupting influences of European design. Intensive training in the skills of drawing was thought to promote a higher level of appreciation that would make it possible to transcend the present stagnation of Indian artistic traditions, thereby reinvigorating the spirit of the entire culture. In other words, India needed British guidance to survive the corrupting onslaught of Britain's cheap industrial products, and, ultimately, of its rule.

However, besides the Indo-Gothic and Indo-Saracenic styles, other architectural endeavours of the period represented a different approach to negotiating the artistic encounter between Britain and India. A case in point is the façade of the Naya Mahal (see p. 86), which blends European and Indian architectural elements in a way that, according to the architect and architectural historian Vikramaditya Prakash, testifies

to a subversive approach on the part of Ram Singh II (Plate 2.20). Evidently, the maharaja had a rather different view of what constituted authentic Indian design from British officials such as Hendley. Located within Jaipur's city walls, the building fell under the jurisdiction of the *Imarat*, at least until the death of Ram Singh II in 1880.[52] Completed in 1883 (possibly with some involvement from Jacob), it housed the Jaipur Exhibition held in that year and now serves as the Sawai Man Singh II Town Hall Museum.

Exercise

What elements of Indian and European architectural styles can you discern in the middle section of the Naya Mahal (Plate 2.20)? How might you interpret their use together here? You may find it helpful to take a quick look at some of the illustrations in later chapters of this book, such as Plates 3.2 and 4.11.

Discussion

The red of the façade, heightened with white accents, is distinctively Mughal, as you may have recognised by comparing it to such monuments as Akbar's Tomb at Sikandra and the Red Fort in Delhi. The composition of the ground floor is classical, however; each window is framed by a post and lintel composition, surmounted alternately by a rounded or triangular pediment, for example. The middle level of the façade, by contrast, presents two rows of windows with a mix of architectural features. The windows of the lower row are grouped in units of three, demarcated by white interwoven bands. Within each unit, the windows are framed by white lines that trace a pointed arch, a form commonly used in both Islamic and Gothic architecture. The second tier of windows presents a simplified version of the ground-floor decorations, with an alternating repeat of rounded and triangular pediments. The top level of the façade features a mix of design elements suggestive of Mughal architecture, including balustraded openings topped by pointed arches again arranged in groups of three.

At first glance, the composition may seem an incongruous and random mix of stylistic features. It could, however, also be interpreted

Plate 2.20 Façade of the Naya Mahal (now Sawai Man Singh II Town Hall Museum), Jaipur, completed in 1883. Photo: Dinodia Photos/Alamy.

as a deliberate attempt to present an alternative view of the cultural encounter between Britain and India. The middle section of the facade, for example, embraces cultural mixing, yet maintains the identity of both cultures. The plausibility of the reading is reinforced by the way that this section is framed by 'pure' European designs on the ground floor and the Indian architectural features on the top one. The whole façade might thus be read as presenting a critique of the European obsession with tradition and the purity of design in a way that defiantly asserts the Mughal practice of appropriating foreign features into Indian visual vocabulary, thus artistically reclaiming past Mughal power and greatness.

The architectural decoration of the Naya Mahal undoubtedly defies the neat binaries of colonial stereotypes ('East is East and West is West ...') and, in so doing, disrupts the boundaries of superior/ inferior and civilised/uncivilised characteristic of colonial ideology. The playful approach that it embodies could be seen as offering a riposte to the way that, in the words of Chopra, the British used 'Indian architectural elements in their buildings as a demonstration of their knowledge and mastery over India's past'.[53] Rather than being unique to Jaipur, however, a similar approach can also be found in other buildings throughout the Indian subcontinent, mostly built by Indian landed classes who laid claim to Mughal inheritance, even if not as deliberately as Ram Singh. They creatively deployed European architectural styles, commissioning

buildings that presented idiosyncratic combinations of features which, from a British perspective, appeared problematically inauthentic and indeed could be seen as constituting just the kind of 'mischief' Hendley warned against (see p. 86). In reality, however, they were following a long-established tradition within India of incorporating 'other' visual elements into local artistic frameworks.

4 Fashion, markets and the Kashmir shawl

However, it was not only aristocratic (and entrepreneurial) Indian elites that responded to their encounter with British visual culture in ways that defied South Kensington's notions of good taste and 'authentic' tradition. Although the image of a timeless India based on a village economy dominated British perceptions of the subcontinent, it was not their sole Indian point of reference. Instead, it constituted but one pole in Britain's narrative of colonial legitimation, with the promise of progress and development serving as its antithetical other. Thus, while village life and craft production were proudly presented at the Indian palace erected for the 1886 Colonial and Indian Exhibition, India's (limited) economic advancement under British rule was put on show in the exhibition's commercial annexe. The displays in the annexe, or 'Economic Court', included a large-scale model of an indigo factory, measuring nearly 2 metres in length, made out of clay (Plate 2.21). It was made by an artisan, Rakkal Chunder Pal, from the city of Krishnanagar in West Bengal, which was famous for its tradition of making clay figures engaged in everyday village activities such as fishing, farming, basket making and cooking.

The commercial development that the British encouraged, however, had a destructive effect on the very village life the exhibition's artisanal sections celebrated: indigo production required small-scale Indian farmers to abandon subsistence farming, with the result that their survival depended on market fluctuations, heightening the risk of famine when food prices rose or that of indigo dropped. Moreover, European indigo entrepreneurs and factory owners had a reputation for their coercive and exploitative practices. The vision of a timeless village idyll

found in British colonial rhetoric thus glossed over widespread changes in the village economy as India was increasingly drawn into the British supply chain for raw materials grown and harvested on an industrial scale.

Colonial ideology was thus inherently contradictory and riven by irreconcilable tensions. On the one hand, it promoted India in the image of the village, while offering the promise of progress, modernisation and economic development on the other. The latter had to be kept in check, however, because it threatened to close the developmental gap on which the legitimation of colonial rule depended. Furthermore, these two poles were not equally present in the public imagination: the image of a backward India as a craft nation dominated, and profoundly shaped the narratives of the Raj. Moreover, since documents presenting this view are prevalent in historical records of the period (often generically referred to as 'the archive'), it also prevails in scholarly discussions of Indian applied arts, as the historian Abigail McGowan has pointed out (her arguments will be discussed further below). This section attempts to challenge the standard account by introducing market forces and economic factors into the picture.

One consequence of the colonial exploration of craft processes was that knowledge previously safeguarded within close-knit, often caste-based, communities was now made available to British manufacturers. The detailed reports by the British explorer, veterinary surgeon and horse breeder William Moorcroft on the techniques of shawl production in Kashmir proved invaluable to British industry, for example.[54] The South Kensington Museum also played an important role as a resource for British manufacturers, who could examine the textures, designs and production techniques of Indian cloth at the museum with a view to imitating them. The museum used a special device for displaying textile and other samples that consisted of a rotating stand with leaves, similar to those of a book, in order to make such information readily available (Plate 2.22). South Kensington's efforts to disseminate manufacturing knowledge were taken even further by John Forbes Watson, 'Reporter for the Products of India' at the India Office, London, in his widely distributed *The Collections of the Textile Manufactures of India*, first published by the India Office in 1866. Envisaged as

Plate 2.21 Rakkal Chunder Pal, clay model of an indigo factory with 96 figures and 4 oxen, Bengal, made for the Colonial and Indian Exhibition of 1886, width c.200 cm. Royal Botanic Gardens, Kew, London. Photo: © The Board of Trustees of the Royal Botanic Gardens, Kew.

a portable industrial museum, the work consisted of 18 volumes of neatly mounted and classified samples of Indian textiles, 700 in total (Plate 2.23). With the help of such information, manufacturers such as the Scottish firm John Orr Ewing & Co. produced bright, synthetically coloured printed cottons that rivalled 'Eastern' fabrics. They even created pseudo-Indian labels that emulated Indian popular prints (which could also be studied at the museum) to appeal to the Indian market (Plate 2.24).

In the second half of the nineteenth century India thus became an important market for mass-produced British goods, many of them fabrics, that is, the very products that in previous centuries had secured India a prime place in global trade. Machine-made British textiles imitating Indian models not only swamped the market there, but also muscled in on India's export trade. A key product here was the so-called Paisley shawl, the Scottish version of a coveted luxury item from India, which took its name from the town near Glasgow where such shawls were made. The much more expensive

original on which they were modelled, the Kashmir shawl, had been produced in the Indian region of that name since the fifteenth century.[55] The original shawls, which were historically made by male weavers, took between three and twelve months to produce, depending on the intricacies of the woven pattern. Sold along Asian trade routes, they were held in high esteem at Mughal, Persian and Ottoman courts, with weavers adapting designs according to prevailing fashions (both Persia and Turkey became markets for the cheaper Scottish version).[56]

The unique softness for which these shawls were valued derived from the *pashm,* the fine inner coat of the central Asian mountain goat, out of which the fabric (*pashmina*) was woven. What most obviously distinguished these shawls, however, was the teardrop motif with a bent tip referred to as a *buta* or flower with which they were decorated (Plate 2.25).[57] The design emerged in the seventeenth century, when the Mughal discovery of European botanical illustrations combined with Emperor Jahangir's love for the floral

Plate 2.22 Henry Cole, design for a vertical display stand for drawings, prints and textile samples. Victoria and Albert Museum, London. Photo: © Victoria and Albert Museum, London.

beauty of Kashmir, with the result that the depiction of flowers became a central feature of Mughal art (see Introduction, Plate 0.5 and Chapter 1, Plate 1.10). The *buta* had its origins in a single flower in a slightly bent shape, the so-called *tribhanga* or tri-flexion pose found in Indian dance, sculpture and painting, which developed into the familiar teardrop shape in the late eighteenth century (Plate 2.26). Initially, these flower-shaped decorations featured only on the borders of otherwise plain shawls (as, for example, in the shawl

worn by one of the young Indian princes in Chapter 1, Plate 1.11). In the early nineteenth century the border expanded and eventually the design covered the entire fabric.

Kashmir shawls became fashionable in Europe in the 1770s, when they arrived mainly as gifts since the import tariffs levied on luxury objects did not make them attractive as a business proposition. Their prohibitive price tag rapidly fostered the production of imitations all over Europe. In the first half of the

INDIAN FABRICS. No. 34

TURBAN.

Cotton: favorite style of pattern.

Length 16½ yards ; width 10 inches ; weight 15½ oz. ; price 3s. 1½d.

From MADRAS.

Prov. No. 116.

ORNAMENTAL END TO SHOW.

PLAIN END NEXT TO HEAD.

Plate 2.23 Indian fabric sample, in John Forbes Watson, *The Collections of the Textile Manufactures of India*, London, 1872–80. Photo: Harris Museum and Art Gallery, Preston, Lancashire/ Bridgeman Images.

nineteenth century, French-made shawls were considered the cutting-edge of fashion and dominated European production. However, the textile trade was a fast-moving and highly competitive global business and, by the 1840s, British textile firms (along with others across Europe) were busily copying popular French models, as well as pirating designs from each other. In 1873, the

first prize at the Exhibition of Punjab Manufactures held in Lahore was, for example, awarded to a shawl designed by the Englishman Mr R. Chapman.[58] Speed was of the essence in capturing the latest fashions and staying ahead of the competition. Agents from Paisley travelled regularly to London to make tracings of the latest designs arriving from India, for example, so that

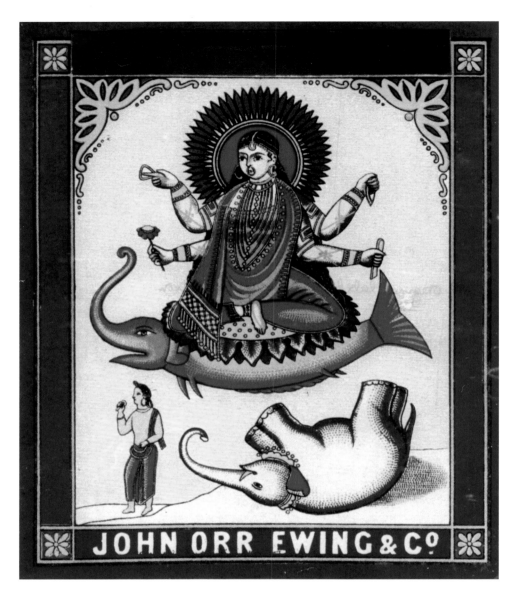

Plate 2.24 Label of John Orr Ewing & Co., for cloth destined for India by the Scottish calico printing firm. Photo: West Dunbartonshire Libraries & Cultural Services.

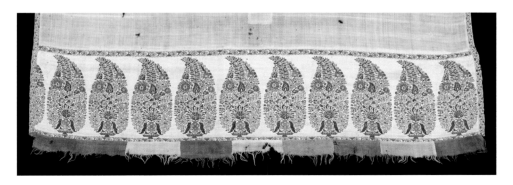

Plate 2.25 Kashmir shawl, c.1785–90, harlequin border added about 1840, cashmere twill tapestry, 117 × 279 cm. Museum of Fine Arts, Boston, Julia Bradford Huntington James Fund, museum no.: 04.269. Photo: © 2017 Museum of Fine Arts, Boston. All rights reserved/Scala, Florence.

Fig. 1. *c.*1680

Fig. 2. 1700–1730

Fig. 3. 1720–1750

Fig. 4. 1740–1770

Fig. 5. 1770–1800

Fig. 6. 1815 onwards

Fig. 7. 1820–1830

Fig. 8. 1850–1870

Plate 2.26 Composite drawing, development of the designs found on Kashmir shawls from *c.*1680 to 1870, from a semi-naturalistic single flower motif to the abstract teardrop shape that became known as 'Paisley' and was further stylised in the latter half of the nineteenth century. Adapted from the image at TextileAsArt. com: http://www.textileasart. com/exc_kash.htm (Accessed 13 October 2017). Individual motifs are from John Irwin, *The Kashmir Shawl*, London, Victoria and Albert Museum, 1973, pp. 11–14.

their firms could offer imitations for sale in London within eight days (Plate 2.27).[59]

The efforts of British manufacturers were also supported by Queen Victoria, who made Kashmir shawls she received as gifts available for copying and, fulfilling her patriotic duty, made it known that she was wearing 'Paisley' at public events.[60]

Paisley shawls soon saturated the British market. By 1850, the town had already gained such a reputation for its shawls that the famous *buta* design began to be referred to as 'Paisley'.[61] These developments muddied the waters about what constituted an 'authentic' Kashmir shawl, making it difficult or even impossible to differentiate between those produced in Kashmir and imitations of them, especially when the copies were also executed in *pashmina* (as in the case of some produced in France) rather than in cheaper, often mixed fibres (such as those typically produced in Paisley). The original product continued to be available, many shawls entering the country in the baggage of British memsahibs, who often sold them on visits home to finance their trip.[62] Nevertheless, manufacturers exploited the confusion resulting from the proliferation of imitation Kashmir shawls by marketing their products under the label of 'cashmere', even though they were not actually made of *pashmina*.[63] But where did these developments leave notions of tradition and authenticity?

References in British literature suggest that Paisley shawls were associated with the 'vulgar' consumerism of the lower classes, while the 'authentic' Kashmir shawl was considered not a 'mere' fashionable item, but a work of art representative of good taste and social status (even if in reality it was also a commodity).[64] 'Imitation shawls', which were deemed to be 'dishonest', also served as the mark of a deceitful woman dressing above her station. As these literary references show, what made the imitation shawls problematic was the risk they presented of visually blurring the distinction between upper and lower classes, since both the lady and her maid might be wearing shawls that looked, at first glance at least, nearly identical. It is, for example, impossible to tell whether the one seen in William Holman Hunt's portrait of his wife, Fanny, is a 'genuine' Kashmir shawl

or a much more affordable imitation from Paisley (Plate 2.28). The frequent appearance of this type of shawl as a status symbol in portraits has in fact prompted scholars to suggest that such pictures, along with fashion prints, may provide a way of tracing the development of Kashmir designs.[65]

However, it is also possible to find positive references to Paisley shawls. In 1852, for example, the abolitionist, feminist and author Harriet Martineau praised the British-made imitation shawl as a modern improvement because of the greater efficiency of its production when compared with shawls from Kashmir, thereby demonstrating the advanced character of European technology and hence, by implication, civilisation (though she did concede that the modern shawl could not compete with the Oriental original in excellence).[66] When the ideas of the Arts and Crafts Movement began to shape public opinion towards the end of the century, however, the value attached to the method of production was reversed, as hand-made shawls came to be considered superior to machine-produced ones.[67] Advocates of Indian crafts, such as Birdwood, Kipling and Havell regarded machine-made products as inherently defective by comparison with hand-made Indian equivalents. Thus, instead of being distinguished on the basis of the fibre out of which they were made, the shawls came to be valued on the basis of the method used in their production.

Here, the story of the Paisley shawl connects up with South Kensington's efforts to foster an approved notion of traditional Indian crafts. For the most part, however, and despite the institution's role in providing models for British manufacturers to copy, the story demonstrates that these efforts had little impact on markets which followed their own global agenda of profits, fashion and marketability. The story of the Paisley shawl thus stands as a case study that supports the agenda traced by McGowan, who, as noted above, has suggested that modern scholarship on Indian applied arts has been overly dominated by nineteenth- and early twentieth-century colonial attitudes, which were based on a conceptual separation of craft idealism and market economies. She seeks to challenge such perspectives by focusing instead on the economic dimension. To this end, she asks different questions

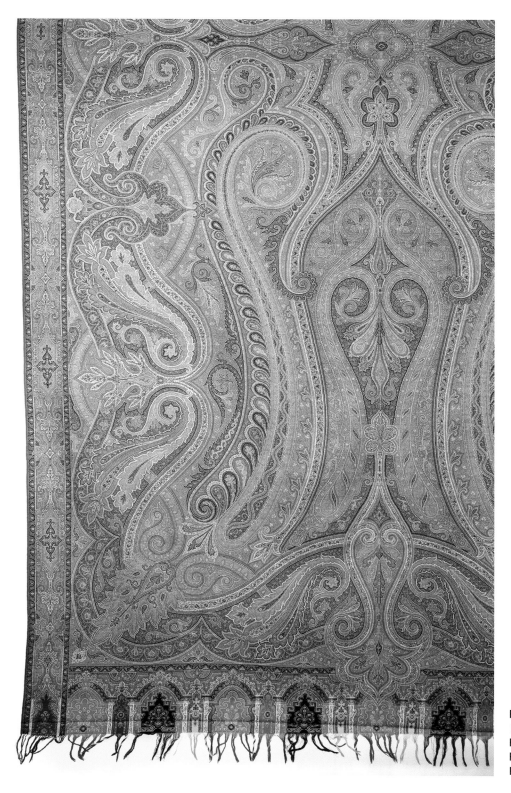

Plate 2.27 Paisley shawl,
1860–70s, Britain (Paisley).
Paisley Museum, Paisley.
Photo: © On licence from
Renfrewshire Council.

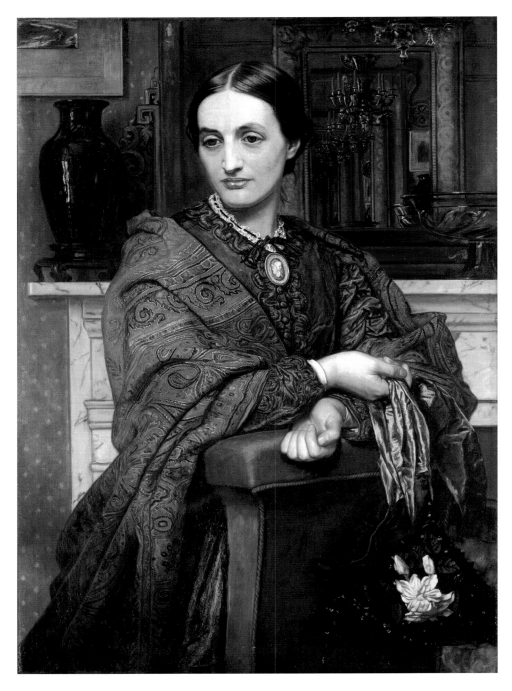

Plate 2.28 William Holman Hunt, *Fanny Holman Hunt*, *c*.1866, oil on canvas, 107 × 74 cm. Private collection. Photo: Bridgeman Images.

of historical documents and draws on alternative sources of information. This type of approach, often referred to as reading the archive 'against the grain', is a widespread strategy in gender and post-colonial studies. Edward Said's *Orientalism* is exemplary of this type of revisionist scholarship that challenges standard historical accounts.

Thus, in her work, McGowan offers a differenced perspective on Indian crafts. She emphasises that the 'British art officials who promoted traditional designs in India ... were only one small subset of a much larger group of people across colonial society engaged in redefining artisanal production'. [68] As she reveals, other groups, such as businessmen and missionaries, who

were not invested in design debates, pursued different agendas. Moreover, rather than being helpless victims of change, Indian craftsmen were not necessarily averse to innovation; producers of Kashmir shawls (and other Indian textiles such as chintz) had long adapted their designs to cater to export markets not only in Europe but also in South-East Asia and the Middle East, for example.[69] In the nineteenth century, many successfully negotiated the unequal market conditions created by colonial trade policies, as cheap mass-produced British goods flowed into India, tariff free, while Indian exports to Britain were subject to levies, though their ability to do so was significantly greater in urban rather than rural areas. Indian artisanal production was thus not the unified field that it was made out to be. The dominant image of timeless Indian village crafts obscured the real market conditions, thereby demonstrating the extent to which ideology and politics have shaped these histories.

Conclusion

This chapter has considered how the complex and contradictory interactions between Britain and India played out in the spheres of craft, design and display during the colonial period. It has demonstrated the crucial importance of Indian ornament for British design reform, the Arts and Crafts Movement and Anglo-Indian architecture as well as for colonial ideology. British approaches to Indian artefacts and design were, however, inherently contradictory. Indian design principles were harnessed in an abstract and rationalised form to ensure the competitiveness of British industrial production. Re-packaged as 'grammar', they were taught to both British and Indian artisans, albeit with different expectations: British craftsmen were prompted to produce modern decoration, while Indian artisans were instructed to create traditional Indian designs.

The insistence that Indian artisans should produce traditional designs was based on fantasies of craft production in idyllic villages, far removed from the actual social and economic contexts in India. The association of craft with the village was bound up with a conception of Indian backwardness, which supported the colonial project by legitimating British rule as essentially benevolent in character on the grounds that it (supposedly) helped India to advance. By contrast, the idealistic, anti-industrialist adherents of design

reform and, later, of the Arts and Crafts Movement hoped that Indian craft, once restored, would inspire social reform in Britain and thereby bring about a less dehumanising and industrialised way of life there.

Furthermore, it is worth noting that the anti-establishment ideals of the Arts and Crafts Movement functioned very differently in an imperial context from the way that they did in Britain. In India they were appropriated as a vehicle for colonial ideology, providing a convenient rationale for colonial officials not to support India's industrial progress, which entailed the risk of competition with British industry. Based as it was on a dual vision of 'village and progress', colonial ideology foregrounded the efforts of design idealists to rekindle traditional village life and craft production in India, and restricted the pursuit of 'progress' to contexts that served the colonial enterprise, such as the construction of the railway, the introduction of the telegraph or indigo factories.

As these histories demonstrate, ideas and cultural practices can acquire different meanings as they traverse cultural, geographical and/or political boundaries and are appropriated for different contexts. The role of craft in the Indian independence struggle is a further example here: English-educated Indian elites endorsed the colonialist notion that India's backward villagers needed guidance to sustain their traditions in the face of the 'corrupting' influence of British mass-produced goods, but claimed for themselves the right to provide such guidance. Although the artisans themselves had no voice in these debates, such claims further politicised Indian crafts, by aligning them with pro-independence agendas.[70] The Indian nationalist leader Mohandas Karamchand Gandhi (commonly known as Mahatma Gandhi), for example, harnessed the romanticised image of Indian crafts for India's independence struggle in the early twentieth century. Focusing on spinning as a unifying national activity, Gandhi appropriated the colonial notion of India as epitomised by village crafts for the nationalist movement, with the Indian artisan now serving as a symbol of the nation-state rather than that of British India (Plate 2.29).[71]

Thus, questions around Indian artefacts, craft and design in British India elicited a range of responses that entailed resistance to cross-cultural interactions, such as the British emphasis on 'traditional' Indian

Plate 2.29 Mahatma Gandhi sitting cross-legged, spinning cotton on a manual spinning wheel, 1925. Photo: Pictorial Press Ltd/Alamy.

design, together with efforts to block the adoption of British visual elements by Indian artisans. Accommodation, appropriation and re-negotiation, as evidenced by the re-inscription of British notions of Indian crafts for Indian nationalism as well as in Anglo-Indian architecture, were also evident in these encounters, and demonstrate that transcultural mediations apply to concrete cultural practices as well as the realm of ideas. Cultural practices and concepts, therefore, do not operate in a vacuum. They, rather, are context-specific and subject to reinterpretation and translation. Moreover, once they cross cultural boundaries, unruly processes of reinterpretation unfold that are difficult, if not impossible, to control.

Notes

[1] Conway, 1882, pp. 22–3.

[2] Dutta, 2004.

[3] Dutta, 2007, p. 3.

[4] Kriegel, 2007, p. 130.

[5] Cassell, 1851, pp. 317–19.

[6] Quoted in Ashmore, 2008.

[7] McGowan, 2009, p. 30.

[8] Jones, 1868 [1856], p. 82.

[9] Jones, 1868 [1856], p. 155.

[10] Jones, 1868 [1856], p. 77.

[11] Jones, 1868 [1856], p. 78.

[12] Jones, 1868 [1856], p. 154.

[13] Jones, 1868 [1856], p. 157.

[14] Jones, 1868 [1856], p. 2.

[15] Shelton and Levell, 1998, p. 16.

[16] Cardoso Denis, 2001, p. 54.

[17] Kantawala, 2012, pp. 208–13.

[18] Parker, 1987, p. 133; Burns, 1909, p. 636.

[19] Ruskin, 1905a, p. 261.

[20] Ruskin, 1905b, p. 307.

[21] Crinson, 1996, p. 60; Mann, 2011, pp. 72–3.

[22] Ashbee, 1909, p. xii.

[23] Hoffenberg, 2001, p. xiv.

[24] Cassell, 1851, p. 318.

[25] Spear, 2008, p. 913.

[26] Keith, 1886, p. 111.

[27] Swallow, 1998, p. 67.

[28] Hendley, 1886, p. 11.

[29] Mathur, 2007, p. 60; Briefel, 2017.

[30] *Colonial and Indian Exhibition: Official Catalogue*, 1886, p. 18.

[31] Dohmen, 2016.

[32] Tillotson, 2004, p. 116.

[33] Hendley, 1883, p. v.

[34] Tillotson, 2004, p. 126.

[35] Dutta, 2007, p. 14; Scriver, 2007, p. 88.

[36] Quoted in Scriver, 2007, p. 74.

[37] Scriver, 2007, p. 89.

[38] Mann, 2011, p. 75; Scriver, 2007, p. 88.

[39] Havell, 1907, pp. 126–37.

[40] Chopra, 2011, p. 61.

[41] London, 2003, p. 8.

[42] Chopra, 2011, p. 39.

[43] Chopra, 2011, especially pp. 73–113.

[44] Metcalf, 2005 [1984], p. 129.

[45] Metcalf, 2005 [1984], p. 122.

[46] Metcalf, 2005 [1984], pp. 132–6; Mann, 2011, p. 75.

[47] Sachdev and Tillotson, 2002, p. 107.

[48] Prakash, 1994, pp. 161–7.

[49] Hendley, 2017 [1888], p. 202.

[50] Quoted in Prakash, 1994, p. 185.

[51] Hendley, 1888, p. 45.

[52] Prakash, 1994, pp. 106–7.

[53] Chopra, 2016, p. 303.

[54] Zutshi, 2009, pp. 427–8.

[55] Zutshi, 2009, p. 422.

[56] Irwin, 1973, p. 20.

[57] Maskiell, 2002, p. 29; Irwin, 1973, p. 11.

[58] Ames, 2008; Irwin, 1973, p. 17.

[59] Irwin, 1973, p. 20.

[60] Blair, 1904, p. 26; Zutshi, 2009, p. 434; Maskiell, 2002, p. 50.

[61] Maskiell, 2002, p. 29.

[62] Zutshi, 2009, p. 423; Chaudhuri, 1992, pp. 234–6.

[63] Maskiell, 2002, pp. 45–8.

[64] Choudhury, 2015, pp. 195–7.

[65] Irwin, 1973, p. 15.

[66] Zutshi, 2009, pp. 434–5.

[67] Maskiell, 2002, p. 42.

[68] McGowan, 2009, p. 9.

[69] Zutshi, 2009, 423–4; Irwin, 1973, p. 13.

[70] McGowan, 2009, pp. 7–8.

[71] Mathur, 2007, pp. 29, 46–51.

Bibliography

Ames, F. (2008) 'Woven legends: carpets and shawls of Kashmir (1585–1870)', in Ames, F., Digby, S., Siudmak, J., Larsen, G. J. and Pratapaditya, P. (eds) *The Arts of Kashmir*, Milan, Five Continents Editions, pp. 192–211.

Ashbee, C. R. (1909) 'Foreword', in Coomaraswamy, A. K. (ed.) *The Indian Craftsman*, London, Probsthain, pp. v–xv.

Ashmore, S. (2008) 'Owen Jones and the V&A Collections', *V&A Online Journal*, no. 1, autumn [Online]. Available at http://www.vam.ac.uk/content/journals/research-journal/issue-01/owen-jones-and-the-v-and-a-collections/ (Accessed 13 October 2017).

Blair, M. (1904) *The Paisley Shawl and the Men who Produced it; A Record of an Interesting Epoch in the History of the Town*, Paisley, Alexander Gardner.

Briefel, A. (2017) 'On the 1886 Colonial and Indian Exhibition', *BRANCH: Britain, Representation and the Nineteenth-Century History* [Online] Available at http://www.branchcollective.org/?ps_articles=aviva-briefel-on-the-1886-colonial-and-indian-exhibition (Accessed 1 November 2017).

Burns, C. L. (1909) 'The functions of Schools of Art in India', *Journal of the Royal Society of Arts*, vol. 57, no. 2952, pp. 629–50.

Cardoso Denis, R. (2001) 'An industrial vision: the promotion of technical drawing in mid-Victorian Britain', in Purbrick, L. (ed.) *The Great Exhibition of 1851: New Interdisciplinary Essays*, Manchester, Manchester University Press, pp. 53–78.

Cassell, J. (1851) 'India and Indian contributions to the industrial bazaar', *Illustrated Exhibitor*, vol. 18, 4 October, pp. 317–36.

Chaudhuri, N. (1992) 'Shawls, jewelry, curry, and rice in Victorian Britain', in Chaudhuri, N. and Strobel, M. (eds) *Western Women and Imperialism: Complicity and Resistance*, Bloomington, IN and Indianapolis, IN, Indiana University Press, pp. 231–46.

Chopra, P. (2011) *A Joint Enterprise: Indian Elites and the Making of British Bombay*, Minnesota, MN, University of Minnesota Press.

Chopra, P. (2016) 'South and South East Asia', in Bremner, G. A. (ed.) *Architecture and Urbanism in the British Empire*, Oxford, Oxford University Press, pp. 278–317.

Choudhury, S. (2015) '"It was an imitashon to be sure": the imitation Indian shawl in design reform', *Textile History*, vol. 46, no. 2, pp. 189–212.

Colonial and Indian Exhibition: Official Catalogue (1886) London, William Clowes & Sons Limited.

Conway, M. D. (1882) *Travels in South Kensington: With Notes on Decorative Art and Architecture in England*, New York, Harper & Brothers.

Crinson, M. (1996) *Empire Building: Orientalism and Victorian Architecture*, London and New York, Routledge.

Dohmen, R. (2016) 'A fraught challenge to the status quo: the 1883–84 Calcutta International Exhibition, conceptions of art and industry, and the politics of world fairs', in Nichols, K., Wade, R. and Williams, G. (eds) *Art Versus Industry? New Perspectives on Visual and Industrial Cultures in Nineteenth-Century Britain*, Manchester, Manchester University Press, pp. 199–216.

Dutta, A. (2004) 'The South Kensington Juggernaut', *Oxford Art Journal*, vol. 27, no. 2, pp. 241–5.

Dutta, A. (2007) *The Bureaucracy of Beauty*, London and New York, Routledge.

Havell, E. B. (1907) 'Art and education in India', in Havell, E. B. (ed.) *Indian Art, Industry and Education*, Madras, G. A. Natesan & Co., pp. 126–37.

Hendley, T. H. (1883) *Memorials of the Jeypore Exhibition, Volume 1: Industrial Art*, London, W. Griggs.

Hendley, T. H. (1886) *London Indo-Colonial Exhibition of 1886: Handbook of the Jeypore Courts*, Calcutta, Calcutta Central Press.

Hendley, T. H. (1888) 'Decorative art in Rajputana', *The Journal of Indian Art and Industry*, vol. 2, no. 21, pp. 45–9.

Hendley, T.H. (2017 [1888]) 'The opening of the Albert Hall and Museum in Jeypore', in Newall, D. (ed.) *Art and its Global Histories: A Reader*, Manchester and Milton Keynes, Manchester University Press in association with The Open University, pp. 202–3.

Hoffenberg, P. H. (2001) *An Empire on Display: English, Indian, and Australian Exhibitions from the Crystal Palace to the Great War*, Berkeley, CA, University of California Press.

Irwin, J. (1973) *The Kashmir Shawl*, London, Victoria and Albert Museum.

Jones, O. (1868 [1856]) *The Grammar of Ornament*, London, Bernard Quaritch.

Kantawala, A. (2012) 'Art education in colonial India: implementation and imposition', *Studies in Art Education*, vol. 53, no. 3, pp. 208–22.

Keith, J. B. (1886) 'Indian stone carving', *Journal of Indian Art*, vol. 1, no. 14, pp. 110–12.

Kriegel, L. (2007) *Grand Designs: Labor, Empire, and the Museum in Victorian Culture*, Durham, NC, Duke University Press.

London, C. (2003) *Bombay Gothic (India)*, Mumbai, India Book House.

Mann, M. (2011) 'Art, artefacts and architecture: Lord Curzon, the Delhi Arts Exhibition of 1902–03 and the improvement of India's aesthetics', in Watt, C. A. and Mann, M. (eds) *Civilizing Missions in Colonial and Postcolonial South Asia: From Improvement to Development*, London, Anthem Press, pp. 65–90.

Maskiell, M. (2002) 'Consuming Kashmir: shawls and empires, 1500–2000', *Journal of World History*, vol. 13, no. 1, pp. 27–65.

Mathur, S. (2007) *India by Design: Colonial History and Cultural Display*, Berkeley, CA, University of California Press.

McGowan, A. (2009) *Crafting the Nation*, New York, Palgrave Macmillan.

Metcalf, T. (2005 [1984]) 'Architecture and the representation of empire: India, 1860–1910', in Metcalf, T. (ed.) *Forging of the Raj: Essays on British India in the Heyday of Empire*, Oxford, Oxford University Press, pp. 105–39.

Parker, S. (1987) 'Artistic practice and education in India: a historical overview', *Journal of Aesthetic Education*, vol. 21, no. 4, pp. 123–41.

Prakash, V. (1994) 'Productions of identity in (post) colonial "Indian" architecture: hegemony and its discontents in 19th century Jaipur', unpublished PhD thesis, Ithaca, NY, Cornell University.

Ruskin, J. (1905a) 'The two paths, lecture 1: "The deteriorative power of conventional art over nations. A Lecture delivered at the Opening Meeting of the Architectural Museum, South Kensington Museum, January 13, 1858"', in Cook, E. T. and Wedderburn, A. (eds) *The Complete Works of John Ruskin*, vol. 16, London, George Allen, pp. 259–92.

Ruskin, J. (1905b) 'The two paths, lecture 2: "The unity of art. Part of an address delivered at Manchester, February 22nd, 1859"', in Cook, E. T. and Wedderburn, A. (eds) *The Complete Works of John Ruskin*, vol. 16, London, George Allen, pp. 293–318.

Sachdev, V. and Tillotson, G. (2002) *Building Jaipur: The Making of an Indian City*, London, Reaktion Books.

Scriver, P. (2007) 'Empire-building and thinking in the Public Works Department of British India', in Prakash, V. (ed.) *Colonial Modernities: Building, Dwelling and Architecture in British India and Ceylon*, London and New York, Routledge, pp. 69–92.

Shelton, A. A. and Levell, N. (1998) 'Text, illustration and reverie: some thoughts on museums, education and new technologies', *Journal of Museum Ethnography*, vol. 10, pp. 15–34.

Spear, J. L. (2008) 'A South Kensington gateway from Gwalior to nowhere', *Studies in English Literature*, vol. 48, no. 4, autumn, pp. 911–21.

Swallow, D. (1998) 'Colonial architecture, international exhibitions, and official patronage of the Indian artisan: the case of a gateway from Gwalior in the Victoria and Albert Museum', in Barringer, T. and Flynn, T. (eds) *Colonialism and the Object: Empire, Material Culture and the Museum*, London and New York, Routledge, pp. 52–67.

Tillotson, G. (2004) 'The Jaipur Exhibition of 1883', *Journal of the Royal Asiatic Society*, vol. 14, no. 2, pp. 111–26.

Zutshi, C. (2009) '"Designed for eternity": Kashmiri shawls, empire, and cultures of production and consumption in mid-Victorian Britain', *Journal of British Studies*, vol. 48, no. 2, pp. 420–40.

Chapter 3

Photography in colonial India

Steve Edwards

Introduction

Photography appeared in India almost immediately after its invention was announced in Europe in 1839. In that year the *Bombay Times* carried a long account of the photographic process recently developed by the French artist Louis-Jacques-Mandé Daguerre; the invention was also discussed at the Asiatic Society in Calcutta. The following year photographs were on display in Calcutta and, according to one newspaper report, portraits were being taken in Bengal. The Photographic Society of Bombay (PSB) was founded in 1854 (of its 13 founder members, three were Indian) and by 1855 it had 250 members. Other societies of the same type soon developed in Calcutta and Madras. Initially, these groups were the preserve of gentlemanly amateurs; the Bombay society, for example, produced a publication entitled *Indian Amateurs' Photographic Album* (1856–58). By then, however, many commercial studios had already been established in Indian cities, and Indians also began to work as photographers. Soon, moreover, professionals from Britain started to travel to India to undertake camera tours, producing images for a range of clients: the colonial administration, the press, the British middle class (in both India and in the UK) and elite Indian patrons. Towards the end of the nineteenth century, when photographic technology became cheaper and easier to use, more and more amateurs recorded their experiences in albums of pictures.

These photographers between them produced a plethora of images. As with much of the emerging mass media in the nineteenth century, this was a culture of novelty centred on depicting unusual events or things. Photographers strove to take the first picture of a royal visit, a famine or an ancient monument. They made pictures of Indian architecture, temples and other historic sites; photographs of Indian 'types'; images celebrating the pageantry of the Raj and portraits of important personages, both British and Indian. Until it became possible to reproduce photo-mechanical images at the end of the nineteenth century, these pictures were often used as the basis for engravings in the illustrated press, which constituted one of the main mass-media innovations of the century; periodicals, such as the *Illustrated London News*, combined reporting with a new genre of documentary-style engravings, often based on photographs (see Plate 3.11). These reproductions would have been seen by many more people than the photographs themselves. Other images were published in commercially produced albums or sold as single items to be pasted into albums. From the end of the century, photo-postcards were produced and circulated with increasing popularity (Plate 3.2). All of these images contributed to building an image of India.

The photographs that will be discussed in this chapter represent particular points of view, both literally and metaphorically. The evidentiary nature of photography often leads to these images being viewed uncritically, as if they were direct or truthful representations of reality; it is almost as though a photograph is not a picture, but a slice of the world. This naturalist fallacy applies even to engravings in the popular journals

Plate 3.1 (Facing page) *Madras Beach during the Famine* (detail from Plate 3.12).

Akbars Tomb, Sekundra-Agra.

Plate 3.2 Postcard of Emperor Akbar's tomb, Sekundra-Agra, *c.*1908. Unknown photographer.

based on photographs, which were viewed as more reliable evidence than other illustrations or witness statements. Writing in a familiar colonial mode, Norman Cheevers, secretary to the Medical Board in Calcutta, commented on the 'untrustworthiness of native evidence in India'.[1] In contrast, he believed that photographs provided reliable evidence. As John Thompson, a photographic instructor at the Royal Geographical Society put it in 1891, 'photography is absolutely trustworthy'.[2] Yet, only by questioning the truthfulness of photographs is it possible to understand the ways in which they were placed in the service of other forms of ideology, including colonial ideology. Popular belief in the veracity of photographs played an important role in creating for nineteenth-century India what the critic of colonialism Edward Said called an 'imaginative geography'. That is to say, photographs spotlight particular places, people and events, while overlooking others. In this way, photographs populated a map of an unknown and alien territory, elevating some locations and actions, while rendering others invisible.[3]

All of the photographs taken in nineteenth-century India were made in the context of British colonialism and were, in some way or another, marked by imperial history and ideology. This chapter will look at a range of these photographs, but makes no attempt at a comprehensive survey of photography

in colonial India. What follows are a series of snapshots intended to give a sense of the diverse ways in which photographs served, and sometimes undercut, the British colonial project in India. This leads to a second point that will be addressed here, one that has been raised by post-colonial historians and critics, particularly those associated with the Subaltern Studies approach. These critics suggest that what representations of colonial subjects reveal is the racialised ideological purview of the colonialist, rather than an Indian perspective. Here, I largely follow this line of argument, but suggest that there are moments when alternative systems of belief register as disturbances in the archival records and disrupt the smooth working of ideology, allowing other experiences to seep into the official record.[4]

1 Samuel Bourne's views of India

In this section, I want to consider some aspects of pictorial negotiation in the 'contact zone' of British India. As the photographic historian Elizabeth Edwards suggests, this zone is characterised by 'cultural confrontation, negotiation and brokerage', and reflects the dynamics of the political and economic aspects of this colonial encounter.[5] The question to be addressed is this: to what extent were existing representational conventions renegotiated by photographers? The

Maharaja Motisingjee Chotta OOdepoor

baggage they carried involved more than their bulky apparatus; it also included artistic norms and social preconceptions about India and its peoples. The photographers of the nineteenth century worked with existing models of image-making. In India, this meant imposing Western norms, artistic and social, onto a very different cultural scenario.

Landscape photographs, for example, depicted an Indian Arcadia, a pastoral idyll of sunny ease based on a classicising vision. Similarly, portraits were made employing the backdrops, props and poses from Western studios (Plate 3.3, see also Introduction, Plate 0.10). Nineteenth-century portrait photography was really a continuation of eighteenth-century

precedents, adapted for the middle-class market. This practice was exported to India; there is something incongruous about seeing Indian people assuming classical poses against Italianate landscapes. Interestingly, the portrait image was one art form that proved amenable to translation into an Indian cultural idiom. The application of colour was sometimes done in a way that brought the familiar mode of Indian miniatures, with flat areas of colour and highly decorative surfaces, to bear on photographs (Plate 3.3; see also Introduction, Plate 0.13).[6]

In such portraits, there is evidence of some mediation between different cultural traditions and expectations, but I want to focus on landscape photographs made by Samuel Bourne. Several photographers, including Dr John Murray and Philip Henry Egerton, toured India, making topographical views, but Bourne's images occupy a far more prominent place in photographic history. The later partnership of Bourne and Shepherd would become the pre-eminent supplier of photographic mementos of India; it is described by the literary scholar and post-colonial critic Zahid Chaudhary, in a stimulating book on photography in colonial India, as representing 'every aspect of the Raj in its most idealized dreams of itself'.[7] During the 1860s, Bourne made several photographic journeys through India, producing thousands of acclaimed landscape images (Plate 3.4). He also published accounts of these tours in a series of articles in the *British Journal of Photography*. Although Bourne's landscape work features prominently in photographic history, only recently have critics begun to ask what kind of vision of India his pictures present.

At the time, making photographs outside the studio was a difficult business: the apparatus was cumbersome, materials both fragile and volatile, and plates had to be processed immediately after exposure or they lost sensitivity. Bourne was an accomplished technician working in a difficult environment. It is worth registering, however, that making images like these wasn't simply a technical matter; it depended on the networks established by colonial bureaucracy, including the army, railways and telegraph. Bourne's own accounts of his work emphasise the extreme effort and physical hardship that he faced in creating these spectacular views. Difficulty and duress are central to his narratives, authenticating his points of view. Of

course, Bourne did not actually lug his apparatus up the mountainside; as he acknowledged, he employed a 'retinue of thirty coolies carrying cameras, chemicals, tents, bedding, provisions, etc.'.[8] Sometimes too he expressed sympathy for the poor who were subject to the 'misrule' of Indian elites. Yet his published memoirs are full of disparaging comments about them. He beat with a stick those who would not work, deprived whole villages of their food to feed his own 'coolies' and complained in one such account of hearing nothing spoken but 'barbarous Hindustani'.[9] Bourne's narratives of his journeys oscillate between an aloof distaste for Indians and Christian awe at the landscape as a sign of God's immensity and power.

Bourne clearly held derogatory opinions with regard to Indian people, but did these views affect the way he depicted the landscape? Bourne stated that he preferred the English landscape to the views he found in India; scenery in England, he thought, was more varied and harmonious and, therefore, superior to that anywhere else. Nevertheless, Bourne evidently discovered something of what he was looking for in Kashmir and the Himalayas, where he travelled extensively, taking many photographs (see Plate 3.5, for example). He would have liked, he said, 'to transport English scenery under these exquisite skies'.[10] Yet, as the cultural geographer James Ryan suggests, Bourne approached such prospects by 'imposing the aesthetic contours of "English scenery" onto foreign environments', thereby 'familiarizing and domesticating a potentially hostile landscape'.[11] The claim here is that Bourne was overlaying British ways of seeing landscape onto an alien terrain. My point is not to present Bourne as a singular villain, not least because his work fits into a long tradition of travelling artists who depicted Indian landscapes, such as William Hodges and Thomas and William Daniell; the aim here is rather to look at the way in which this cultural tradition informs his work.

The obvious artistic mode for the translation of Indian landscape, particularly the Himalayas, into a British idiom is the sublime mode. Since the eighteenth century, the 'sublime' has been the standard term for characterising pictures that offer an experience of awe through physical immensity, conjuring up vast forces beyond our control, which imaginatively threaten our destruction. Rendered in pictorial form, however,

Plate 3.4 *Picturesque Bridge over the Rungnoo below Ging, Darjeeling*, *c.*1869. Photographed by Samuel Bourne. Royal Photographic Society. Photo: © SSPL/Getty Images.

this threat can be viewed from a safe distance at exhibitions or at home. The effect of the sublime is thus somewhat akin to that of contemporary horror movies. Another eighteenth-century aesthetic mode that remained popular throughout the nineteenth century, especially in photography, was the picturesque, a key term for Bourne. Often associated with tranquilly beautiful scenery, the picturesque has more specific connotations of wildness, roughness and irregularity. As such, it is not wholly distinct from the sublime. The anthropologist Christopher Pinney, the literary scholar Sandeep Banerjee and the art and design historian Gary D. Sampson all claim that Bourne produced picturesque views; the photographic historian Rahaab Allana employs the terms 'sublime' and 'picturesque' interchangeably for Bourne's scenes, while Chaudhary refers to the sublime in the context of discussion of picturesque practice.[12] All, though, seem to agree that Bourne's landscape views are shaped by picturesque priorities. As one writer has observed: 'Bourne carefully selected scenes and camera angles, ultimately depicting the Himalayas as a compliant and serene landscape, waiting to be

recorded for the camera.'[13] *Picturesque Bridge over the Rungnoo below Ging, Darjeeling* (Plate 3.4), made in Kashmir, for example, represents a charming scene, with a typically picturesque emphasis on the irregular, which poses no threat to the viewer.

Commentators have noted that this visual 'taming' of a threatening India does not really accord with Bourne's travel journals, which repeatedly demonstrate a palpable unease and discomfort in the face of both the vastness of the Himalayas and his recalcitrant baggage carriers.[14] In my view, Chaudhary offers the best solution to this mismatch, suggesting that Bourne translates the sublime landscape and associated fear of Indian people into a picturesque view, transforming terror into the pretty prospect.[15] In this manner he is able to displace his fears and render the landscape in an appealing and saleable form. This is, though, an interpretation and you may disagree. What is important is to recognise that Bourne's photographs are not objective records, and that he translated the Indian landscape according to the terms of Western pictorial traditions.

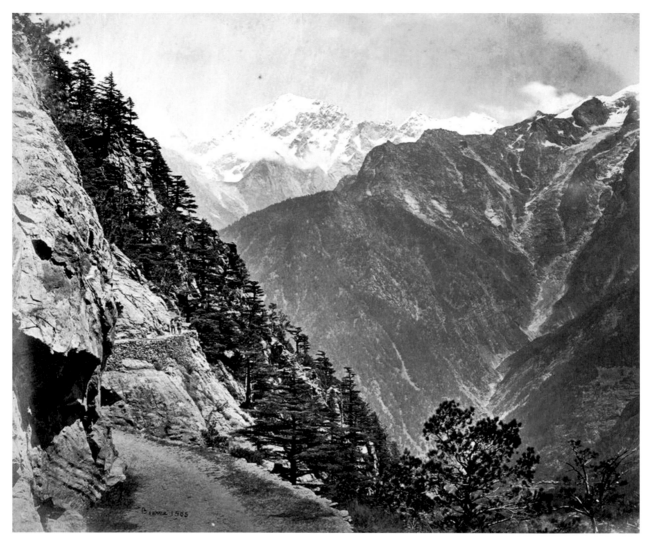

Plate 3.5 *The New Road Near Rogi – Chini Mountains in the Distance*, 1866. Photographed by Samuel Bourne. Photo: © The Hugh A. Rayner Collection, www.indiaphotographs.co.uk.

Exercise

Examine Samuel Bourne's *The New Road Near Rogi – Chini Mountains in the Distance* from 1866 (Plate 3.5) and explore which of the image features relate to the sublime, and which are representative of the picturesque. (It might also be helpful to refer back to the discussion of the picturesque on pp. 45–6.)

Discussion

In this image Bourne presents a view of the Himalayas. He has chosen an unusual viewpoint that emphasises the immensity of the mountains. The photograph positions the viewer as a traveller, with a clear view of the path ahead that perilously clings to the steep side of the mountain with a deep precipice to the right, highlighting the precariousness and arduousness of the journey. The path is headed towards a mass of dark fir trees that cuts across the image, creating a stark diagonal from the top left of the image to just beyond its mid-point, adding visual drama. It acts as a barrier that separates the traveller from the mountain ranges in the distance. It also frames and contains the mountain that lies behind it, creating a further, if less dramatic, diagonal line from the left to the top right of the image that acts

as a frame for the expanse of sky. The image therefore is structured by two internal frames: the first one to the left contains the immensity of the mountain behind, and together with the one on the right reins in the potentially limitless sky. Thus 'double-framed', the photograph 'tames' the vastness of the Himalayas while underscoring the size of the mountain and the dangers it harbours. This neutralises the potential threat posed by the mountain without, however, diminishing its awe-inspiring immensity. In other words, the image combines elements of the sublime, such as the viewpoint that emphasises the overwhelming scale of the mountain, with elements of the picturesque, such as the use of asymmetrical framing, that render the sublime experience of viewing this mountain safe.

To depict India as sublime involved a Westernising perspective, yet doing so still posed a challenge to the British viewer, suggesting something wild, immense and uncontrollable (though always from the safe space of viewing a picture). In contrast, picturesque views tend to domesticate the land and cast India as a colonial extension of the English landscape, rendering the alien scene reassuring and familiar. These techniques were in line with the planting of hill stations with European flora, laid out in the English style. Hill stations (and the reference to hills and not mountains is revealing) were the sites of administration and residence to which the British withdrew when the plains became stiflingly hot.

Bourne's picturesque photographs, like most colonial views, enact an imaginative geography. That is to say, they represent a way of seeing and understanding that is less about the place itself than about its role in fantasy or ideology. It involved a sort of visual mastery of the landscape, screening out the natives, or presenting them as picturesque staffage in such a way as to add a suitably exotic yet unthreatening touch to a scene. In this way, his photographs obscure the people, such as the coolies, who made them possible, presenting a scene of harmony and unity. Bourne's landscapes often offer an omnipotent point of view that imaginatively neutralises any serious risk or challenge, while also showing tantalising glimpses of the thrill of sublime terror.

2 Horror and sympathy

Rebellion

Some people involved in the colonial project thought India was destined to become a modern metropolitan society: industrious and prosperous. However, this vision of India's future as an extension of industrial Britain with exotic colour was probably a minority view. The British colonial establishment for the most part promoted the notion of an Indian economy based on traditional handicrafts that needed to be revived, or even reinvented, in order to bring about a slow, steady and peaceful path to 'progress' under British guidance. This vision conceived of India as a supplement to the British economy rather than as a competitor, and framed India's development as improvement rooted in the past. In this section I am going to look at some events that disturbed this conception of progress under British rule. Photographs draw their meanings from the situations in which they circulate and this section will be dealing with colonial fantasies as much as with historical events. Principally, you will be looking at images of the Indian Rebellion of 1857 and the Madras famine of the 1870s as moments of disjuncture that shook the paradigm of India's betterment under British rule. A word of warning before you continue: you may find some of the images in this section disturbing.

Probably no event prior to the Irish Easter Rising of 1916 troubled the British imperial mission as much as the Indian Rebellion of 1857 (the British called it a 'mutiny'; in India it is sometimes called the 'First War of Independence'). Although sepoys played a central role in the rebellion, it was by no means exclusively confined to them but drew in wide sections of the population, certainly in the northern parts of India. The revolt began in Meerut, a military station about 70 kilometres north-east of Delhi, but rapidly engulfed northern and western India. By 1858 the rising had been brutally repressed. In the rebellion and its suppression, atrocities were undoubtedly committed on both sides: British people, including women and children, alive and dead, were thrown into a well in Cawnpore and stories – now thought to be exaggerated – of the rape of European women created a wave of intense British horror. The retaliation was ferocious, wiping out areas thought to harbour rebels; there were mass executions of prisoners and large-scale sexual terror was perpetrated on Indian

Plate 3.6 Pages from *An Illustrated Historical Album of the Rajas and Taaluqdars of Oudh*, 1880, albumen prints, 25 × 17 × 4 cm. Photographed by Darogha Haji Abbas Ali. The Alkazi Collection of Photography, ACP: 96.20.0404.2. Used with permission.

women. As is often the case in such conflicts, stories of atrocity on the other side serve to justify horrific reprisals. The enemy comes to be seen as less than human. General Neill, one of the senior British officers at the siege of Cawnpore, wrote that when a rebel leader was caught, before summary execution, he was forced to clean up 'a portion of a pool of blood, still two inches deep. He added: 'To touch blood is most abhorrent to the high-caste natives. They think, by doing so, they doom their souls to perdition. Let them think so. My object is to instill a fearful punishment for a revolting, cowardly, barbarous deed'.[16] In this account, the 'barbarous deed' of the Indian rebel acts as justification for a reign of terror. The captive is broken – subjected to violence and abjection – before execution.

While there are many images surrounding the events of 1857, there are no photographs of the rebellion as it unfolded. A photographer, James William Newland, was among those killed, reportedly having been 'mutilated with great barbarity', but Newland was travelling, rather than making pictures, at the time.[17] European photographers were hardly welcome in the middle of an anti-British uprising and, in any case, the technology was cumbersome and slow; it wasn't

suited for capturing dynamic events. The pictures that exist were made after the event as part of the struggle to control meaning and define memory. Exemplary in this respect are portraits commemorating those who remained loyal to the British, as in the case of *An Illustrated Historical Album of the Rajas and Taaluqdars of Oudh* (1880) by the engineer and photographer Darogha Haji Abbas Ali, which consists of 344 portraits of loyalist landlords, including individuals who had received land confiscated from those involved in the rebellion. It was offered to them by the colonial administration as a tribute to their support during the rebellion, with the aim of consolidating their allegiance (Plate 3.6).[18] Portraits could also be used to the opposite effect; earlier portraits of the Indian elite who supported the rebels were republished in accounts offering moral warnings about the dire consequences of treachery.

Although there are no pictures of the events as they happened, so-called 'aftermath' images were made after the fact at sites of significance for the rebellion. Often they contain few, if any, signs of the conflict. These photographs do not depict 'action', but draw their meanings from association with important

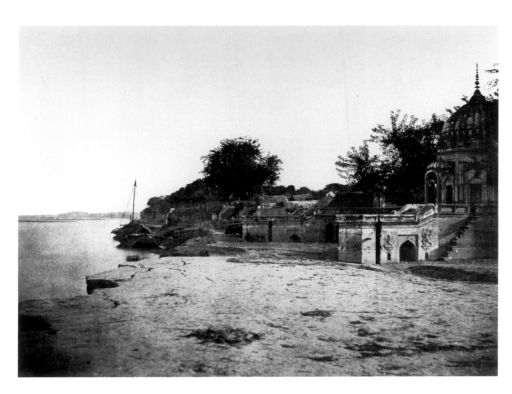

Plate 3.7 *Slaughter Ghat, Cawnpore*, 1858. Photographed by Harriet and Robert Tytler. The British Library, London, shelfmark: Photo 193/ (20). Photo: © The British Library Board.

episodes and significant places. The calm, still character of these images seems to charge them with poignancy. The absence can make them compelling, calling for intense scrutiny as, for instance, in *Slaughter Ghat, Cawnpore*, taken by the military officer, naturalist and photographer Robert Tytler and his wife Harriet, who made a name for herself as a photographer and for her accounts of the Indian Rebellion (Plate 3.7). In the photograph, buildings, trees and a boat are pushed to the middle distance. It presents – unusually for an image of this period – a largely empty foreground. This spot had been the site of a traumatic event. British escapees boarded barges with the permission of a rebel leader in the belief they would be allowed to leave, but as they set off they were shot at and most were killed. With this knowledge in mind, it is difficult not to see the cracks and dark patches in the soil as ominous marks of events, as stains and bodily traces. Such images encourage the viewer to engage in acts of imaginative projection; looking is informed by what you know.

Photographs like these are significant in the 'imaginative geography' of British colonialism. For decades the name of Cawnpore, slaughter ghat, the diving well and other key scenes of the insurrection

were better known to most British people than some major Indian cities. More people visited the monument erected at Cawnpore than went to the Taj Mahal. Images of these places, combined with reports and memoirs, lodged in popular memory as a kind of *idée fixe* or constant reiteration, serving both as the mark of a trauma and as justification for colonial violence (Plate 3.8).[19] By extracting particular episodes from the wider story, these images play their part in blocking history and freezing memory. One might even say that Bourne's landscape photography was a response to the shock of 1857.

The very absence of signs of the rebellion or the slaughter associated with it invoked a prevailing sense of dread. This sense had to do not only with the loss of life, but also with a loss of innocence. The empire was haunted by the events of 1857, by the fear that, underneath the everyday calm and order, the natives were sharpening knives, secretly intent on mayhem. Lurid journalism, panorama displays, exhibitions, memoirs and popular histories surrounded and framed these events, at least until the trauma of the First World War displaced this difficult scene. In this respect, these images play a significant role in what Chaudhary calls 'mutiny

Copyright Secured.] [Entered at Stationers' Hall.

PREPARING FOR IMMEDIATE PUBLICATION BY SUBSCRIPTION,

BY

H. HERING,

Photographer, Printseller, and Publisher to the Queen,

137 REGENT STREET, LONDON,

A MAGNIFICENT COLLECTION OF

PHOTOGRAPHIC VIEWS AND PANORAMAS,

TAKEN BY SIGNOR F. BEATO,

During the Indian Mutiny in 1857-58, and the late War in China,

OF

LUCKNOW, CAWNPORE, DELHI, AGRA, BENARES, & PUNJAB,

HONG-KONG, THE PEIHO FORTS,

PEKIN, THE SUMMER PALACE, AND CANTON,

ALSO,

PORTRAITS OF THE CELEBRITIES ENGAGED DURING THE MUTINY IN INDIA AND THE LATE WAR IN CHINA.

Size of each View 12 inches by 10. The whole of the Photographs will be delivered unmounted.

SINGLE VIEWS CAN BE HAD FOR 7s. EACH.

INDIA.

1st SERIES—LUCKNOW AND CAWNPORE	61 VIEWS	£18 6 0	
2nd „ DELHI	69 „	21 14 0	
3rd „ AGRA AND BENARES	29 „	8 14 0	
4th „ PUNJAB	19 „	5 14 0	
	COMPLETE	£54 8 0	

CHINA.

1st SERIES—FROM HONG-KONG TO PEKIN, including the PEIHO FORTS	54 VIEWS	£16 14 0	
2nd „ FROM PEKIN TO CANTON	69 „	20 14 0	
	COMPLETE	£37 8 0	

PORTRAITS OF THE CELEBRITIES, SIX SHILLINGS EACH.

INDIA.

LUCKNOW AND CAWNPORE (First Series).—SIXTY-ONE VIEWS.

⁎⁎⁎ The absent numbers have been omitted, the Views not being considered of sufficient interest.

A Panorama of Lucknow, taken from the Kaiser Bagh Palace, 1858. *(In six pieces.)*

B Panorama of Lucknow, taken from the great Emaumbara, 1858. *(In six pieces.)*

1 Two Sepoys of the 31st Native Infantry, who were hanged at Lucknow, 1857.

3 The Dilkoosha Palace.—First Attack of Sir Colin Campbell in November, 1857; Second Attack, 2nd March.

4 The Martiniere School.—First Attack of Sir Colin Campbell in November, 1858; Second Attack, 2nd March.

5 Bridge of Boats over the Goomtee crossed by Sir James Outram at the Capture of Lucknow.

6 The Martiniere Braysyer's Sikhs.—The First Attack of Sir Colin Campbell in November, 1857; Second Attack in March.

7 Banks' House.—First Attack of Sir Colin Campbell in November, 1857; Second Attack on the 2nd of March, 1858.

8 Battery near the Begum Kotie.—Second Attack of Sir Colin Campbell in March, 1858.

9 The Begum Kotie.—Second Attack of Sir Colin Campbell in March, 1858.

11 Gateway of the Small Emaumbara.—Second Attack of Sir Colin Campbell in March, 1858.

12 The Secundra Bagh, showing the breach and gateway.—First Attack of Sir Colin Campbell in November, 1857.

13 Interior of the Secundra Bagh after the slaughter of 2,000 rebels by the 93rd Highlanders and 4th Punjab Regt.—First Attack of Sir Colin Campbell in November, 1857.

15 The Shah Mujjuf.—The First Attack of Sir Colin Campbell in November, 1857.

18 The Mess-house, showing the Fortifications.

19 The Motee Mahal.—First Attack of Sir Colin Campbell in November, 1857.

Plate 3.8 Page from sale catalogue for *Photographic Views and Panoramas, Taken by Signor F. Beato During the Indian Mutiny in 1857–58, and the Late War in China …*, 1860, publisher Henry Hering. The British Library, London, shelfmark: Photo 6/(13). Photo: © The British Library Board.

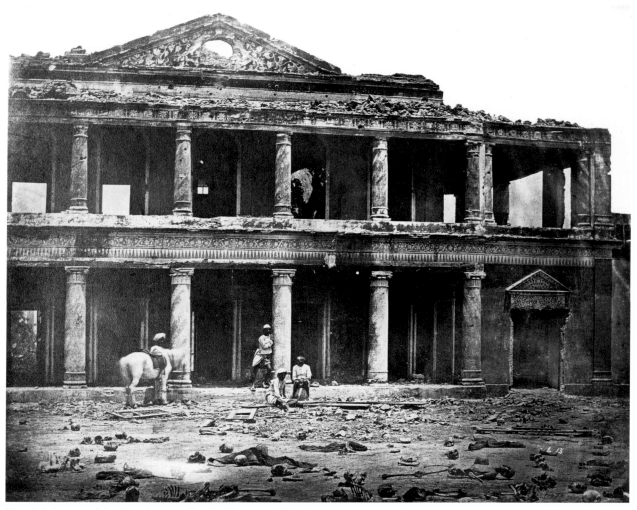

Plate 3.9 *Interior of the Sikanderbagh after the Massacre*, 1858, albumen silver print, 24 × 29 cm. Photographed by Felice Beato. The J. Paul Getty Museum, object number: 84.XO.421.13. Digital image courtesy of the Getty's Open Content Program.

memoirs', evoking fear, fascination and fantasy. In this imaginative geography, banal images constantly recall the horrors perpetrated against women and children, who embody British innocence. Gender plays a central role in this racialising dynamic. In Victorian ideology, middle-class women stood for the domestic virtues of piety, morality, charity, stability, good governance and restraint. Stories of assaults on British women in the rebellion played a particularly significant role in unleashing racialised horror. In her memoirs Harriet Tytler invoked 'the hearts of gentle, tender-hearted women' in the same passage in which she wrote of a dead sepoy: 'serve you right for killing our poor women and children who never

injured you'.[20] Photographs, like those by Robert and Harriet Tytler, served a pre-emptive role, conjuring the fantasy of sexual violence against British women as the justification for any necessary colonial violence. These pictures share what the cultural theorist Raymond Williams termed a 'structure of feeling' with General Neill, albeit in a lower key.[21] In order to understand the paradox of aftermath photography, it is useful to consider another example, *Interior of the Sikanderbagh after the Massacre* (Plate 3.9). It shows the site in Lucknow where the British executed Indian rebels. When the photographer, Felice Beato, arrived in the city four or five months after the event, he had the human remains exhumed.

Exercise

Now look at *Interior of the Sikanderbagh after the Massacre* (Plate 3.9) and try to identify its key features. How does it compare to the previous example of aftermath photography (Plate 3.7)? In the light of the information above, consider what it reveals about this type of photography.

Discussion

Clearly, this too is an aftermath picture, looking back to earlier events, but it is different in approach from pictures of empty, but poignant, spaces. The photograph shows a ruined building, four Indian men, a horse and, scattered across the ground, you may be able to make out human remains. There aren't as many skeletons as first appears; they are interspersed with bricks and masonry.

It looks as if the photographer had simply stumbled across this scene of horror, but this was of course not the case, since Beato deliberately had the remains exhumed in order to photograph them. The fundamental paradox entailed in photographing places in which something momentous happened in the past is heightened by reinserting the remains into the site of conflict. In part, photographs produce meanings through this kind of framing that brings unrelated things into association, leaving the viewer to make a connection. Here, a link or contrast is established between the Neo-classical building and the dead rebels, the destruction suggests an assault on Western civilisation itself; a wound in the empire. Considered in this light, the bodies act as memento mori or reminder of death; they are signifiers of the rebels' hubris in the face of a superior society and the inevitable fate of those who would challenge British power.

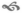

Beato's photographs of the revolt were exhibited at the Victoria and Albert Museum. He issued them both as single prints to be inserted in an album and as a ready-made album. Photographs like these were sometimes purchased by soldiers who had served in repressing the rebellion and were pasted into albums along with portraits in uniform. They functioned for these men as condensed memories or war trophies. In their use, they are not unlike the images of inmates in Abu Ghraib, the former American detention centre in present-day Iraq, made after the Second Gulf War.

Famine

All agrarian societies experience periods of dearth and associated cycles of population expansion and collapse. The Bengal famine of the 1770s resulted in the estimated deaths of one-third of the population. Between 1876 and 1878 famine took hold in Madras. Colonialism wasn't the cause of the Madras famine any more than it was responsible for the potato blight that resulted in the Irish famine of 1845–50. However, one needs to be careful about the common description of such events as 'natural disasters'. A dogmatic commitment to laissez-faire economics and tight control of state expenditure meant the colonial power preferred not to intervene in the situation of scarcity, and when it finally took action it was too little and too late.[22] The governor of Madras, Richard Grenville, Duke of Buckingham and Chandos, embarked on a tour of the Andaman Islands, Burma and Ceylon when it was already evident that the monsoon rains had failed. Traditional grain-holding patterns had been reorganised after 1857, and now prices rocketed and grain riots spread throughout the Deccan cotton areas. A flood of refugees poured into Calcutta. In an important sense, it was these price increases that were central to the outcome, with grain becoming unaffordable to the rural poor, low-caste labourers and ex-weavers.

At the time, the viceroy of India, Lord Lytton, was preoccupied with the planning of the 1877 'Proclamation Durbar', a spectacular pageant held in Delhi that marked the crowning of Queen Victoria as Empress of India (see Introduction, Plate 0.11). It is estimated that, during the week-long sumptuous festival, 100,000 people starved to death. Lytton stuck dogmatically to the prevailing nostrums of political economy, refusing to interfere with prices or allow restriction of the market by stockpiling grain. In fact, this 'Nero' as he was subsequently called (in reference to the Roman emperor who reputedly fiddled while Rome burned), as well as other key figures, followed the doctrine of the parson and economist Thomas Malthus,

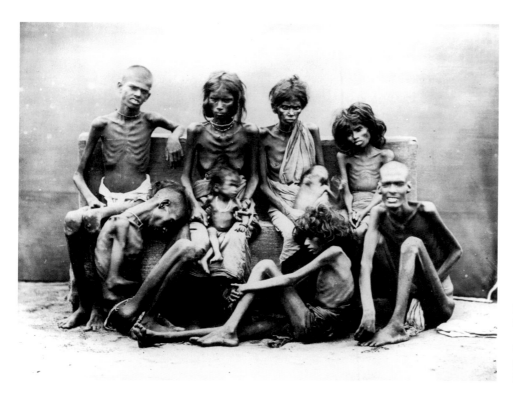

Plate 3.10 *Madras Famine of 1876–78*, 1877. Photographed by Willoughby Wallace Hooper. Photo: © Bridgeman Images.

who held that populations of the poor expanded at a faster rate than the food supply. Taking a callous attitude to human life, the followers of Malthus viewed famine as a natural corrective to 'over population'. When the colonial administrator Sir Richard Temple was tasked with addressing the famine, he sought to determine the lowest calorific value on which 'coolies' could survive. The figure he arrived at, known as the 'Temple wage', was lower than the ration at the Nazi concentration camp Buchenwald.[23] Estimates of the number of deaths vary, but William Digby, author of a two-volume history of the Madras famine published in 1878, put the figure at 10.3 million.[24] Sometimes, the most extreme kind of violence is impersonal or bureaucratic and involves just sticking to the rules.

Seconded from his military duties to record ethnographic subjects, Captain Willoughby Wallace Hooper of the Madras army, a keen amateur photographer, documented the effects of the famine (Plate 3.10). The images are familiar enough from famines in our own time: parched soil, emaciated people, dying children and vultures picking over the bones of livestock. Hooper was also known as a photographer of elaborately staged hunting scenes with stuffed animals that served as souvenirs for hunters

(the long exposure time made it impossible to capture an actual hunt). His pictures of the famine similarly have something of the feel of a still life or *nature morte* (French for still life, literally meaning 'dead nature'). His focus is on the plight of individuals, and, like contemporary charity images, they offer little or no explanation of the situation. The causes of starvation are outside the frame, as if they were the effects of nature or God. The figures appear inert and resigned to their hopeless fate; their end seems inevitable. Hooper focuses on the presence of these desperate people and presents his viewers with a harrowing tableau of impending death. It is difficult to look at these images and, across time, not feel sympathy.

Sympathy (from the Greek term meaning fellow feeling) is a complex emotion. It entails a direct response to the suffering of others and can lead to a sense of involvement, even action. However, an orchestrated public response evoked by the press, as in the case of the famine photographs which circulated as engravings in illustrated publications, is liable to have a different effect (Plate 3.11). Sympathy is a double emotion that can induce humane feeling while reinforcing distance and comfort among viewers: 'poor people'/'thank God it isn't me'. In this sense the emotion of sympathy often

"FORSAKEN"

"THE LAST OF THE HERD"

THE FAMINE IN INDIA — SCENES IN THE BELLARY DISTRICT, MADRAS PRESIDENCY

Plate 3.11 'Forsaken' and 'The last of the herd' showing 'The famine in India – scenes in the Bellary district, Madras Presidency', engravings in *The Graphic*, 6 October 1877. Photo: © Illustrated London News Ltd/Mary Evans Picture Library.

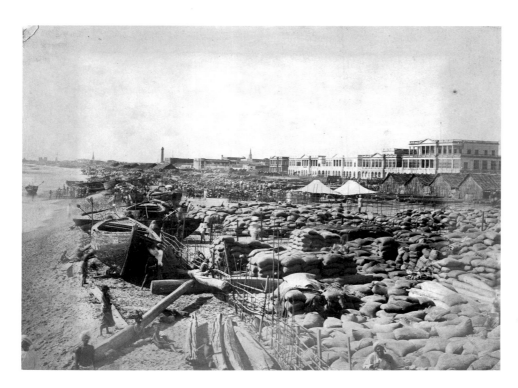

Plate 3.12 *Madras Beach during the Famine*, 1877. Photographed by Willoughby Wallace Hooper. Photo: Royal Geographic Society (with IBG).

contains a dimension of horror. Some critics have argued that Hooper's images reinforced the colonial mission, rather than challenged misrule. Chaudhary, for instance, suggests that the predominant response by the British public was to see these images as demonstrating precisely why Britain had to rule India, bringing modern civilisation to bear on backward conditions. In this way, Hooper's famine photographs could be employed to reinforce a sense of Christian superiority and British pre-eminence.

One picture by Hooper provides a different image of the famine. In 1877 he photographed Madras beach piled with sacks of grain awaiting export (Plate 3.12). As the historian Mike Davies observes, throughout the famine grain was being exported to Britain, so that 'Londoners were in effect eating India's bread'.[25] This photograph shifts our gaze from morbid bodies to a wider, social purview. Might it offer an attitude critical of colonial policy? Set against the images of emaciated bodies, it is certainly possible to see it like that. One should, though, also consider an alternative possibility. As Chaudhary notes, there is no evidence that Hooper held anything but mainstream views: he is said to have posed his famine victims, made the picture and then told them to move along without

providing assistance. One can speculate that Hooper may have seen a newsworthy subject in the grain stacks. His pictures are imbued with a structure of sympathy, but there is, surely, also a morbid curiosity in them. Ten years later he made some other images that may lead to a better understanding of his photographs of the Madras famine. During the Second Burmese War, Hooper photographed executions in which he set up his camera to trigger at the precise moment the firing squad's bullets hit the bodies of Burmese insurgents (Plate 3.13). The photographs didn't circulate at the time, but accounts in the press of the incident caused an outrage that reached the British Parliament. Hooper's pictures were deemed 'ghastly' and 'cruel'. Evidently something about his action offended a British sense of decency and fair play (though it is hard, from a present-day perspective, to see why the photograph, rather than the execution, is especially vicious). It seems to me that Hooper was fascinated by the opportunity to capture novel events and emotions on the spot; he appears to have been captivated by the potential of the camera to show human subjects *in extremis*, facing death. His work engages a structure of sympathy, but that does not necessarily entail a critical attitude to colonialism and may reinforce some of its core racialised assumptions.

Plate 3.13 *Execution at Mandalay*, 1886. Photographed by Willoughby Wallace Hooper. The British Library, London, shelfmark: Photo 447/8(1). Photo: © The British Library Board.

This section discussed the ways in which some photographers responded to traumatic events in British India. It should be evident that one is not looking at simple records, but images imbued with values or ideologies.

3 Salvage and 'type'

Pinney has argued that throughout the nineteenth century two distinct photographic programmes were applied in India: the 'salvage paradigm' and the 'detective paradigm'.[26] The latter involved using photographic images to identify particular individuals. In a talk at the Photographic Society of Bengal in 1856, for example, the Reverend Joseph Mullins suggested that photographs should be taken of all pensioners (probably ex-soldiers or their widows) to prevent impersonation, and various attempts were made to record the appearance of prisoners (although it was felt this involved too large an investment for poor results). It is worth noting that the key technology for identifying individuals, that is, fingerprinting, emerged in British India about this time. Such technologies for identification, which are now taken for granted, were developed by nineteenth-century state administrations as a means of controlling deviant or rebellious populations.[27] Photographic portraiture

might credibly be seen as an honorific version of this individuating paradigm.

The salvage paradigm, which will be the focus in this section, centres on the alternative approach concerned with exemplary cases. This is a methodology associated with early twentieth-century ethnology, principally the work of the anthropologist Franz Boas and his students, who studied the society and culture of indigenous Americans. The assumption at the heart of this approach is that 'primitive' people and their ways of life inevitably disappear once they come in contact with a higher civilisation. In salvage ethnology, the objects of attention are imagined to be as if frozen in the distant past outside of history, existing in a state of cultural purity.[28] It was believed that the traces of a disappearing world required collecting and collating before they were lost forever: material artefacts were gathered, music noted down, beliefs and stories written out and images recorded. Photography was an ideal tool for such a project. As an anonymous reviewer in *The Quarterly Review* put it in 1864, the noble task of the photographer was to remove 'the impediments of space and time, and to bring the intellects of civilized lands to bear upon the phenomena of the vast portion of the earth whose civilization has either not begun, or is passing away'.[29] The project of salvage photography was to collect samples or 'types' that could represent supposedly uncivilised or doomed peoples and their cultures.

Collecting people

The salvage paradigm is part of a larger vision of Western progress in which other societies, whether based on hunting and gathering or pastoralism, were thought to be destined to disappear in the face of commercialism, industry and science. India was a complicated case, because the refinements of court culture and exquisitely crafted objects clearly demonstrated a high level of culture. Nevertheless, the salvage paradigm held a prominent place in the colonial imagination; photographers busied themselves collecting pictures of what they believed were the threatened aspects of 'Hindoo' society. The colonial administrator J. W. Breeks, for instance, claimed in *An Account of the Primitive Tribes of the Nilgiris* (1873) that the tribal people who lived in the Nilgiri Hills in Tamil Nadu, southern India, were abandoning their ancient culture so that it was a matter of urgency to photograph what remained. Similarly, the natives of the Andaman Islands were thought to be facing imminent extinction.[30]

Many photographic projects sought to record and classify the types and castes of India. This work developed particularly in British India and was shaped by racialising assumptions. Usually, the images were presented in lavish albums, sometimes containing extensive texts and captions purporting to describe and categorise caste hierarchies and racial types. Prominent examples here are *The Oriental Races and Tribes, Residents and Visitors to Bombay: a Series of Photographs with Letterpress Descriptions* (2 vols, 1863, 1866) by the colonial administrator William Johnson; *The People of India* (1868–75) (see Plates 3.14–3.16) co-edited by John Forbes Watson and the journalist and author Sir John William Kaye, who held the position of secretary of the Foreign Department of the India Office between 1858 and 1874; and the multi-volume *Tribes and Castes of the North Western Provinces and Oudh* (1896) by William Crooke, who worked in the Bengal civil service. Many of these albums reveal a desire for a comprehensive overview of Indian social, religious and ethnic differences, yet display an inconsistency and lack of standardisation typical of the period. There is a tension here between the dream of complete knowledge, and the particularities and discrepancies of the presentation. At least three overlapping concerns are at stake in this kind of photo-investigation. First, there is a simple fascination

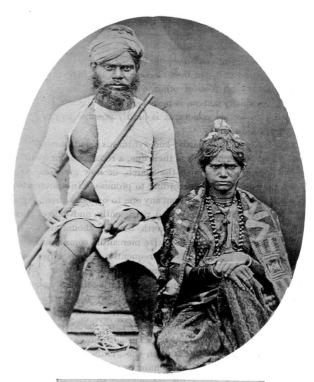

Plate 3.14 'Brinjara and wife, itinerant grain merchants, Saharunpoor', in John Forbes Watson and John William Kaye (eds), *The People of India*, London, India Museum, 1868–75, Plate 161. The Miriam and Ira D. Wallach Division of Art, Prints and Photographs, Photography Collection. The New York Public Library.

with people who look different from the presumed European norm, though this invariably shades into exoticism. Second, there is an Orientalist desire to penetrate and know an alien society in an attempt to dispel anxieties arising from incomprehension. Third, there is the gathering of intelligence that allows colonial administrators to take control through identifying differences, demarcating status groups and distinguishing friends from potential threats. Each variant involves reading photographs for bodily traces or distinctive costumes and habits. They all assume that social or racialised dispositions are to be observed by outward signs of the body.

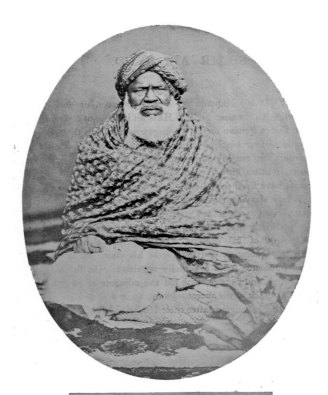

SHAIR ULLEE SYUD.
SHIAH MAHOMEDAN:
DESCENDANT OF MAHOMED.
ALLYGHUR.
(139)

Plate 3.15 'Shair Ullee Syud, Shiah Mahomedan, descendant of Mahomed, Allyghur', in John Forbes Watson and John William Kaye (eds), *The People of India*, London, India Museum, 1868–75, Plate 139. The Miriam and Ira D. Wallach Division of Art, Prints and Photographs, Photography Collection. The New York Public Library.

Perhaps the most important of these albums was *The People of India* (1868–75). This project was initiated by Lord Canning, who had been governor-general during the 'mutiny' and became the first viceroy of British India (1858–62). Canning encouraged army officers and others to take photographs on their journeys and to send him copies. Public interest in display of such images at the 1862 Great International Exhibition in London prompted the expansion of this project from one focused on the people of eastern Bengal to a much broader one concerned with documenting the full range of India's communities.[31] It is not hard to see this gathering of information as a product of the anxieties

released by that most traumatic of events, the Indian Rebellion. Co-edited by Kaye and John Forbes Watson of the India Office, the resulting publication took the form of a collection of 486 photographic prints made by 15 credited photographers, mostly amateurs, and bound in an eight-volume collection (Plate 3.16). The photographs in *The People of India* are accompanied by letterpress captions and longer descriptions. Two hundred copies were produced, with half reserved for official use. Throughout, individuals are presented as types, standing for social or ethnic groups. Pinney notes that the image formats differed considerably:

> The photographs were a mixture of full-face quarter-length portraits, full-length formal portraits with studio paraphernalia and group shots in varying degrees of formality. The classification is extremely erratic and is sometimes by 'caste', sometimes by 'tribe'; other captions present groups as 'sects' and images of individuals are also included.[32]

No clear instructions appear to have been given to the photographers and it is not evident what purpose the album was intended to serve. Indeed, *The People of India* is a deeply contradictory work that testifies to either misapprehension or incomprehension. Even when there was a degree of consistency in colonial ideology, this did not necessarily translate into a coherent approach 'on the ground'. Nevertheless, colonial fear and unease come through in the overall uncertainty and in texts that comment on the various peoples, noting their loyalty in 1857, but also their inclination to thievery, lawlessness and violence. At some points, authors also note the attractiveness of women. The work gives the impression of being a guide to loyalism and danger, pleasure and risk, always for a (male) colonial viewer positioned outside, or above, these groups.

One encounter with *The People of India* stands as an occasion when the colonist's vision was confronted with another perception: the response of Sir Syed Ahmed Khan, a prominent Muslim scholar, reformer and British loyalist of noble Mughal descent. He worked as a judge in the colonial administration, was knighted in 1888 and had authored *The Causes of the Indian Revolt* (1858), which blamed the British for the outbreak of the rebellion. For him, the photographs in *The People of India* showed Indians as 'savage' and the 'equivalent of animals'. He recounts an incident when he and his two sons, on a visit to London, examined the albums at the India Office. A young Englishman came up to one of his sons, asking

Plate 3.16 John Forbes Watson and John William Kaye (eds) *The People of India: A Series of Photographic Illustrations, with Descriptive Letterpress of the Races and Tribes of Hindustan*, 8 vols, 1868–75, albumen prints, 35 × 26 × 4 cm (each). The Alkazi Collection of Photography, ACP: 99.27.0001-0008. Used with permission.

whether he was a 'Hindustani'. Blushing, his son replied in the affirmative and hastened to explain that he was not one of the aborigines, but that his 'ancestors were formerly of another country'. For Syed Ahmed, the image of 'Hindustanis' presented in *The People of India* is embarrassing; he states that 'until Hindustanis remove this blot they shall never be held in honour by a civilised race'.[33] It is not clear what the 'blot' in this passage refers to. Is it the book itself or the presence of savages/animals/ aboriginals? What is evident is that Syed Ahmed felt ill at ease in the presence of this collection of portraits; he seems to express shame, or at least records a slight on his status, as if he were the object of the colonial gaze.

One passage in *The People of India*, accompanying a photographic image captioned 'Moghuls, Mussalmans, of Royal Family of Delhi', for example, suggests that the depicted were 'vicious and dissolute, idle and ignorant; too proud to seek employment, and too discontented to abstain from plots and intrigues, as futile as they were foolish'. Another passage says of *moulvees* (teachers of Islamic law) that, on any subject but law, they are 'profoundly and persistently ignorant'. Moreover, people

known personally to Syed Ahmed's family are described in disparaging terms. One such individual is described in typically Orientalist manner: he is said to exemplify the 'obstinancy, sensuality, ignorance and bigotry of his class'. Another is said to belong to an ignorant class of minor landowners who, despite being Muslim, 'have been Hindooized in a great measure, and are in the last degree superstitious; practising, especially their women, Hindoo rites in secret'.[34] There was plenty here to disturb Syed Ahmed. Pinney suggests that his unease resulted from the 'systematic normalising and rendering visible of diverse communities in a unitary framework'.[35] As an eminent nobleman, Syed Ahmed was troubled to find that he was engulfed in this vision and viewed by Europeans as being on a par with lowly 'savages' and aboriginals. His response can also be related to the tendency among Indian elites to elevate their own position by presenting the ordinary people and aboriginals in negative terms. Indeed, Pinney has argued that Syed Ahmed's reaction came from seeing the colonialists' view of Indian people as 'backward' turned on elite people like him. His response was born of elite resentment against colonial ignorance, but also testified to the destabilisation of hierarchies and his

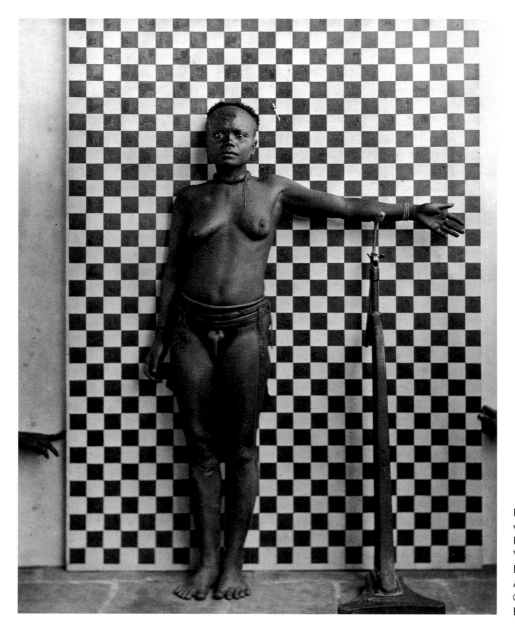

Plate 3.17 Andamanese woman, c.1890. Photographed by Maurice Vidal Portman. British Museum, London, As,Portman,B30.15. Photo: © The Trustees of the British Museum.

simultaneous distaste for the ordinary poor. Although not a radical critique of colonialism, his response is one of the places where the colonial vision comes into the open.

European anthropologists, psychologists and administrators were intent on placing the world's population on a scale of supposed racial 'development'. 'Advanced' races were contrasted with 'backward' peoples whose lives and customs should be reordered for their own good, reasonably if possible, but forcibly if necessary. It should be noted that this conception

extended to the lower classes of European societies, who were also regarded as lesser beings, sometimes even as degenerate populations or separate 'races', which had to be controlled, or even exterminated. All the peoples and cultures of the world were to be measured on a spurious scale, with elite European men at the apex. In 1869, the eminent naturalist and Darwinist Thomas Henry Huxley called for a systematic photographic study of the people of the empire. Huxley, who had been looking at *The People of India*, argued that existing ethnological photographs 'lose much of their value from not being

taken upon a uniform and well considered plan. The result is that they are rarely either measurable or comparable with one another and that they fail to give the precise information respecting the proportions and the conformation of the body'.[36] Huxley recommended that subjects should be photographed naked, at a fixed distance from the camera, and that a measuring scale be incorporated. Two full-length images were to be made: one frontal and one side on. This is a racialising plan for determining bodily differences thought to constitute races, but it is worth noting that Huxley was not on the extreme racialist wing of British anthropology.[37] In the same year, that is, 1869, Huxley's proposal was amplified in the *Journal of the Ethnological Society* by Jones H. Lamprey, assistant secretary of the Society and librarian to the Royal Geographical Society. He outlined a system for photographing naked colonial subjects in front of a grid made from stretched threads arranged in two-inch squares that became known as the 'Lamprey Grid'.

The Colonial Office adopted these proposals and wrote to governors throughout the empire requesting that they initiate such a survey in their areas. As Elizabeth Edwards has demonstrated, what came back was both patchy and far from systematic. Images of this type were made by the amateur photographer and army surgeon G. E. Dobson in India as well as by the civil servant Maurice Vidal Portman on the Andaman Islands (Plate 3.17) and by the amateur ethnographer W. E. Marshall among the Toda people. How thoroughly the plan was enacted depended on the energy of particular administrators; some felt the nudity inappropriate and worried that they would not be able to get subjects to comply, so sent completely different images. In addition, the Colonial Office became concerned about the cost of the project. There is an important point to be made here: however dubious this project, it was not the over-arching model of colonial surveillance that some have claimed. Huxley's plan, though flawed, was not simply a form of intelligence-gathering for state power. Although implicated in the colonial project, colonial anthropology was far from being a well-oiled machine running on a preconceived plan. It was haphazard, contradictory and largely piecemeal.[38] Colonial administrators and photographers also had to come to terms with the dynamism of Indian society, and to reconcile racial conceptions of Indian inferiority with a sense of the prosperity and efficiency brought about

by the British Empire. These images need therefore to be seen alongside pictures of the modern labour force of British India, which, at the end of the nineteenth century, often circulated as postcards, thereby cutting paradoxically against the idea of salvage.

Collecting monuments

Salvage ideology does not only apply to gathering photographs of people as 'types'. In 1847, the British governor-general of India called for 'the collection in each of the three Presidencies of really accurate, and well classified information as to the nature, extent, and state of existing monuments': architecture was taken to offer an index of 'races' or cultures.[39] There were many attempts at such a project of recording ancient buildings. The work was carried out in a sporadic, fragmentary fashion, often initiated by private individuals relying for funds on central government or the Presidency administrations, which they combined with selling prints and albums. Often the projects were extravagant, involving huge sums of money invested in producing lavish presentation volumes of photographs of little scientific value. The wonderfully named Captain Linnaeus Tripe of the Madras infantry, who had acquired photographic skills while on leave in Britain, for example, accompanied the Governor-General of India Lord Dalhousie on a trip to Burma, which had been annexed in 1852, where he recorded Burma's architecture. Many of the buildings he photographed were literally recorded for posterity; they were soon demolished to make way for the headquarters of the colonial administration. Tripe undertook several photographic tours between 1852 and 1860, and was appointed photographer of the Madras Presidency in 1857 under the salvage paradigm (Plate 3.18). With the end of EIC rule after 1857, stricter fiscal control was, however, imposed on the administration, and Sir Charles Trevelyan, the new governor of Madras, put an end to Tripe's commission.[40]

Despite economic restrictions, records of architecture and antiquities continued to be produced. The amateur photographers Captain Alexander Greenlaw of the Madras Native Infantry and the medical officer Dr John Murray made pictures of temples, fortifications, palaces and other antiquities. In 1869, Brajo Gopal Bromochary, the court photographer of the Maharaja of Benares, produced *Views of Benares from the Riverside*. Lala Deen Dayal, the most prominent Indian photographer at the

Plate 3.18 'The south façade of Subrahmanya Swami's Temple [Brihadishvara Temple, Thanjavur]', in Linnaeus Tripe, *Photographic Views in Tanjore and Trivady, Madras*, 1858. Photographed by Linnaeus Tripe, silver gelatin print. The British Library, London, shelfmark: Photo 955/(18). Photo: © British Library Board. All Rights Reserved/Bridgeman Images.

time, whose work will be considered in more detail in the next section, contributed to an album called *Views of Central India*. Bourne photographed the façade of the Horse Mandapa (pillared outdoor hall for public rituals) in the Ranganatha Temple, at Seringham (Srirangam), in Trichinopoly (Tiruchirappalli), Tamil Nadu (Plate 3.19), commonly referred to at the time as the Horse Temple at Seringham. He observed, with his typical racial bile:

> The priests have a curious notion that these fine carvings are improved by white-washing, and this has been done so often that some of the finer details are almost clogged up and obliterated ...

One longs to take a sharp instrument and after cutting the priests' throats with it, scrape away these diabolical accretions.[41]

Not all salvage work is as murderous as this, but Bourne's comment displays, in particularly stark terms, the feeling that Indian heritage had to be saved from Indian people.

The photographic recording and presentation of ancient monuments gave rise to one of the most remarkable episodes in Indian photography of the period. In some ways, this is as close as one comes to finding a moment of resistance to colonial ideology in photography. In 1857, the year of the rebellion, the well-respected native scholar Rajendralal Mitra was

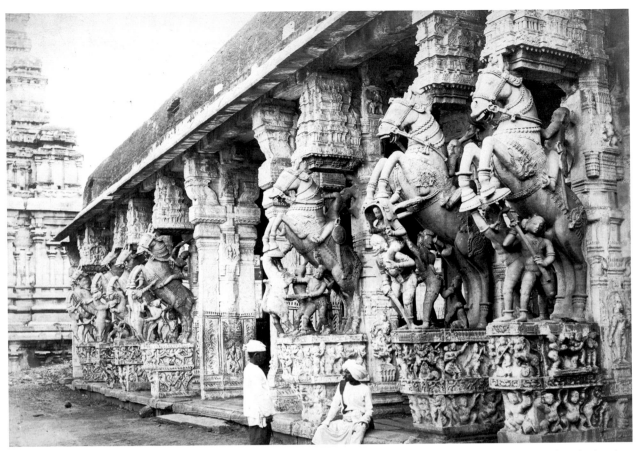

Plate 3.19 *View of the Horse Temple at Seringham, Trichinopoly*, 1869. Photographed by Samuel Bourne. Photo: © Hulton Archive/ Getty Images.

expelled from the Photographic Society of Bengal (he was re-admitted in 1868). An archaeologist who is now seen as the first Indologist of Indian origin, Mitra was a founding member of the society. His crime was to have publicly defended the so-called Bethune Bill (1850), which sought to allow Indian judges to preside over cases involving Europeans in regional courts; the bill was passed but then suspended due to pressure from the resident British Community, foreshadowing the better-known Ilbert Bill (1883) that sought to achieve a similar objective and caused an even greater furore (see also Chapter 2, p. 86). The bill represented a threat to powerful indigo planters, who played a major role in the often brutal transformation of Bengali agriculture, since they might be called to account by Indian judges. Moreover, Mitra had criticised 'the ruin and devastation' caused by the planters, whose subordination of peasant production to a large-scale capitalist plantation economy often resulted in riots.

The conflict did not stop there. Mitra was employed by the Bengal government to document ancient monuments, which resulted in the archaeological treatise, *The Antiquities of Orissa*, published by the government of India in 1875. Mitra worked under the same conditions as European archaeologists and had his own team of Indian assistants selected from the best moulders and draughtsmen trained at the Calcutta School of Art. (The moulders were employed to make plaster casts of the monuments.)[42] Even though Mitra was a competent photographer, the images included in the book were made by his team under his supervision (Plate 3.20). In the preface he described his intention to adhere to the directions of Lord Canning, which were to accurately record 'such remains as most deserve notice, and with the history of them so far as it may be traceable, and a record of the traditions that are retained according to them'.[43] Mitra, who negotiated the double identity of modern scholar and critical insider, also produced

Plate 3.20 'Temple of Jagannath', in Raja Rajendralal Mitra, *The Antiquities of Orissa*, Calcutta, 1875–80. The British Library, London, shelfmark: General Reference Collection 1700.a.20. Photo: © The British Library Board.

Indo-Aryans: Contributions towards the Elucidation of their Ancient and Mediaeval History (1881). In this work, he responded to James Fergusson, the most important British architectural historian of India at the time, who attacked Mitra's work in an ever more highly charged scholarly debate.[44]

Pinney has provided an excellent account of the differences between the two men, which led Fergusson to publish *Archaeology in India, with Especial Reference*

to the Works of Babu Rajendralala Mitra (1884), a book-length denunciation of Mitra that constituted the culmination of a ten-year 'scholarly' disagreement over the origin of Indian architecture.[45] The background to this dispute was the source of Fergusson's fortune in Bengal indigo planting and Mitra's criticism of such men; the foreground comprised the two men's very different attitudes to Indian building and history. Fergusson viewed the history of Indian architecture as a story of decline from the zenith represented by Buddhist art,

which he categorised as 'Aryan' and saw as rational in its simplicity of form; the nadir was represented by the decadent, 'non-Aryan', 'Brahmanical' (that is, superstitious) Hindu architecture marked by 'excessive' ornamentation. Key here was the discovery in Gandhara of Buddhist sculptures that showed great naturalism in the treatment of the Buddha figure (see Chapter 1, Plate 1.17) and were thought to be inspired by Greek influences. This discovery had a bearing on the dispute between Fergusson and Mitra over whether India had developed a true architecture that went beyond the 'mere piling up of stones'.[46] For Fergusson, higher-level architecture had been introduced to India through Greek influence, which served as a precedent for the cultural benefits of British rule. Mitra, by contrast, sought to prove that India had achieved a high level of cultural development prior to the arrival of the Greeks and could claim to have experienced a 'golden age' independent of any external influences. The implications of this argument were highly political: India did not need Britain in order to develop.

Fergusson wrote: 'If instead of inditing sentimental nonsense about the injured feelings of his countrymen, the Babu [Mitra] had only spent a few hours in studying the photographs of Mauryan Chaitya caves of Western India', such as for instance 'this [cave] at Bhaja' (Plate 3.21), he would have seen, 'even with his limited knowledge of art, that they were literal copies of structures built with wood and wood only'.[47] There are three points to note here. First, 'Babu' is a form of address more or less equivalent to 'Mr', which was, however, often used in a derogatory way to refer to English-educated Indians. Fergusson uses the term with biting irony, and claims that Mitra is actually ignorant of the art in question and, moreover, incapable of interpreting photographic evidence. Second, reference to the 'injured feelings' of Mitra's 'countrymen' points to Fergusson's sense that *The Antiquities of Orissa* presents a narrative not only different from Fergusson's own history, but also critical of colonial attitudes to India's past, which he rightly understands to imply a critique of British rule. Third, there is the substantive point about the date of stone building. From Fergusson's perspective, Mitra fails to understand the difference between architecture as a fine-art tradition versus its merely utilitarian aspects, which betrays his 'limited knowledge of art'.[48] In *Archaeology in India*, Fergusson repeatedly questions the trustworthiness of Indian observers. Indians, he thought, unlike Europeans, were

Plate 3.21 'View of a cave at Bhaja', engraving in James Fergusson, *Archaeology in India, with Especial Reference to the Works of Babu Rajendralala Mitra*, London, Trübner and Co., 1884. The British Library, London, shelfmark: General Reference Collection 7707.df.5.(7). Photo: © The British Library Board.

incapable of dispassionately evaluating evidence. The refusal to believe the evidence of Indian witnesses is a fundamental colonial attitude, also borne out by Cheevers' comments already mentioned. The Babu, Fergusson said, 'had no system and no story to tell, one photograph in his eyes was as good as another'.[49] Yet the crucial point here is that Mitra *was* telling a story, one that Fergusson refused to accept.

Fergusson explicitly positioned these claims about photographs of monuments in a debate about the suitability of Indians to serve in the judicial system, a highly contested political issue at the time (see p. 133). It stirred up similar virulent emotions as the Indian Rebellion had done in India as well as Britain, resulting in intense political protests by the resident British in India against Viceroy Lord Ripon, who promoted the Ilbert Bill. Its passing would likely affect indigo planters, who had much reason to fear a judicial system not rigged in their favour; the fierce opposition to the proposed legislation was in large part masterminded by them. The protests were presented in highly gendered terms. They invoked the trope of British women violated by the rebels of 1857 and painted a lurid picture of lascivious Indian males pronouncing judgment over

innocent white women, cast in a language of sexual violation that caused mass hysteria.[50] Fergusson's linking of these political events to seemingly dry, scholarly discussions over architectural theories demonstrates the significance of their implications. His point was that if Indian people were not, as he thought, able to evaluate evidence, then they should not be allowed to judge Europeans. For him, Mitra had not only criticised indigo planters, but also asserted the authority of Indian magistrates. In contrast, Fergusson thought his own ability to evaluate the photographic evidence upon which his scholarly work was based made him a reliable expert, able to rise above the 'uneducated eye' of the Babu.[51] It should be apparent that fundamental attitudes towards colonial rule are embedded in this debate between a Bengali scholar and archaeologist and a Scottish indigo planter turned architectural historian. Evidence and the evidential claims of photography are always wrapped up with authority and trustworthiness. Mitra's interlinked comments on indigo planting, judicial authority and photographs of ancient Indian buildings provide a unique intervention from the point of view of one English-educated Bengali man.

4 At the court of the Nizam

In recent years a great deal of scholarly attention has been paid to images made by non-European photographers in an attempt to assess whether or not they embody a distinct anti- or non-colonial attitude.

Shri Singh, the Raja of Chamba (r.1839–70), a district in today's state of Himachal Pradesh, in northern India, was an enthusiastic photographer, as was the Maharaja of Jaipur, Sawai Ram Singh II (r.1835–80). In 1857, 33 members of the 100-strong Photographic Society of Bengal were Bengalis. In addition, Pinney notes the existence of a 'vast number of local Indian-run studios'.[52] Ahmed Ali Kahn, who worked as a photographer at court in Lucknow as early as the 1840s, subsequently fought with the rebels in 1857. He was later pardoned but, as one contemporary account noted, he 'lost his fortune and name and died a miserable man'.[53] While some art historians find evidence of Indian agency and critical attitudes to colonial rule in images by these photographers, others argue that colonised image-makers moulded themselves to, or mimicked, the dominant culture and that there is thus no alternative view to be found in such pictures. This section will assess the work of the most acclaimed Indian photographer of the nineteenth century, Lala Deen Dayal, with these questions in mind.

From a family of Jain jewellers, Deen Dayal became a surveyor, practising photography as a subsidiary part of his trade. As the curator Deepali Dewan notes, surveying entailed measuring and recording the land, and surveyors were expected to sketch as part of their work; Deen Dayal made the transition from such activities to camera work. In the 1870s he began taking photographs for the Central India Agency (a political body of the British Empire in India that oversaw

Plate 3.22 'Two-part panorama of Chowmahalla Palace, Hyderabad', in Lala Deen Dayal, *Views of HH the Nizam's Dominion, Hyderabad Deccan*, 1888, albumen prints, 20 × 26 and 21 × 26 cm. Photographed by Lala Deen Dayal, 1887, Photographer's Refs 3645 and 3646. The Alkazi Collection of Photography, ACP: 95.0063(03a & b). Used with permission.

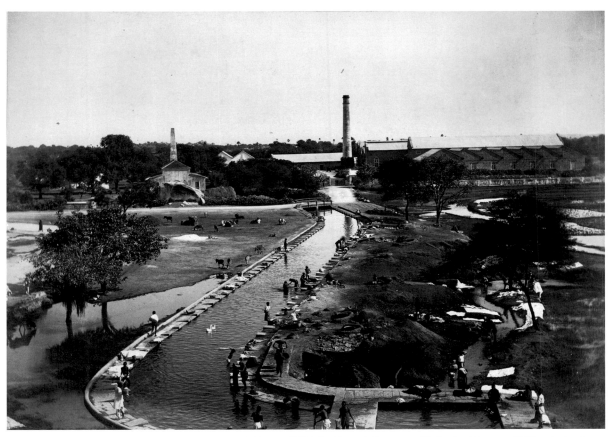

Plate 3.23 'Mills at Hyderabad', in Lala Deen Dayal, *Views of HH the Nizam's Dominion, Hyderabad Deccan*, 1888, gelatin silver print, 20 × 28 cm. Photographed by Lala Deen Dayal, 1887, Gift in memory of Maria McNabola and Irene Peters. The J. Paul Getty Museum, object number: 2008.78.36. Digital image courtesy of the Getty's Open Content Program.

princely states), particularly of bridges, railways and construction projects. Dewan observes that these were hardly neutral subjects, but rather constituted the infrastructural works that linked the princely states to British commercial and strategic interests. Topographical views of such 'modernisation' projects featured prominently in souvenir books commissioned by colonial officials and princes.[54] After working on an album of monuments for the Agency, Deen Dayal made pictures of notable sites, some of which appeared in the London-based illustrated magazine *The Graphic*.

On retiring from the Agency, Deen Dayal opened a studio in Secunderabad, in the territory of the Nizam of Hyderabad, the wealthiest of the princely states under the Raj. The studio was a great success; it employed a large staff, including Europeans, and he went on to open further studios in Indore and Bombay.[55] As a speculative venture Deen Dayal

produced an album containing 110 photographs, which he titled *Views of HH the Nizam's Dominion, Hyderabad Deccan* (1888) (Plates 3.22 and 3.23). Subjects included the royal palace, processions, temples and other ancient sites, but also views of industry and bridges, Hyderabad's principal street, and a day at the races. As the curator Deborah Hutton observes, the album offers a multi-faceted view of the Nizam's territory, carefully balancing old and new, religious and secular, Islamic heritage with European culture and modernisation, thereby combining the traditional Deccan view of kingship with openness to European ideas.[56] Clearly, his approach worked. The Nizam purchased 30 copies, at vast expense, and gave them to visiting European and Indian dignitaries. In 1894, Deen Dayal was made official court photographer to the Nizam and given the title of 'Raja'.[57] In this role he made thousands of photographs of life at court, records of Hyderabad,

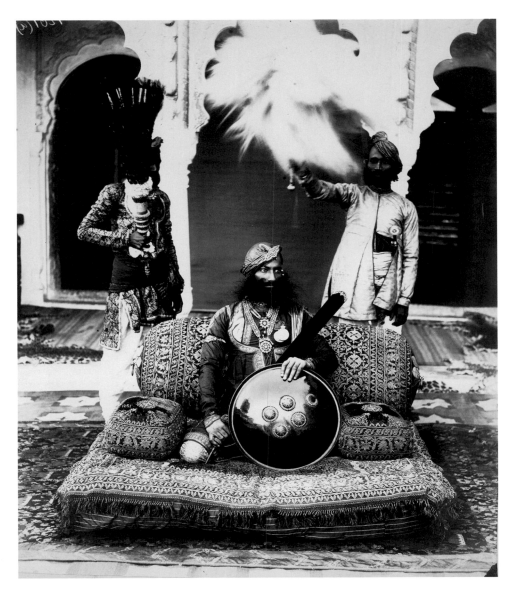

Plate 3.24 *Portrait of HH the Maharaja Sir Pratap Singh of Orchha, at Tikamgarh, c.1882*, albumen print, 26 × 21 cm. Photographed by Lala Deen Dayal. The British Library, London, shelfmark: Photo 1000/16(1658). Photo: © British Library Board. All Rights Reserved/ Bridgeman Images.

official portraits (Plate 3.24) and pictures of ceremonial events.

Gift albums played a part in court life. Cultural events, such as royal visits, banquets, sporting events (usually involving horses) and big-game hunts, were part of the political and diplomatic arsenal of indirect rule that characterised the imperial governance of princely states. The gift album memorialised these occasions and cemented connections. Historians have noted the way in which traditional gifts of tribute were replaced with portraits and such albums.[58] When Lord Canning toured in the wake of the rebellion of 1857, rewarding loyal members of the elite, he often presented them with lavish photographic albums. These gifts were often reciprocated.

The Nizam used photographic albums to promote a vision of his rule as combining the traditional Mughal court with fidelity to the modern colonial empire, bestowing such albums on Indian dignitaries, but also on Lady Lansdowne; the Czarevich of Russia; Prince Arthur, Duke of Connaught (son of Queen Victoria), the first member of the British royal family to visit in some years (Plate 3.25); and Lord Curzon, the viceroy (Plate 3.26).[59]

Typically, the albums that Deen Dayal made for the Nizam combine images of notable sites that Deen Dayal had already made with specially taken commemorative photographs. The grand visitors to Hyderabad were depicted at banquets and reviewing military processions. The formal group portrait played an important role, with

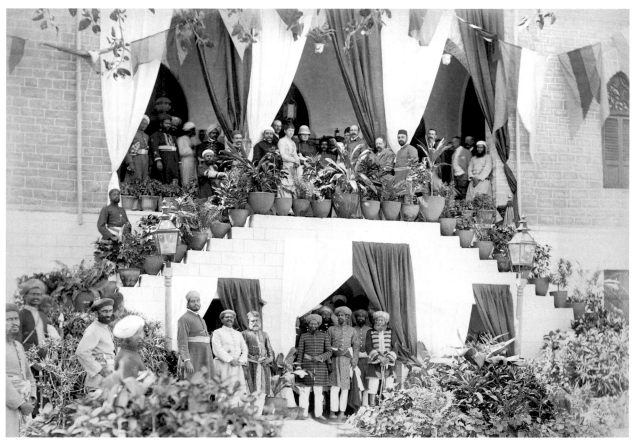

Plate 3.25 'Asmangurh – after breakfast' (the Nizam Mahbub Mir Ali Khan with the Duke and Duchess of Connaught and party at Asmangarh Palace after breakfast), in Lala Deen Dayal, *The Royal Visit 1889, Hyderabad Deccan*, 1889, albumen print, 19 × 27 cm. Photographed by Lala Deen Dayal, 1889, The Alkazi Collection of Photography, ACP: 98.60.0013(18). Used with permission.

individuals positioned according to their status, carefully balancing visibility and authority among both European visitors and their local hosts (Plate 3.25). Another notable feature of the gift album was the record of the big-game hunt, with its pinnacle, the tiger hunt (Plate 3.26). Events like this involved significant planning and large-scale labour as well as huge expense. Again, the traditions of Mughal kingship came together with the international elite culture of the Raj; the power and authority required to kill such a large and dangerous animal attested to the status of the hunter and was exemplified by the 'trophy shot', in which the manly visitor stood over his dead prey. The Nizam engaged in lavish hospitality on such trips, ensuring participants were comfortable. The image of the colonial hunter is a presiding presence in imperial culture, but the Nizam made this possible; it marked his generosity and power. In the Curzon album (1902), half the images relate to the hunt.[60] It is hard not to see the magnificent, but dead,

tiger in these photographs as a figure of subdued India, caught up in the alliances and balance of power between colonial and Indian rulers.

There is no single or unique style to be found in the work of Deen Dayal. He was undoubtedly a good technician, but it is worth noting that he employed many assistants and worked with his sons. It is not really possible to know which images he made himself. Rather, his significance comes from his ability to move across a range of networks employing diverse forms of photography. Coherence, or authorship, is lodged in the spaces of patronage, both colonial and princely, that he was able to occupy. In what sense can this be regarded as a practice of Indian agency? Do the images, or albums, display an indigenous vision of, or against, colonialism? In their excellent book on Deen Dayal, Dewan and Hutton argue that his photography cannot be 'reduced to linear narratives of colonialism, nationalism or modernity alone'. Rather, they argue, his

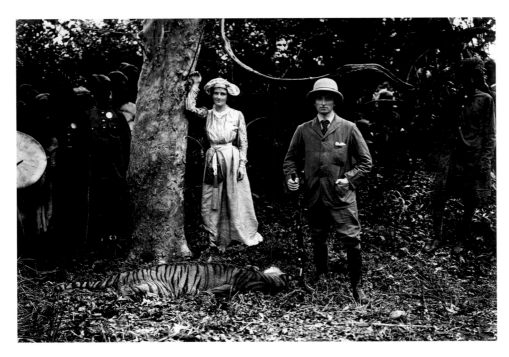

Plate 3.26 'Just after shooting' (Lord and Lady Curzon with bagged tiger), in Lala Deen Dayal & Sons, *Souvenir of the Visit of Their Excellencies Lord and Lady Curzon to Hyderabad Deccan*, 1902. Photographed by Gyan Chand, Secunderabad, 1902, gelatin silver print, 14 × 20 cm. Photographer's Ref. 18357. The Alkazi Collection of Photography, ACP: 97.19.0002(43). Used with permission.

work 'was being produced within and circulated across the overlapping arenas of the colonial administration, princely India, and the emergent cosmopolitan metropolis'.[61] Their point captures something important about Deen Dayal's ability to work across or between cultures in a way that would have been difficult for a European photographer, but I think it underestimates the force of the colonial system, which integrated local rulers into a dominant British system of power and control. In this sense, these are images of, and for, a perforce loyal Indian elite that sought to balance Indian traditions, their independence in internal state affairs and expectations that they would assimilate to European norms. The images that Deen Dayal made for the nizam emphasise his wealth, power and position, but the photographer was just as capable of producing equivalent pictures for the Central India Agency. Whether working for colonial administrators or local rulers, Deen Dayal, according to Pinney, produced images of the 'beneficence that befitted a just rule'.[62]

Conclusion

This chapter has explored a number of ways in which photography was employed in British India. In each case the practice was marked by colonialism. It is, though, important to understand that a medium

such as photography has no single history, but is instead defined by its various uses. Meanings are not inherent in photographic images, but emerge from the ways in which they are deployed in specific social settings. Photography was soon put to use by the Indian independence movement against British rule. The photographer Narayan Vinayak Virkar, for example, turned aftermath photography on its head, documenting a 1919 British massacre in which troops fired on a peaceful crowd, killing 379 people (Plate 3.27). He also made portraits of nationalist leaders, which Pinney describes as an 'anti-Imperial portrait gallery'.[63] In a similar vein, Deen Dayal created an album for Eardley Norton, one of the very first Englishmen to join the Indian National Congress, entitled *Souvenir of Hyderabad* (1892–93). Even if this album does not directly address colonialism or nationalist politics, it does contain images that break with standard colonial hierarchies and attitudes; in one image, for example, Norton holds the bridle of a horse, which would normally be the task of an Indian stable groom, while an Indian is seated on the horse and thus elevated above him.[64] At the same time, photographs appeared in a stream of publications celebrating the British Empire and the Colonial Office Visual Instruction Committee (established 1902) produced books and lantern slides for projection in the classroom.[65] Photography exists within an evidentiary

Plate 3.27 Survivor of the Jallianwala Bagh massacre points out the bullet holes, 1919. Photographed by N. V. Virkar.

framework, yet the meanings attributed to photographs derive from external relations of use and authority. In this case the external frame was colonialism.

Notes

[1] Quoted in Pinney, 2008, p. 19.

[2] Quoted in Ryan, 1997, p. 24.

[3] Said, 1979; see also Said, 1993 and Said, 2000.

[4] For example, Stoler, 2009.

[5] E. Edwards, 2001, p. 200.

[6] For the debate on over-painting, see Gutman, 1982 and Pinney, 1997, p. 77.

[7] Chaudhary, 2012, p. 109.

[8] Bourne, 1869, p. 15.

[9] Quoted in Ryan, 1997, p. 51.

[10] Bourne, 1863, p. 346.

[11] Ryan, 1997, p. 51.

[12] Pinney, 2008, p. 51; Banerjee, 2014; Sampson, 2002; Allana, 2014, p. 27; Chaudhary, 2012, pp. 108–19.

[13] Marien, 2002, p. 104.

[14] Banerjee, 2014.

[15] Chaudhary, 2012, p. 108.

[16] Quoted in Chaudhary, 2012, p. 58.

[17] Pinney, 2008, p. 22.

[18] Pinney, 2008, pp. 39–40.

[19] For the rebellion in the British imagination see Chakravarty, 2005.

[20] Quoted in Chaudhary, 2012, p. 57.

[21] Williams, 1977, pp. 132–4.

[22] For an excellent account, see Davis, 2001.

[23] Davis, 2001, p. 39.

[24] Chaudhary, 2012, p. 171.

[25] Davis, 2001, p. 26.

[26] Pinney, 1997, p. 45.

[27] Sekula, 1986; Tagg, 1988.

[28] E. Edwards, 1992, p. 112.

[29] Quoted in Ryan, 1997, p. 21.

[30] E. Edwards, 1992, p. 109.

[31] Pinney, 1997, p. 34; Ryan, 1997, pp. 155–8.

[32] Pinney, 1997, p. 35.

[33] Quoted in Pinney, 2008, p. 42; for Pinney's account of Syed Ahmed's response, see Pinney, 2008, pp. 41–7.

[34] Watson and Kaye, 1868, description of image 138.

[35] Pinney, 2008, p. 44.

[36] Quoted in Spencer, 1992, p. 99.

[37] E. Edwards, 2001, p. 134.

[38] E. Edwards, 2001; Stoler, 2009. For a comparable understanding of photographing criminals in nineteenth-century Britain, see S. Edwards, 1990.

39 Quoted in Branfoot, 2015, p. 50.

40 Taylor, 2015, p. 46.

41 Quoted in Pinney, 2008, pp. 52–3.

42 Guha-Thakurta, 2004, p. 96.

43 Quoted in Pinney, 2008, p. 71.

44 Guha-Thakurta, 2004, pp. 103–11.

45 Fergusson, 1884, pp. iii–v.

46 Fergusson, 1884, p. 13, footnote 1.

47 Fergusson, 1884, p. 16

48 Fergusson, 1884, pp. 15–16.

49 Fergusson, 1884, p. 59.

50 For more information on the protests against the Ilbert Bill and the gendered hysteria surrounding it, see Sinha, 1992.

51 Pinney, 2008, p. 73.

52 Pinney, 1997, p. 72.

53 Quoted in Pinney, 2008, p. 33.

54 Dewan, 2013a, pp. 63–6.

55 Dewan and Hutton, 2013, pp. 27–31.

56 Hutton, 2013a, pp. 85–104.

57 Dewan and Hutton, 2013, pp. 32–3.

58 Natasha Eaton, quoted in Pinney, 2008, p. 38; for court portraits, see Pinney, 2008, pp. 142–3.

59 Dewan, 2013b, pp. 114–16.

60 Hutton, 2013b, pp. 137–62; Ryan, 1997, pp. 102–4.

61 Dewan and Hutton, 2013, p. 27.

62 Pinney, 2008, p. 34.

63 Pinney, 2008, pp. 83–4.

64 Hutton, 2013c, pp. 177–88.

65 Ryan, 1997, pp. 186–203.

Bibliography

Allana, R. (2014) 'Early landscape photography in India', in Allana, R. and Delpelchin, D. (eds) *Unveiling India: The Early Lensmen 1850–1910*, Ahmedabad, Mapin, pp. 14–43.

Banerjee, S. (2014) '"Not altogether unpicturesque": Samuel Bourne and the landscaping of the Victorian Himalaya', *Victorian Literature and Culture,* vol. 42, no. 3, pp. 351–68.

Bourne, S. (1863) 'Photography in the East', *British Journal of Photography*, vol. 10, pp. 268–70, 345–7.

Bourne, S. (1869) 'Photographic journeys in the higher Himalayas', *British Journal of Photography*, vol. 17, pp. 15–16, 39–40.

Branfoot, C. (2015) 'Intersection of architecture and religion in Tripe's photographs of India and Burma', in Taylor, R. and Branfoot, C. (eds) *Captain Linnaeus Tripe: Photographer of India and Burma*, London, Prestel, pp. 49–63.

Chakravarty, G. (2005) *The Indian Mutiny and the British Imagination*, Cambridge, Cambridge University Press.

Chaudhary, Z. D. (2012) *Afterimage of Empire: Photography in the Nineteenth Century*, Minneapolis, MN, University of Minnesota Press.

Davis, M. (2001) *Late Victorian Holocausts: El Niño and the Making of the Third World*, London, Verso.

Dewan, D. (2013a) 'Public works and princely states', in Dewan, D. and Hutton, D. (eds) *Raja Deen Dayal: Artist-Photographer in Nineteenth Century India*, Ahmedabad, Mapin, pp. 53–79.

Dewan, D. (2013b) 'Royal and viceregal encounters', in Dewan, D. and Hutton, D. (eds) *Raja Deen Dayal: Artist-Photographer in Nineteenth Century India*, Ahmedabad, Mapin, pp. 110–33.

Dewan, D. and Hutton, D. (2013) 'Introduction', in Dewan, D. and Hutton, D. (eds) *Raja Deen Dayal: Artist-Photographer in Nineteenth Century India*, Ahmedabad, Mapin, pp. 16–51.

Edwards, E. (1992) *Anthropology and Photography, 1860–1920*, New Haven, CT and London, Yale University Press.

Edwards, E. (2001) *Raw Histories: Photographs, Anthropology and Museums*, Oxford, Berg.

Edwards, S. (1990) 'The machine's dialogue', *Oxford Art Journal*, vol. 13, no. 1, pp. 63–76.

Fergusson, J. (1884) *Archaeology in India, with Especial Reference to the Works of Babu Rajendralala Mitra*, London, Trüebner and Co.

Guha-Thakurta, T. (2004) *Monuments, Objects, Histories: Institutions of Art in Colonial and Post-Colonial India*, New Delhi, Permanent Black.

Gutman, J. M. (1982) *Through Indian Eyes: Nineteenth and Early Twentieth Century Photography from India*, Oxford, Oxford University Press.

Hutton, D. (2013a) 'Views of the Nizam's dominions', in Dewan, D. and Hutton, D. (eds) *Raja Deen Dayal: Artist-Photographer in Nineteenth Century India*, Ahmedabad, Mapin, pp. 81–109.

Hutton, D. (2013b) 'Images of the hunt', in Dewan, D. and Hutton, D. (eds) *Raja Deen Dayal: Artist-Photographer in Nineteenth Century India*, Ahmedabad, Mapin, pp. 134–63.

Hutton, D. (2013c) 'Elite life in Hyderabad and Secunderabad', in Dewan, D. and Hutton, D. (eds) *Raja Deen Dayal: Artist-Photographer in Nineteenth Century India*, Ahmedabad, Mapin, pp. 164–91.

Marien, M. W. (2002) *Photography: A Cultural History*, London, Laurence King.

Pinney, C. (1997) *Camera Indica: The Social Life of Indian Photographs*, London, Reaktion.

Pinney, C. (2008) *The Coming of Photography in India*, London, The British Library.

Ryan, J. R. (1997) *Picturing Empire: Photography and the Visualization of the British Empire*, London, Reaktion Books.

Said, E. W. (1979) *Orientalism*, New York, Vintage Books.

Said, E. W. (1993) *Culture and Imperialism*, London, Chatto & Windus.

Said, E. W. (2000) 'Invention, memory and place', *Critical Inquiry*, vol. 26, no. 2, pp. 175–92.

Sampson, G. (2002) 'Unmasking the colonial picturesque', in Sampson, G. and Hight, E. (eds) *Colonialist Photography: Imag(in)ing Race and Place*, London and New York, Routledge, pp. 84–105.

Sekula, A. (1986) 'The body and the archive', *October*, no. 39, pp. 3–64.

Sinha, M. (1992) '"Chathams, Pitts, and Gladstones in petticoats": the politics of gender and race in the Ilbert Bill controversy, 1883–84', in Chaudhuri, N. and Strobel, M. (eds) *Western Women and Imperialism: Complicity and Resistance*, Bloomington, IN and Indiana, IN, Indiana University Press, pp. 98–116.

Spencer, F. (1992) 'Some notes on the attempt to apply photography to anthropometry during the second half of the nineteenth century', in Edwards, E. (ed.) *Anthropology and Photography, 1860–1920*, New Haven, CT and London, Yale University Press, pp. 99–107.

Stoler, A. L. (2009) *Along the Archival Grain: Epistemic Anxieties and Colonial Common Sense*, Princeton, NJ, Princeton University Press.

Tagg, J. (1988) 'A means of surveillance: the photograph as evidence in law', in Tagg, J. (ed.) *The Burden of Representation: Essays on Photographies and Histories*, London, Macmillan, pp. 66–102.

Taylor, R. (2015) 'The pioneering photographic expeditions of Linnaeus Tripe', in Taylor, R. and Branfoot, C. (eds) *Captain Linnaeus Tripe: Photographer of India and Burma*, London, Prestel, pp. 4–48.

Watson, J. F. and Kaye, J. W. (eds) (1868) *The People of India: A Series of Photographic Illustrations, with Descriptive Letterpress, of the Races and Tribes of Hindustan*, vol. 3, London, India Museum; London, W. H. Allen & Co.

Williams, R. (1977) *Marxism and Literature*, Oxford, Oxford University Press.

Chapter 4

Building the British imperial world 1900–1939: the architecture of New Delhi

Elizabeth McKellar

Introduction

In 1911 the British decided to move their capital in India from Calcutta to Delhi. This was a move, rich in symbolism, from a trading entrepôt, which had served as the governmental centre since 1774, to an ancient imperial Indian capital replete with the monuments of earlier civilisations from the twelfth century onwards. The move was prompted in part by the mis-handled and unpopular partition of Bengal into Muslim and Hindu areas by the viceroy, Lord Curzon, in 1905. It had led to continuing unrest in the region, making Calcutta an unsafe environment for the seat of imperial government. Delhi was located inland, in a more central location, and had an illustrious pedigree as the seat of the Mughal emperors from 1639 until 1857. In re-siting their capital, the British were making a bold move to create a new imperial city in the centre of India that would symbolise their transformation from colonial traders, as represented by the East India Company coastal port of Calcutta, into imperial masters of the entire Indian subcontinent. Furthermore, Delhi had symbolic value as a key battleground in the Indian Rebellion of 1857, where the British had won a great victory, so that the city was firmly associated with British militarism and authority. The dramatic announcement of the move was made by George V during his visit to India in 1911 (Plate 4.2).

However, as the American historian David Johnson has argued, the image of apparent imperial might represented by this Royal Proclamation was more ambiguous than it appeared at first sight.[1] The early twentieth century was a time of growing nationalism in India and the construction of the new city was bound up with attempts by the British to satisfy demands for political reform. Indian nationalism was not an isolated phenomenon; there were similar pressures for self-determination throughout the empire. This chapter will consider the building of New Delhi in the wider context of British imperialism and city-building more generally in the early twentieth century. The discussion that follows draws on what has been termed the 'new imperial history', which considers the narratives of Britain and its colonies as an interrelated whole.[2] For the period around 1900, this approach has given rise to a new scholarly interest in studying the concept of 'commonwealth' and white colonial settlements, as well as the more traditional imperial relationships such as those in India. Like the concept of the 'British Atlantic', which has played a key role in recent scholarship on Britain's overseas expansion in the eighteenth century, it relies on a notion of transnational global networks throughout the empire, which as much as interacting with the centre,

Plate 4.1 (Facing page) The Red Fort, Delhi, 1639–47 (detail from Plate 4.11)

Plate 4.2 King George V and Queen Mary in the Royal Pavilion during the Coronation Durbar, Delhi, 12 December 1911. Private collection. Photo: Bridgeman Images.

influence and connect with each other. Consequently, I will look at imperial architecture in Britain in order to explore the architectural experience of empire 'at home', in this case in London, as well as in India. In examining the creation of a new capital for the subcontinent, I will consider how ideas of nationhood and *imperium* were embodied in the landscapes and architectures of colonialism, in both governmental and domestic spaces.

In 1886, a map was published in the magazine *The Graphic* in order to promote the Imperial Federation League, which had been founded two years previously (Plate 4.3). It shows the trade routes connecting the different parts of the British Empire coloured in pink. From the map, it is possible to identify four cities that all underwent major imperial building schemes in the first 30 years of the twentieth century: London, New Delhi, Pretoria and Canberra. A wave of urban expansion marked the beginnings of a new political order in the empire, together with an evolving relationship between London and its dependencies as they moved towards new forms of colonial relations. In Australia, the federal capital of Canberra exemplifies the approach taken to colonial town planning at the time, whereby a giant geometrical plan was overlaid on an often virgin site with little regard to topography, and the ensemble crowned by a lofty imperial capitol (Plate 4.4). In all these locations, architecture and planning were to play a critical role in consolidating shifting colonial identities through the creation of new spaces and monumental forms. They were intended to underscore state authority, but at the same time represented new political relations.

At the turn of the twentieth century, the British Empire seemed to be at its zenith in terms of its geographical extent and political and military might. Imperialism, 'The White Man's Burden' of Rudyard Kipling's famous 1899 poem, was considered to be fundamental to British identity and to the nation's destiny. Yet only two years later, with the death of Queen Victoria in 1901, there was a widespread sense of crisis in Britain. The empire had lost its main symbol and figurehead, and there was a keen conviction that an era had ended. Fierce competition for global resources during the last quarter of the nineteenth century, together with the military and industrial mechanisms needed to retain them, meant that in reality Britain's economic power was already waning; it became just one among many powerful industrial states. This development resulted in the foundation of pressure groups such as the Imperial Federation League (1884) and the Tariff Reform League (1903), which argued for a closer and more formal relationship between Britain and its empire, termed the Imperial Federation, or, later, the British Commonwealth (Plate 4.3).[3] At the time, however, this relationship was restricted to the self-governing dominions of Canada, Newfoundland, Australia, New Zealand and South Africa, and excluded India.

Throughout the empire, calls for self-government led to the white settler colonies being granted the status of dominions, that is, semi-autonomous protectorates within the empire, beginning with Canada in 1867. Although India was a subject rather than a settler colony, pressure there for increased self-governance

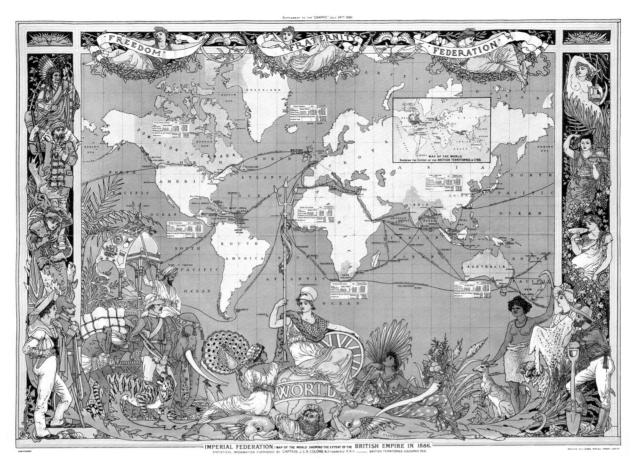

Plate 4.3 Walter Crane, *Imperial Federation: Map Showing the Extent of the British Empire in 1886*, 1886, colour lithograph, 24 × 32 cm. Published by Maclure & Co. as a supplement to *The Graphic*, 24 July 1886. Photo: AF Fotografie/Alamy.

from the Indian National Congress prompted the Indian Councils Act 1909. This legislation, referred to as the Morley-Minto Reforms, resulted in a limited increase in Indian involvement in the governance of the country. In 1910, a new viceroy was appointed, Lord Hardinge, who, unlike Curzon, recognised the need to make concessions to Indian political demands and wished to further the creation of a new kind of imperial rule based on greater Indian participation in the political process. The transfer of the capital from Calcutta to Delhi formed the centrepiece of Hardinge's strategy for initiating a new phase in Britain's imperial history. The viceroy and Lord Crewe, secretary of state for India, managed to gain the support of George V for their project for colonial reform; it was they who predicament stage-managed the monarch's unexpected announcement during his time in Delhi.

The king made his proclamation during the durbar, a ceremony that marked the climax of the festivities, held to celebrate the first and only British monarch to visit India in person. Durbars were originally Mughal court events, serving to define and display power through elaborate rituals, which reinforced relationships between different social groups, spatially as well as visually.[4] The British co-opted these elaborate ceremonies to dramatise their authority and to position themselves as heirs to the Mughal dynasty. A series of magnificent coronation durbars were staged in 1877, 1903 and 1911 in Delhi, the city being chosen specifically for its symbolic imperial and historical connections. The 1911 Coronation Durbar was a spectacular event attended by more than 100,000 people, including 20,000 massed troops. Its visual climax centred on the king and queen seated under a

AS IT IS TO BE: THE FUTURE OFFICIAL AND SOCIAL CENTRE OF AUSTRALIA.
DRAWN BY W. B. ROBINSON FROM OFFICIAL PLANS.

AS IT WILL APPEAR WHEN SET UP IN THE CHOSEN DISTRICT, PART OF WHICH IS UNEXPLORED; CANBERRA, THE PROJECTED FEDERAL CAPITAL CITY OF AUSTRALIA—LOOKING WEST.

Plate 4.4 Unknown artist of English school, *Canberra, the Projected Federal Capital City of Australia – Looking West*, 1913, litho. Private collection. Photo: © Look and Learn/Bridgeman Images.

canopy surmounted by a highly symbolic Mughal-style golden dome, representing imperial continuities past and present (see Plate 4.2). The glittering spectacle of King George's Coronation Durbar presented an image of the British Empire seemingly at its zenith. At the same time, however, the proclamation of the new capital indicated a recognition that novel political conditions required a new approach to governing an India undergoing rapid change.

This shift in constitutional arrangements took place throughout the empire and also within Britain, under the reforming Liberal government of 1905–15. The dilemma that the British faced in the early twentieth century was how to maintain the unity of their colonial possessions at a time of decreasing central political control, as empire increasingly gave way to a commonwealth of nations. One response to this predicament was to employ architecture as a unifying force throughout the colonies, using a standard iconography of architectural forms deployed in multiple locations. Around 1900 a consensus was emerging as to what the most appropriate style to signify empire might be. Architects in Britain were turning away from the so-called 'free styles' (such as the Queen Anne revival), which had themselves succeeded the Arts and Crafts Movement, towards a far more rigorous form of classical architecture.[5] Dubbed 'the Grand Manner' by the architect Edwin Lutyens, this mode looked back to the native English Baroque of Christopher Wren and John Vanbrugh, but also to the Beaux-Arts tradition of formal, rational compositions practised by contemporary French and American architects. This approach was particularly strong in the United States, where it informed the influential replanning of the official district of Washington, DC in 1901 as a spacious green city of wide processional routes lined with classically inspired buildings. The new classicism found its fullest expression in public buildings, which allowed its traditions of stone carving, manipulations of scale and rhetorical

gestures to be employed at their most dramatic (see Plate 4.6, Admiralty Arch). Its internationalism, monumentality and predominant use of stone made it especially suitable for a new architecture of empire; as Alex Bremner, one of the leading scholars in this field, comments, it was the closest Britain ever came to creating a consistent imperial style.[6]

The chapter begins by looking at London's image as the centre of the British Empire and how this was shaped in large-scale schemes in the early twentieth century. The focus then shifts to the construction of new government buildings in Pretoria, South Africa, which provided one of the most direct precedents for the subsequent creation of New Delhi. The rest of the chapter explores the history and controversies surrounding the building of the new Indian capital, and considers its planning and architecture, along with their symbolic significance in the creation of imperial identities.

1 London as the 'heart of empire'

Before looking at New Delhi, let us consider the political signification of empire in its London heartland. It had long been lamented that the capital's architecture singularly failed to match its political and economic status, comparing unfavourably with both ancient Rome and its modern European counterparts. The first opportunity to remedy this deficiency came after the death of Queen Victoria in 1901, when plans were drawn up to commemorate her reign and provide a suitable way of marking Britain's international prestige. An architectural competition was held in 1901 to provide a setting for a 'Victoria Memorial', which was won by Sir Aston Webb (1849–1930) (Plate 4.5), who went on to design the new frontage to the Victoria and Albert Museum in 1909 (see Chapter 2, Plate 2.2). A second competition for the design of the memorial itself was won by the sculptor Thomas Brock in 1902.

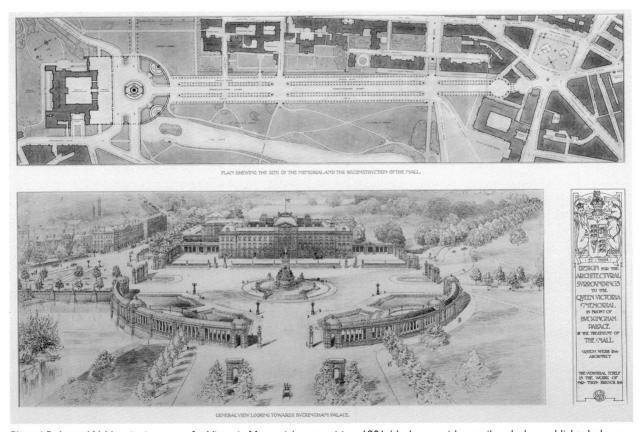

Plate 4.5 Aston Webb, winning entry for Victoria Memorial competition, 1901, black pen with pencil underlay and light dark grey washes on laid paper, 75 × 112 cm. Royal Academy of Arts, London. Photo: © Royal Academy of Arts, London. Photographer: Prudence Cuming Associates Limited.

Exercise

Have a look at Webb's winning 1901 scheme (Plate 4.5). How has he positioned the Victoria Memorial outside Buckingham Palace and how has he linked the palace with Trafalgar Square in the top right-hand corner? What kind of urban planning ideals do you think he was influenced by?

Discussion

The Victoria Memorial has been placed opposite Buckingham Palace to form the centrepiece of an axial route leading down to Trafalgar Square. The monument is set within semi-circular colonnades surrounded by other regularly placed sculptural features from which avenues radiate in different directions. Of these, the wide central boulevard to Trafalgar Square is easily the most dominant and its termination is marked by the creation of a circular space (known as a *rond-point*). The scheme draws on a grand, formal tradition of city planning, as in seventeenth-century Paris and Rome (known as the Baroque), as well as on the contemporary Beaux-Arts classical approach, as in Washington, DC. Its main concerns were to create grand linked assemblages of geometrical spaces across large areas, often with little regard to the underlying topography.

The actual memorial sat surrounded by the elaborate stone piers and gateways of Webb's scheme. Funds were sought from across the empire to finance commemorative statues to be placed on the monument as a means of demonstrating colonial loyalty, although, as the Canadian historian Tori Smith comments, the final design does not seem commensurate with their contribution.[7] A grand processional route was formed by widening The Mall, which leads from Buckingham Palace to Trafalgar Square. The latter, site of Nelson's Column and the National Gallery, both erected in the early nineteenth century, provides a reminder that imperial sites and symbols dating from earlier phases of colonialism already existed in London.[8] What was generally lacking in the capital, however, was any successful attempt to link such monuments into a greater sequence of spaces and axial routes. A similar

process was undertaken at the Kingsway, named in honour of Edward VII, which opened in 1905. It ran northwards from a freshly created monumental crescent at the Aldwych, which later became the site of India House, designed in 1925 by Herbert Baker, one of the architects of New Delhi.[9]

Webb's architectural scheme for the Victoria Memorial was extended in 1903 when an enormous triumphal arch, known as Admiralty Arch, was erected at the intersection of The Mall and Trafalgar Square (Plate 4.6). Helping to mask an awkward turn between the two thoroughfares, it represented a skilful blending of a triumphal arch, the traditional Roman symbol of imperial might, with office blocks to either side, while at the same time allowing traffic through the central opening. The arch thus served not only a symbolic but also a practical purpose, one that provides a reminder that imperial rule in the twentieth century was as much bureaucratic as military. The project marked the beginning of a world-wide phase of building public classical architecture that monumentalised empire.

No less important to Webb's arch was its capacity to allow for movement, such that the processional flow from The Mall might continue unimpeded for national and royal events. Throughout the globe, classically inspired architecture was used not just to consolidate new identities for the state but also to create spaces for the 'performance of empire'. It has been argued that the turn of the twentieth century was a particularly fertile period for the 'invention of tradition', in the form of rituals and ceremonies, to bolster and represent imperial identities.[10] The grand boulevards carved through the metropolis were used for jubilee, coronation and military parades, as well as for the annual Empire Day celebrations held on 24 May (which was only instituted in 1904). These routeways have been called 'spaces in movement', since they were shaped by their users and the activities that took place within them, as well as by those who created and controlled them.[11] Both Victoria's Diamond Jubilee in 1897 and Edward VII's coronation procession in 1902 were seen as opportunities to reinforce imperial relations, with thousands of troops, statesmen and officials attending from the colonies. These public processions formed a crucial component in the assertion of imperial ideologies in London, in a similar fashion to the durbars in Delhi.

Victory March in London, July 19th, 1919: Troops entering the Mall through the Admiralty Arch
EEE 489

Plate 4.6 First World War Victory Parade with troops entering The Mall from Trafalgar Square through the Admiralty Arch, 19 July 1919. Nelson's Column and St Martin-in-the-Fields can be seen to the left in the square. Private collection. Photo: The Stapleton Collection/Bridgeman Images.

The central Westminster area was not the only site in London associated with empire; similar processes occurred in the economic heartland of the City and in the South Kensington museum area, to which the monumental Imperial Institute was added in 1893.[12] As the cultural geographers Felix Driver and David Gilbert write: 'From at least the time of the Great Exhibition, in 1851, Londoners found a variety of ways to think of their city as the centre of empire, and by implication of the world'.[13] However, there was also an anxiety that Britain's pre-eminence might pass, as had that of imperial Rome, to which London was so often compared, a concern famously explored in Joseph Conrad's novel, *Heart of Darkness* (1899). Although the dominant ideology remained undeniably imperialist, the transience of empire was thus starting to be acknowledged well before the First World War. Paradoxically, at the same time, such anxieties found expression in, or even possibly gave rise to, an expansionist policy of new colonial city building across the globe.

2 Precedents for New Delhi

As already noted, New Delhi was not the first brand-new capital in British imperial history. As Thomas Metcalf, a historian who specialises in colonial India, writes: 'One must start with Pretoria in South Africa [where] a set of principles about imperial architecture [was] worked out ... during the decade of reconstruction that followed the Boer War.'[14] Its architect was Herbert Baker, later to be the co-architect of New Delhi. Baker, unlike the better-known Lutyens, was one of a growing band of colonial specialists who travelled the world carrying out international building projects. Baker believed that it was the role of the architect to give physical form to Britain's national ideals and 'to turn them to shape and give them a local habitation and a name' throughout the colonies.[15]

When Baker arrived in South Africa in 1892, he was taken up by Cecil Rhodes. A mining magnate, prime minister for the Cape Colony 1890–96 and founder of Rhodesia (now Zimbabwe), Rhodes was the leading British imperialist in southern Africa. Baker imbibed Rhodes's imperialist vision wholesale and even wrote his biography, *Cecil Rhodes by his Architect* (1934). Following his mentor's death in 1902, Baker designed his memorial in Cape Town as well as Rhodes House, Oxford (1926–29), home of the Rhodes Scholarships, one of several benefactions to his *alma mater* (Plate 4.7). In 1900, Rhodes had sponsored Baker to go on a tour of classical sites in the Mediterranean. Baker saw the development of a monumental classical style, similar to that used in antiquity, as a potent means of symbolising the union of the various southern African colonies into the fledgling nation. At Pretoria, Baker decided to site the new government buildings on a rocky outcrop, echoing the Acropolis in Athens. He created a series of terraces and steps, a *via sacra* (sacred way), up to a monumental structure. It comprised two horizontal office blocks symbolising the union of the 'two races' of South Africa: not the black and the white, but the Dutch and the English. The blocks were connected by a giant semi-circular colonnade from which the rulers

Plate 4.7 Herbert Baker, Rhodes House, Oxford, 1926–29, front elevation with portico and domed rotunda surmounted by a bronze Zimbabwean bird. Photo: Steve Cadman via Flickr.

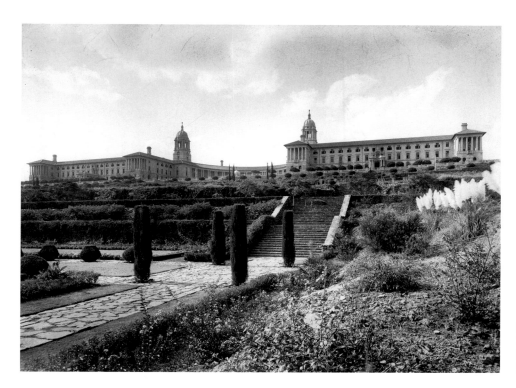

Plate 4.8 Herbert Baker, Union Buildings, Pretoria, South Africa, 1910–14. Photo: RIBA Collections.

of the new state could survey the existing town below, a feature that Baker was to repeat in New Delhi (Plate 4.8). Although symbolising empire, like the London scheme, the Union Buildings were erected just as the British dream of power in South Africa was beginning to fade and the Boers returned to power. Thus, when Lutyens asked the more experienced colonialist Baker to join him in India in 1912, Baker accepted with alacrity.

In India, the situation was somewhat different, since the association between official buildings and classicism already had a long pedigree there. In East India Company cities, such as Calcutta and Madras, as in the rest of the British colonies in the eighteenth century, the architecture was classical, as in the case of the Council House in Calcutta. This was the headquarters of the East India Company and the principal government centre for Bengal prior to 1803 (Plate 4.9). Another such building was Government House, the residence of the governor of Bengal (Plate 4.10). However, the first classical buildings in British India were churches, such as St John's, Calcutta (1787), designed by Lieutenant James Agg of the Bengal Engineers. The majority of British buildings in India were the work of military surveyors and engineers or other non-architects, like Agg. The exception to the rule was the position of official architect to the East India Company. Even after 1854,

only a handful of well-known British architects worked in India, and even then many of them, like Sir George Gilbert Scott who designed buildings in Bombay, never set foot on the subcontinent but sent their designs over for others to construct. The establishment of the Public Works Department (PWD) in 1854 did not change this pattern, as its focus was on providing the infrastructure for the colonial system in the form of roads, railways and irrigation systems alongside strictly utilitarian buildings. It was not until the late nineteenth and early twentieth centuries that architects were generally employed by the PWD.[16] The first consulting architects were appointed from the 1880s and the first chief architect, Robert Tor Russell, in 1919.

In the eighteenth century Calcutta became known for the magnificent merchants' town houses and commercial buildings that lined its principal streets, such as the Calcutta Turf Club (c.1820), which still survives. However, it was not until 1800 that the building of the new Government House in Calcutta provided, in the words of the architectural historian Preeti Chopra, 'the first unambiguous architectural pronouncement of British imperial power on the Indian subcontinent'.[17] It was instigated by the incoming governor-general, Lord Wellesley, and designed by Charles Wyatt of the Bengal Engineers. The new official building was based on

153

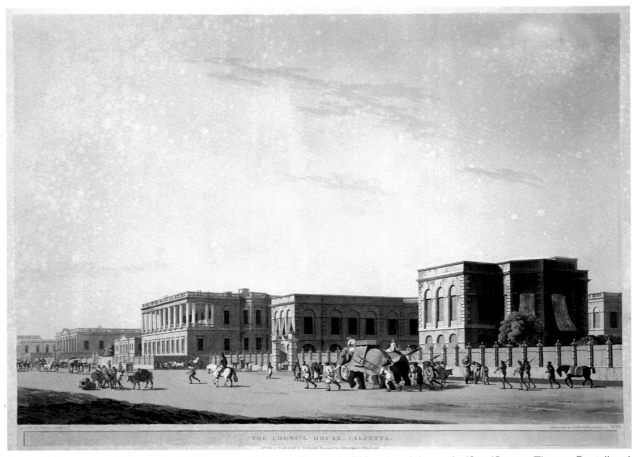

Plate 4.9 Thomas and William Daniell, 'The Council House, Calcutta', 1798, colour lithograph, 48 × 65 cm, in Thomas Daniell and William Daniell, *Oriental Scenery: Twenty-Four Views in Hindoostan*, Part 2, London, Thomas Daniell, 1798, Plate 29. Private collection. Photo: The Stapleton Collection/Bridgeman Images.

Plate 4.10 Charles Wyatt, Government House, Calcutta, 1803, photograph in J. H. Furneaux, *Glimpses of India: A Grand Photographic History of the Land of Antiquity, the Vast Empire of the East*, Bombay, C. B. Burrows, 1895. Private collection. Photo: © Look and Learn/Bridgeman Images.

Kedleston Hall, Derbyshire (1761), which was designed by James Paine, who illustrated it in his *Plans, Elevations, and Sections, of Noblemen and Gentlemen's Houses* (1767). At Kedleston, Paine deployed a Palladian villa, a common building type in British domestic architecture inspired by the work of the sixteenth-century Italian architect Andrea Palladio, but manipulated the standard format with novel variations. Government House echoed its prototype in consisting of a large central block, connected by curving corridors to not just two (as at Kedleston), but rather four symmetrical pavilions. An Ionic portico approached by a huge ceremonial staircase, befitting the building's official status, marked the entrance, while the centrepiece of the garden front was a domed rotunda topped by a large figure of Britannia. Up until this time, the governor-general had lived in rented quarters, an arrangement that echoed Calcutta's origins as a trading, commercial city whose growth was unplanned. Wellesley felt, however, that such accommodation was unbefitting, a view shared by Lord Valentia, who, defending the scheme against extravagance, stated, 'I wish India to be ruled from a palace, not a counting-house; with the ideas of a Prince, not with those of a retail-dealer in muslins and indigo'.[18] As a further sign of confidence in British rule, the new governmental centre was built outside the old fortified area of the city facing the *maidan*. The latter was originally a large open space used as a military firing range, but became a parade ground in the much wider sense of the word, with a performative purpose for ritualised gatherings and promenading by the British community.

3 The creation of New Delhi (1911–31)

By the early twentieth century, Calcutta had developed a strong identity and the proposed move to Delhi was strongly resisted by its British and Indian commercial and political elites. Besides the primary political factors motivating the move, Delhi was chosen because of its more central location and its historic importance as former seat of the Mughal Empire. Furthermore, the climate was far better than that of Calcutta for Europeans, resulting in a shorter removal of the British administration each year to the summer capital. Since 1863 the entire government had decamped to the cool of the hill station of Simla (Shimla) for seven months, whereas from Delhi the relocation would 'only' be for five months. The decision to build the capital

afresh resulted in a vast governmental construction programme that continued well beyond the end of the First World War. The bill for the building of the new capital was initially put at £4 million, an estimate that was to plague its supporters for years to come when costs inevitably escalated.[19] As at Pretoria, by the time construction had finished nearly 20 years later, the political landscape of India had shifted immeasurably. This section will explore both the issues and processes behind the reshaping of Delhi, as well as the changing ideologies and identities attached to its architecture, as the independence movement gained momentum during the early twentieth century.

The British, as has been noted, deliberately chose for their new governmental centre a city that had an imperial past. Delhi had been the capital of the Mughal Empire until 1857, when the British conquered the city following a fierce battle during the Indian Rebellion. It was known as Shahjahanabad, after the Mughal Emperor Shah Jahan, the builder of the Taj Mahal, who created a palace-cum-fortress at the Red Fort (Lāl Qila) in 1639–48 (Plate 4.11) as well as other notable monuments such as the city gates and the Jama Masjid mosque (1644–56). The fort derives its name from the red sandstone from which its outer walls and gateways were constructed. Other characteristic features of Mughal architecture can be seen on the exterior, notably the use of the Islamic pointed arch and the *chatris* (domed pavilions) appearing prominently on the skyline (see Chapter 2, Plates 2.18 and 2.19). The textured roughness of the sandstone contrasts strongly with the smooth gleaming surfaces of the white marble with which the imperial buildings inside the compound were faced. Marble was used extensively for the most prestigious Mughal edifices, most famously at the Taj Mahal at Agra. The Mughals were Muslims of central Asian origin but had absorbed many Persian and Hindu influences. Like Agra, which it had replaced as the Mughal capital, Shahjahanabad was therefore a hybrid transcultural city. It was this Mughal city that the British looked to for New Delhi's topographical and architectural context, while at the same time overwriting the more recent bloody history of conflict and suppression during the Indian Rebellion.

The British placed New Delhi next to the seventeenth-century capital now re-labelled by them as 'Old Delhi'. They had already re-shaped the existing city to some extent after the Indian Rebellion, when railway lines

Plate 4.11 The Red Fort, Delhi, 1639–48. Photo: Bridgeman Images.

were driven through the town and many Mughal buildings between the Red Fort and the Jama Masjid were razed in order to create a 450-metre free-fire zone, within which anyone could be a legitimate military target. Subsequently most of the old city was allowed to sink into a slow decline through neglect. The intended imperial capital likewise ignored the majority of the existing buildings, but key monuments from the Mughal past were incorporated into the new city through strategic positioning. The chosen structures were aligned with the chosen site by creating axial linkages within Lutyens's classical plan (Plate 4.12). The aim was to create a narrative that stressed the continuity of colonial rule between the Mughals and the British, thereby helping to justify and explain the new 'Imperial' Delhi.

The principal way in which this was achieved was through the Archaeological Survey of India (ASI), founded in 1861 to document and survey the architectural remains of Indian antiquity, which built on James Fergusson's pioneering work. The ASI was just

one of the so-called 'scientific departments' by means of which the British sought to classify and control their colonial subjects; other examples of such work included the census, cartographic maps and ethnographic gazetteers.[20] The ASI judged all Indian styles against the standard of Western classicism; by this measure, Mughal architecture, particularly that dating from the reigns of Emperor Akbar and Emperor Shah Jahan, was held to be the most significant, although of course still inferior to European structures. In this way, Delhi became configured as the 'Indian Rome', and, as such, the natural place for siting the latest 'Rome' of British imperialism.[21]

In looking at the Red Fort, it is possible to see how the regular geometry and limited use of decoration would have had greater appeal to European classicists of the early twentieth century than other, more decorated, indigenous architecture. The Mughal style was of course itself a hybrid, containing a mixture of Islamic, Indian and Persian elements. The fort served the Mughals both as the centre of government and as the court, where

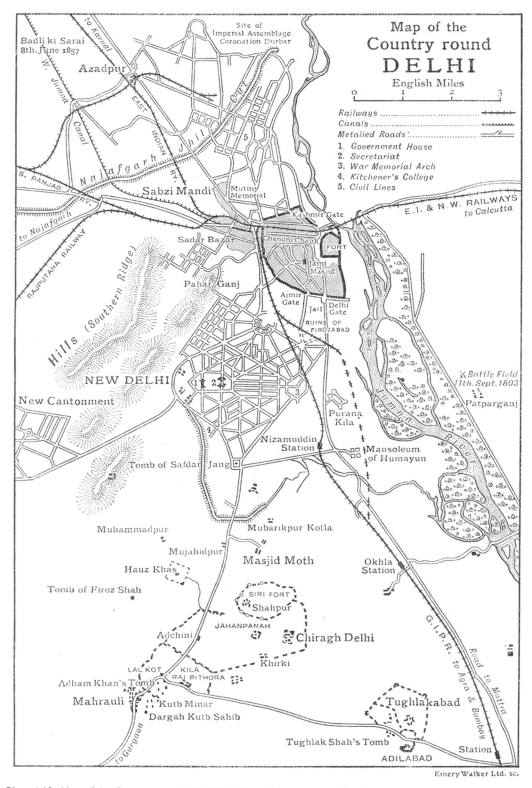

Plate 4.12 *Map of the Country round Delhi*, 1924, 32 × 21 cm, engraved by Emery Walker Ltd. Photo: Antiqua Print Gallery/Alamy.

Plate 4.13 Diwan-i Amm (Hall of Public Audience), The Red Fort, Delhi, 1639–48. Photo: Bridgeman Images.

they received homage and conducted business. It was the most important of many sites that received special funding from the British for restoration prior to their incorporation into the new city. Work on it had already begun during Lord Curzon's time as viceroy in 1899–1905, with as much attention being paid to the interior as the exterior. The Diwan-i Amm (Hall of Public Audience), which had been the main Mughal governmental and reception space for official visitors, was returned to something close to its former glory (Plate 4.13). It was one of a number of magnificent marble structures in the imperial enclosure and no expense was spared in the restoration, including hiring a Florentine craftsman to restore the mosaic wall decoration and *pietra dura* or stone inlay work, which Shah Jahan had appropriated from Italian models (see Introduction, Plate 0.5). This exceptional effort was justified by the Fort's continuing use by the British as a site for official functions, second only to Lutyens's Durbar Hall at Government House. Not only was the Red Fort 'restored', but also missing elements were recreated to provide a suitably imperial air, such as the life-sized statues of elephants that originally stood in front of the Delhi Gate.

In the case of the Red Fort, an existing Indian building was recreated and recast as a crucial monument in the new British conception of the city. It became one of the key performative spaces of empire, in a similar way to The Mall and the Admiralty Arch in London. It was used for the Delhi Coronation Durbar of 1911 as a state ritual space and the setting for one of the royal garden parties held on this occasion. The Mughal monuments were used like pavilions in an English garden, as a means of adding variety and interest to the ruler's estate. In his description of the Secretariat Buildings at New Delhi, Baker wrote that officials could look out from his porticoes across 'the far ruinous sites' of a historic capital, and then look down 'to the new capital beneath them that unites for the first time through the centuries all the races and religions of India'.[22] In this way, the British abrogated to themselves the power to interpret and edit the Indian past at the same time as they sought to reclaim and reincorporate it into their own invented version of India. In addition, the positioning of the new British capital against a backdrop of decayed indigenous cities helped to contrast Britain's enlightened, rational, modern view of the world with India's imperial, 'Oriental' history.[23]

New Delhi, like the contemporaneous cities of Pretoria and Canberra, can be seen as a product of the realignments within the British Empire in the early twentieth century. Although India, unlike the white settler colonies, was not awarded dominion status, New Delhi was nevertheless conceived by Lord Hardinge as a symbol of the new 'liberal' India. The moves towards self-government had resulted in a situation in which the British retained political control but now depended even more on the expertise of the Indian administrative

class. Hardinge stated that the new city would not, as had been the case in Calcutta, simply be ruled by a British administration, but rather it would be the product of a joint British-Indian one.[24] The question was, what was the most appropriate architectural style to symbolise these new arrangements?

Lutyens and Baker were in accord that New Delhi, like Pretoria, should be built in a classical style as the most appropriate one for a colonial city. Indeed, Lutyens's first sketch designs were for a super-sized Palladian villa (Plate 4.14). His enthusiasm for the style shines through in his exuberant declaration that: 'In architecture Palladio is the game!!'.[25] However, Hardinge was equally certain that, in a political climate favouring a redefinition of empire, it must include at least some 'Indian' elements. He himself urged the use of the Indo-Saracenic style, while the principal of the Calcutta School of Art, E. B. Havell, wished to see the adoption of a fully Indian style; he favoured Mughal architecture, which he considered particularly appropriate in the context of Delhi. This became a hugely contentious issue in both India and Britain, with debates in Parliament and heated correspondence, not just in the architectural press but also in the national newspapers. According to Giles Tillotson, the controversy 'was essentially a continuation of the nineteenth century quest for a politically appropriate style, expressive of the imperial role'.[26] There was also, however, a second debate regarding the execution of the project, which promoted the technical and educational benefits of incorporating Indian elements, on the grounds that it would be a chance for the state to support a revival of handicraft techniques that had been lost.[27] In his *Indian Architecture* of 1913, Havell wrote: 'what finer opportunity can there be than the building of the new Delhi for inaugurating a new architectural and educational policy'.[28] Support also came from Indo-Saracenic designers such as John Begg, the government's chief official architect in India, who argued that the classicism of Calcutta was the style of 'mere Western occupation', and that architectural policies should echo changes in political ones.[29]

Neither Lutyens nor Baker, nor the previous viceroy, Lord Curzon, a vocal contributor to the debate, were impressed by such arguments; the latter objected that the 'feminine' nature of Eastern architecture made it unsuited for the masculine project of imperialism. Replying to a letter from Havell in *The Times*, Baker wrote that hybridity 'may well seem impossible in

architecture as in race and national characteristics'.[30] Lutyens was even more dismissive, stating: 'personally I do not believe there is any real Indian architecture or any great tradition'. Bringing his hero into the argument, he then asked rhetorically: 'Would Wren, had he gone to Australia, have burnt his knowledge and experience to produce a marsupial style?'[31] Lutyens constantly denigrated Indian architecture and Indians so that, in the words of his biographer, it is 'small wonder that many Indians today dismiss him as an Imperialist and racist'.[32] However, Hardinge was adamant that the political significance of the new buildings overrode the normal deployment of Western classical architecture as a marker of superior 'civilised' values. He argued that the use of an 'Oriental' style would help emphasise imperial continuities, presenting the British as the new Mughals, as well as indicating sympathy with Indian nationalist aspirations. What he wanted to see, he wrote, was a composite architecture, at once British and Indian, that would symbolise twentieth-century India.[33] In the end, Hardinge prevailed, with the result that Lutyens, who had already completed the outlines of the scheme before Baker's arrival, was forced to add Indian elements to his Western compositions. Sir Swinton Jacob, the Indo-Saracenic specialist, was even appointed as a special advisor to Lutyens in order to educate him in the use of Indian styles. Lutyens, however, was irritated by Jacob who, already in his seventies at the time, soon resigned from this advisory role and retired to Britain.[34]

The development of the site was overseen by the 'Imperial Delhi Committee', the members of which included Lutyens and Baker. They were in charge of the planning of the new city and all the major buildings within it. Some of the less prestigious architecture was entrusted to the Government of India Architectural Group, who were responsible for all the other official buildings in the country; they also ran the project during Lutyens and Baker's long absences from India. Although the overall design was firmly in European hands, right down to the light fittings and the door handles, the construction and the execution of the decorative details were exclusively carried out by local craftsmen and builders. A painting by Marjorie Shoosmith, wife of Arthur Shoosmith (the project architect from 1920 onwards), illustrated the eventual compromise; her use of an Indian idiom for the picture affirms the British claim to legitimacy through their reinvention as the new Mughals (Plate 4.15). It shows Lord Irwin seated in the pose of a Mughal emperor, while Lutyens and Baker

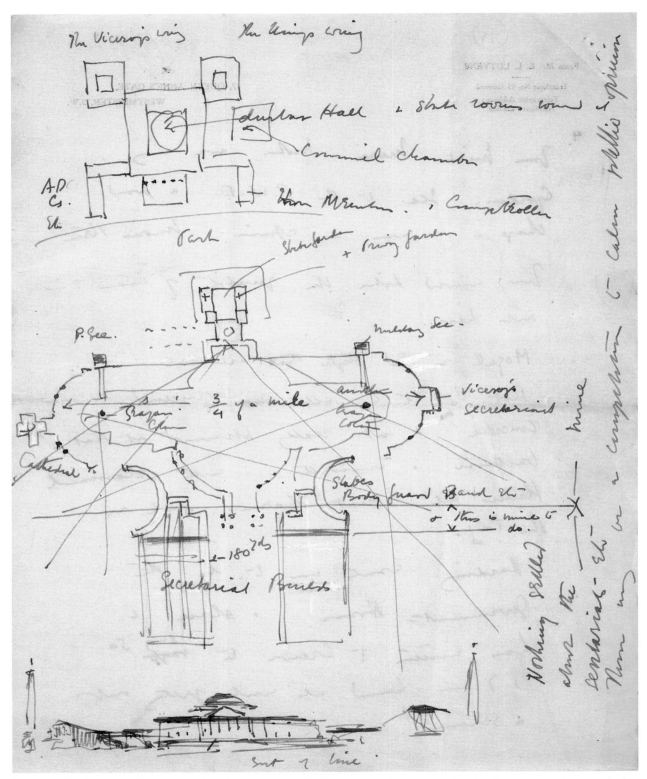

Plate 4.14 Edwin Lutyens, letter to Herbert Baker with a preliminary sketch plan and elevation for Government House, with plan of the capitol complex, 13 June 1912, New Delhi. Photo: RIBA Collections.

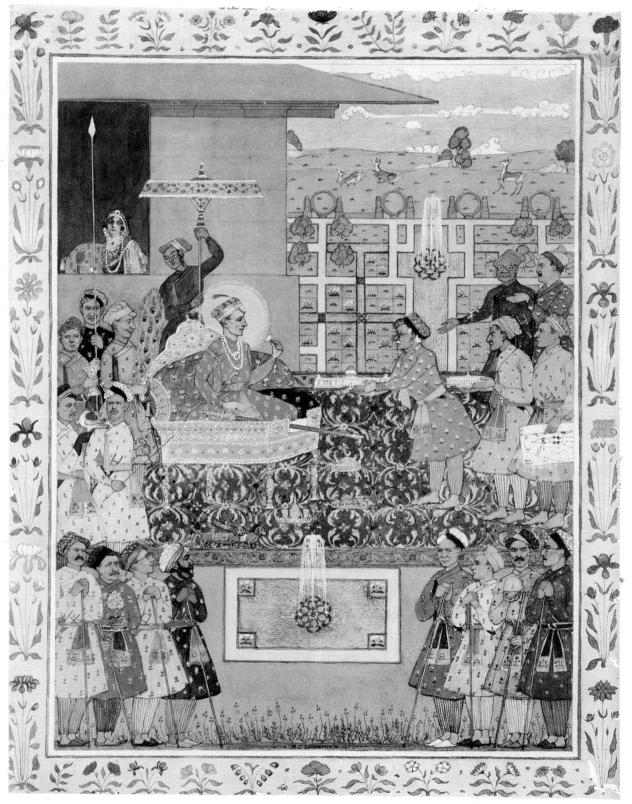

Plate 4.15 Marjorie Shoosmith, *New Delhi Completed*, depicting Edwin Lutyens and his team presenting a model of the Viceroy's House, New Delhi, to Lord Irwin (then viceroy), 1931, print of original watercolour. Photo: RIBA Collections.

present models of their designs to him, with Sir Alexander Rouse, the chief engineer, behind, holding the plan. Lady Irwin can be seen in the pavilion in the background as if she were in *purdah*. The workforce for the project included, at one end of the scale, some big construction firms and, at the other, unskilled Indian labourers, including women and children, who were housed in a temporary slum city of tin shacks known as 'Tin' Delhi.

4 The design of New Delhi

The layout of 'Imperial' Delhi was a grand radial arrangement of the Baroque type, deriving originally from Wren's post-Great Fire of London plan, by way of more recent examples such as Washington, DC and Canberra, organised around a giant equilateral triangle (Plate 4.16). The resulting ground plan mixed Beaux-Arts rationalism with the idea of a green city, the latter derived from the garden city movement of the period. An imperial acropolis was placed on the high ground of Raisina Hill, orientated away from the Jumna River with views over the existing city and the ruins of the ancient city of Indrapat (Indraprastha) (1000–1800 BCE) (see Plate 4.12). A grand avenue called the King's Way provided the central axis, which was itself bisected by a secondary line called the the Queen's Way. These formed the basis for a complex series of interconnecting triangles stacked into hexagons, with roundabouts marking the critical junctions, as in Webb's scheme for The Mall in London. The central processional and symbolical spine of the King's Way ran from Viceroy's House and the Secretariat Buildings (the civil service accommodation), and was punctuated along its two-mile length with key monuments such as the Jaipur Column, the All India Arch and, in due course, a monument to George V. The scheme was an assertion of political authority, as expressed through the classical tradition of grand, geometrical plans, creating vistas and linking monuments, old and new, across a vast and imposing landscape.

Following the model of Canberra, the plan was organised on modern planning principles into distinct zones. They comprised three distinct areas: governmental, residential and commercial. No provision was made for industry, which was confined to the old city and the suburbs. The government buildings were located in the central zone, surrounded by housing which was distributed hierarchically, with the residences of the most senior politicians and officials located nearest to the centre, along with an area for Indian royalty, and the rest arranged in decreasing layers of social importance towards the periphery. The entire residential sector was encircled by a green belt, consisting of a ring of mainly recreational spaces for the sports so central to colonial life, such as polo and golf. Adjoining the new city lay the residential areas of the military cantonment and the civil station, which typically formed the twin bases of the planning of British cities in India; the regular grids of military accommodation are still referred to today by their colonial designation as 'lines'. The commercial district at Connaught Place lay half-way between the old and new cities; it was accessible only by car by residents of the so-called 'Bungalow Zone' a couple of miles away (as explained in the next section). In contrast to the narrow bazaars of Old Delhi, its shaded, circular European colonnades were intended for a new chauffeured elite (see Plate 4.25).

The political, racial and class dimensions of this plan were first explored by the urban theorist Anthony King, who, in a ground-breaking book published in the 1970s, mapped the relations of class and caste on to the physical elements of the old and new cities.[35] King analysed the way that the hierarchy of building types, from the monumental to the domestic, was elaborated in the spatiality of the city's ordering. During the nineteenth century, the British increasingly sought physical separation from the indigenous population, due to the prevalent ideologies of social exclusivity, racial purity and discourses of health and hygiene. This development resulted in a contrast between New Delhi, which was characterised as new, clean, European and civilised, and Old Delhi, which was seen as disorderly, insanitary and Indian. The binary oppositions that King outlined have been challenged by more recent scholarship, which has queried the idea of a 'dual city' in the case not only of Delhi but also of other colonial cities.[36] The new imperial history, along with the broader shift in post-colonial approaches, has stressed the importance of hybridity and the recognition of indigenous perspectives and experiences within colonial spaces. The architect and cultural historian Jyoti Hosagrahar, for example, has questioned the extent of social and spatial segregation between the old and new Delhis in the pre-independence era. She shows that Old Delhi too underwent modernisation in this period and also that New Delhi formed a site of acculturation, or selective adoption of cultural practices often from a dominant

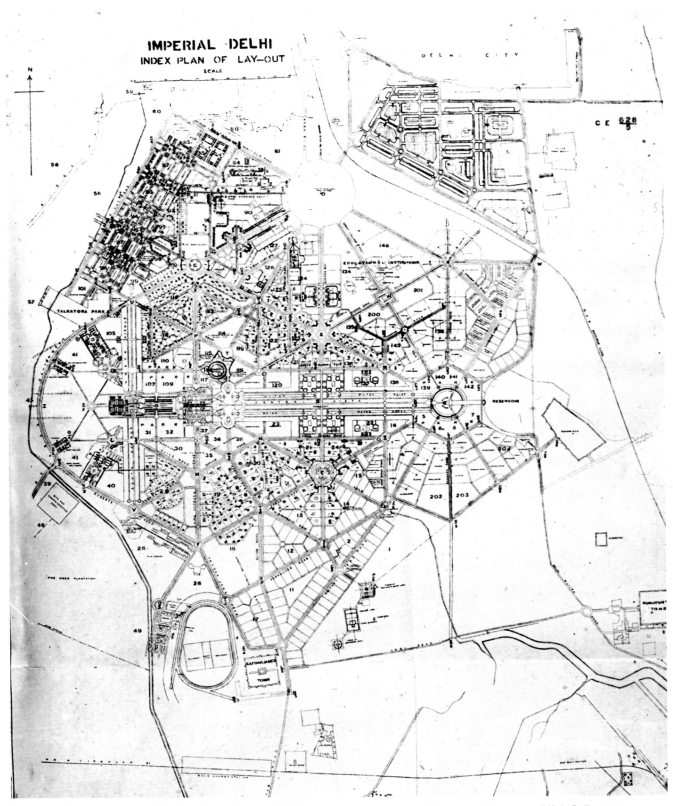

Plate 4.16 Edwin Lutyens and Herbert Baker, 'Imperial Delhi, index plan of lay-out', 1920, lantern slide. Photo: RIBA Collections.

culture, by a growing Indian middle class, something I shall explore further when I look at housing. Hosagrahar has proposed the concept of 'indigenous modernities' as a means of exploring how the Western universal notion of modernity was challenged and reinvented by Indians in the many layers and types of spaces that comprised Delhi in the early twentieth century. She argues that even where the architectural elements were European, 'in a reconstituted context', 'the spatial culture – use, meanings and practices – in which the buildings were embedded, differed significantly'.[37] Colonial urbanism, then, was a complex process of, on the one hand, assertions of imperial might and modernisation by the colonial state and, on the other hand, strategies of contestation, modification and acculturation to the new planning layouts and building forms by the indigenous population.

The New Delhi plan combined long-standing classical geometry with a new modernist rationalism based on the principles of scientific management, as expressed through the nascent means of town planning. This quasi-scientific approach to urban design was assumed to be universally valid, regardless of location, culture or society. Despite its classical layout, New Delhi is a modern city designed for the motor car and the bicycle, the first a form of transport used by Europeans and the other one primarily that of Indians. Old Delhi, with its tightly knit agglomeration of buildings, internal courtyards and narrow alleyways, was a city created for movement on foot. For a Western audience, the very contrasts in layout and density embodied the supposed superiority of modern, logical planning over the organic, unplanned development of a historic settlement, or, as

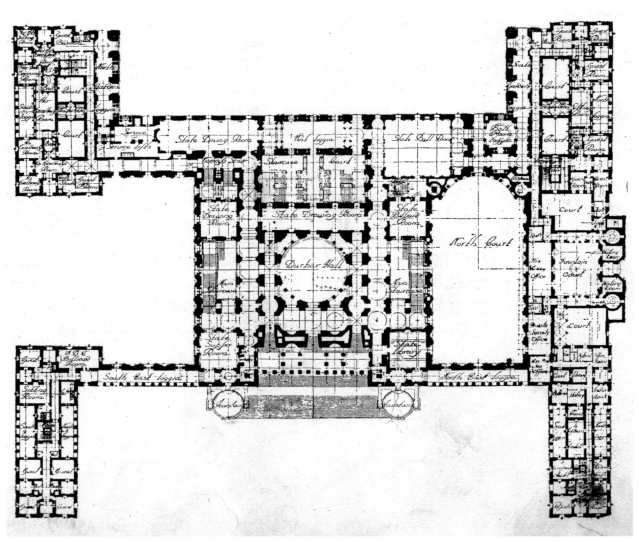

Plate 4.17 Edwin Lutyens, plan of Viceroy's House, New Delhi, 1931. Photo: RIBA Collections.

it was increasingly termed, a 'slum'.[38] The low density layout of the new city relied not only on the motor car, which allowed Europeans to traverse its hot streets in comfort, but also on new technology, particularly the telephone, which allowed for rapid communication between politicians and civil servants across its widely spaced offices. New Delhi re-ordered the traditional divisions of the colonial city in a new way shaped by modern technologies. King characterised it as the first modern colonial city.

The hierarchies of the plan, as at Pretoria, were topographical as well as spatial. The site chosen lay to the south of the old city on high ground, with Viceroy's House, later known as Government House and today as Rashtrapati Bhavan, occupying the apex of the site. The intended effect was obliterated by Baker's decision to move his Secretariat blocks up the hill to give them

greater prominence, thereby substantially obscuring Lutyens's dome from the King's Way and diminishing the climax of the entire city's composition, an unintended consequence not discovered until it was too expensive to rectify. It led to the end of the friendship between the two men and a prolonged battle in which Lutyens was eventually forced to concede defeat, claiming, with his characteristic wit, that he had met his 'Bakerloo'. However, despite the obscuring of its dome, from close to the vast scale of Viceroy's House could not be mistaken. It covered 19,000 square metres, providing a palace of gigantic Piranesian proportions. Under the dome at the heart of the edifice sat the Durbar Hall, as can be seen on the plan of the building (Plate 4.17). It formed a spectacular round reception space, complete with imperial thrones, set within the square central block of state rooms (Plate 4.18). While the interior was modelled on the Roman Pantheon, the exterior shape references

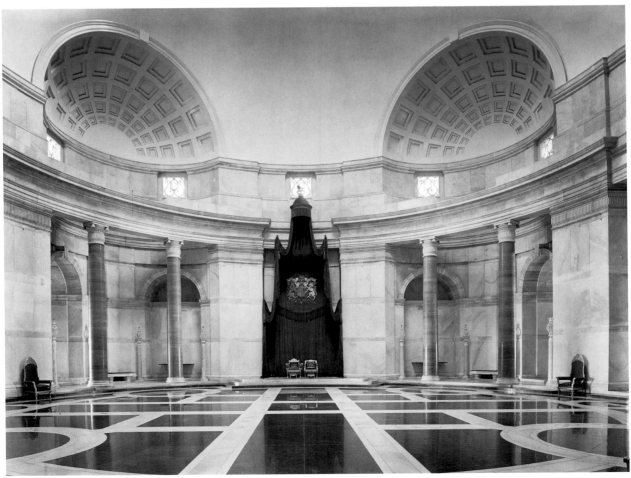

Plate 4.18 Edwin Lutyens, the Durbar Hall, Viceroy's House, interior with viceregal thrones and the Delhi order on the capitals of the colonnade, New Delhi, 1931. Photo: © Country Life.

Plate 4.19 Edwin Lutyens, fountains in the water gardens, Viceroy's House, New Delhi. Photo: Chris Hellier/Alamy.

the Buddhist *stupa* at Sanchi; it also makes allusions to domed imperial Mughal tombs around Delhi, such as that of Humayun (1569–70). The columns in the hall and those used on the exterior have their own unique Delhi order, consisting of a stylised acanthus motif, with angle bells derived from Mughal designs. In inventing a new order for Delhi, Lutyens followed the precedent of the United States Capitol, where an American order had been created.

The four wings contained guest and staff accommodation and offices, while the viceroy's private residence was located in the south-west block, forming in effect an English country house in its own right, complete with numerous servants. The viceregal estate comprised 154 hectares of largely green space, including 6 hectares of formal gardens further reinforcing, albeit on a gigantic scale, parallels with the British country house and its landscape. The gardens were explicitly intended to evoke Mughal imperial water gardens, such as those at the Red Fort and Agra, which were associated in Indian culture with paradise and the eternal (Plate 4.19). The extensive theatrical use of water in both house and gardens, creating a green oasis in a dry landscape, symbolised as powerfully as the structures themselves British technological and political domination of the land and its resources.

Exercise

Study Plate 4.20, showing the main entrance front to Viceroy's House. How would you characterise the composition of the elevation? Consider what its main elements are and how successfully they combine. What design features of Indian origin can you identify and how are they integrated into the overall design? Take the Red Fort (Plate 4.11) as your point of reference for doing so.

Discussion

As the main entrance front to the palace, this would have been intended to be the most imposing elevation from both near and far and is expressed by the imposing length of the colonnaded façade surmounted by the prominent dome. The contrasting cream and red sandstone is the most immediate indicator of the Indian context, which creates a link to Mughal buildings such as the Red Fort. The careful proportioning between the different geometrical elements of the design derives from classicism, with the dome being twice the height of the house. Domes are traditionally used in Western architecture to mark great monuments, such as cathedrals and palaces, and Lutyens

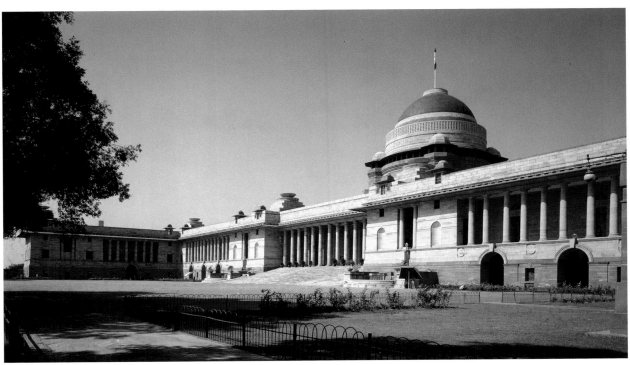

Plate 4.20 Edwin Lutyens, Viceroy's House, east front, New Delhi, completed 1929. Photo: Bridgeman Images.

was drawing on both British and other classical precedents here. However, the dome's profile and smooth form derive from the Great Stupa at Sanchi, the oldest stone structure in India. It was originally commissioned by the Emperor Ashoka in the third century BCE. The dome is surrounded by four smaller *chatris* and others are placed above the parapet, as was common in Mughal architecture and can be seen at the dome of the Red Fort. Some features which may appear classical at first glance are also deceptive. The cornice may seem oversize for it is in fact a *chajja*, the large dripstone used to throw off the monsoon rains and provide shade in the summer. The overall effect is of a hybrid composition, combining the proportioning and layout of Western classicism with a dramatic skyline of Indian domes and *chatris*. The inclusion of the latter can be read as having a double signification, being simultaneously both traditionally imperialist and reformist. On the one hand, they signify the Western predilection to appropriate Indian forms and demonstrate European power over native heritage. On the other hand, the abandonment of a purely classical

approach (such as had been used in Pretoria) and the incorporation of indigenous elements can be seen as symbolic of a new form of colonial contract.

Lutyens's viceroy's residence gives the appearance of a vast elemental construction, such as a fabled ancient palace, come to life. The Buddhist form of the dome was chosen as a more neutral alternative to selecting either a Hindu or Islamic form. Some commentators have criticised Lutyens's handling of the Indian features as being clichéd; Tillotson, for example, describes the building as a combination of disparate elements, rather than a true synthesis. The incongruity would originally have been heightened further by the inclusion on the façade of two larger-than-life statues of George V and Queen Mary that were removed after independence. In this respect, it echoed the unconventional juxtapositions of vernacular and classical details for which Lutyens's country houses were renowned.[39] A case in point is Abbotswood in Stow-on-the-Wold, Gloucestershire (1901–02), where finely carved stone doorways and

Plate 4.21 Herbert Baker, Secretariat Buildings, north block, New Delhi, completed 1926. Photo: Ephotocorp/Alamy.

windows are counterpoised against rustic walling, creating almost Michelangelesque mannerist effects. Baker was to employ a similar technique at Rhodes House, Oxford (1926–29), where he added a severe classically derived rotunda with portico onto the main Arts and Crafts-style building, the transition between the two providing a dynamic contrast internally and externally (see Plate 4.7).

In incorporating details taken from Indian architecture within what are thoroughly classical designs, the British architects working at New Delhi were continuing a technique they commonly employed in the rather different context of their domestic work to create eye-catching effects. It is the Viceroy's House with its dome that can, above all, be read as a symbol of what Johnson has referred to as a double narrative of authority and reform. On the one hand, it symbolised British imperial might brooding 'over the city, astoundingly animate, like the topeed head of a British soldier ... while great arms below grasp to subdue in their embrace an alien land and culture', as Robert Grant Irving puts it.[40] On the other hand, as Johnson argues, its use of what many of its Indian audience would have recognised as a Buddhist form advertised the desire for a new regime based on consent and co-operation rather than coercion and conquest.[41] It is also worth noting that nineteenth-century commentators, such as Fergusson, had championed Buddhist art, which they saw as the peak of Indian civilisation. The choice of

the Buddhist dome may well have been influenced by these debates, as well as by the fact that it tallied with the imperial message. Ironically it was the whimsical Lutyens, rather than the imperialist Baker, who is generally acknowledged to have most successfully brought together the two architectural traditions to create his own unique hybrid style, to represent a new British India. Ultimately, however, it was the vast scale of the viceroy's estate as much as anything that was representative of Western political domination. It would have been impossible for the British to construct such an edifice without the benefits that they reaped from the imperial economy, including, most importantly, cheap labour.

The other main edifices in the original scheme were the Secretariat Buildings atop the imperial acropolis, which were designed by Baker to house the various ministries of the regime (Plate 4.21). Here Baker provided his own version of the 'Grand Manner', using strong sculptural blocks placed in a repeating pattern that created a dynamic rhythm and a fitting frame for the more statuesque qualities of Viceroy's House. To an even greater extent than there, the skyline of the Secretariat blocks is dominated by large *chatris* set atop projecting pavilions. For both compositional and practical reasons, Baker also made extensive use of the pierced screens called *jalis*, which allowed air to circulate freely through the building. Indeed so successful was Baker in eliminating light and heat from the blocks that they became notoriously cold

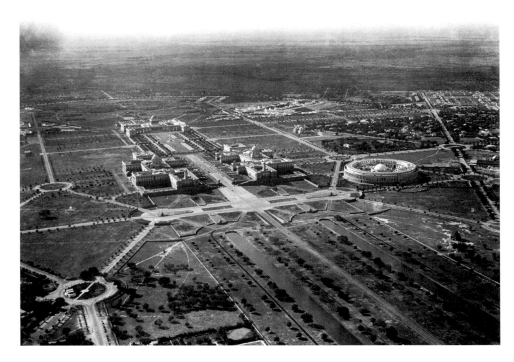

Plate 4.22 Aerial view of government buildings in New Delhi, c.1935. The two symmetrical structures facing each other are are the north and south blocks of the Secretariat Buildings with the Viceroy's House in the background. On the right is the Council House. Photo: Keystone/Hulton Archive/Getty Images.

and uncomfortable for occupation during the winter, when the administration was in residence. They were later joined by a Legislative Council building, made necessary by reforms under the Government of India Act in 1919; this addition was placed off-axis, subverting the geometry of the original plan (Plate 4.22).

These measures were made in response to the increasingly effective campaign by the Home Rule Leagues Movements from 1916 onwards, which resulted in limited self-government over selected areas such as education and health. As a further indication of the changing political climate with the growth of the independence movement, the name of the city was changed from Imperial Delhi to New Delhi in 1916. The Legislative Building or Council House, designed by Baker, housing three horseshoe-shaped assembly chambers within a circular structure reminiscent of the Colosseum in Rome, opened in 1927 (Plate 4.23). Rather than the Viceroy's House, it is perhaps the Council House and Secretariat Buildings, which housed members of the Indian middle classes on whose cooperation the new consensual model of British rule rested, which most clearly substantiate Johnson's argument that the city displayed 'a double narrative of promised liberation and continued colonial dependence'.[42] On the one hand, New Delhi

was created as part of a policy of granting greater political power to Indian subjects, but, on the other, this policy was meant ultimately to bolster British rule and maintain hegemony. It was not intended, as eventually happened, to replace them with self-government.

Other monuments on the site that gave expression to the same policy included the four Dominion Columns at Government Court. They were the gifts of Canada, Australia, South Africa and New Zealand, thereby representing the new idea of Commonwealth. Like the Jaipur Column in the viceregal courtyard, they were designed in a manner that invoked ancient precedents both Western and Eastern, namely Trajan's Column in Rome, on the one hand, and the commemorative pillars that the Buddhist Emperor Asoka placed throughout his united Indian Empire in the third century BCE, on the other.[43] The columns were unveiled in 1931, by which time dominion status for India was the stated aim of British policy; the four pillars therefore represented not just common sovereignty but India's future equality with other colonial countries. The most important of the other symbolical monuments, the All-India War Memorial Arch, later known as the India Gate, was designed by Lutyens to commemorate the Indian troops who had died in the

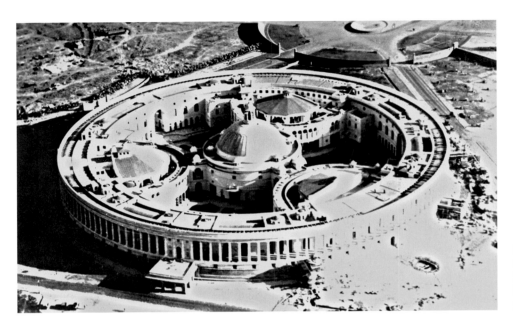

Plate 4.23 Herbert Baker, Council House, aerial view, New Delhi, 1927. Photo: © SZ Photo/Scherl/Bridgeman Images.

Plate 4.24 Edwin Lutyens, India Gate, New Delhi, begun 1921. Photo: Jonathan Irish/National Geographic Creative/Bridgeman Images.

First World War and the Afghan Wars. Lutyens was the chief designer for the War Graves Commission after 1918 and his design echoes those at the Cenotaph in Whitehall and Thiepval in France (Plate 4.24). The India Gate follows in the classical tradition of triumphal arches, such as those in Rome and the Arc de Triomphe in Paris, in forming the gateway into the ceremonial city.

Hosagrahar has argued that the entire New Delhi plan can be read as a microcosm of the durbar, that is, as a ritualistic and symbolic landscape conceived to assert imperial domination.[44] The city echoed the durbar not just in reinforcing social and racial hierarchies but also in its radial spatial patterning, with those of highest status being placed nearest to the centre of authority, namely Raisina Hill, with its epicentre at the Durbar Hall, while the most humble were relegated to the margins or simply out of sight. In her analysis, therefore, the construction of New Delhi not only embodied empire but did so through the symbolic sublimation of the old city of Shahjahanabad.

5 The Bungalow Zone

The main residential area of colonial New Delhi consisted of some 3000 single-storey houses for civil servants, clerks and officials in the so-called 'Bungalow Zone'. Indians had been employed by the British government since the days of the East India Company. In the early twentieth century, this Indian cadre of government employees increased substantially as a proportion of government employees, helping to fuel the accelerated growth of the Indian middle class. At New Delhi the rise of this class of government employees is evidenced by their accommodation in the same spatial zone and the same building type as their colonial masters. This 'Indo-European' suburb, as it was termed, formed part of a much wider process of Westernisation that extended to this new group's dress, living arrangements and participation in global consumerism, the latter exemplified by the Western-style shopping parade at Connaught Place (Plate 4.25).

As King argued in his foundational book *The Bungalow: The Production of a Global Culture* (1984), the bungalow is the colonial dwelling type *par excellence*. The word derived from the Bengali for a small one-storey house, but was then adopted throughout India in

Plate 4.25 Connaught Place, New Delhi, shops with curved colonnades. Photo: ImageDB/Alamy.

the eighteenth century as a generic description for European houses (Plate 4.26). The term can be found in *Hobson-Jobson,* a lexicon of Anglo-Indian terms derived wholly or in part from the various Indian languages published in 1886. King argued for the bungalow as evidence of a distinctive hybrid colonial or, as he put it, 'third culture', drawing on elements from both the European and the Indian.[45] As he noted in a later reflection on the theme, 'the introduction of the bungalow at this time and its subsequent development in the twentieth century is probably the single, most geographically widespread illustration of the influence of imperialism'.[46] As such, it represents India's most important architectural contribution to the corpus of global culture. The significance of the bungalow is that it became a transnational phenomenon, greatly aided by the use of prefabricated building parts throughout the empire from the early nineteenth century onwards. It was adopted enthusiastically not only in other colonies such as Australia, New Zealand and Canada, but also in Britain and the Americas, so that 'the movement of the idea … was from East to West rather than in the opposite direction'.[47]

At New Delhi, the layout of the bungalow quarter was determined by similar principles of socio-spatial segregation as those that underlay the plan of the whole city. The bungalows were designed in the same classical idiom as the rest of the site and located in huge square or rectangular secure compounds. This arrangement was typical of bungalow planning in general, which,

a) Basic form b) Developed form 1 c) Developed form 2

Plate 4.26 Evolution of ground plans for Delhi Bungalow Zone, in Karl Pfeil, *Die indische Stadt*, unpublished thesis, 1935. © British Library Board. All Rights Reserved/Bridgeman Images.

particularly after the Indian Rebellion, sought to insulate and protect the sanctity of the British home through what Metcalf has called an 'ideology of distance'.[48] Rather than individual dwellings being fortified, as in the case of West Indian planters' houses, the primary means of defence for Anglo-Indian bungalows of the eighteenth and nineteenth centuries was to situate them in secure compounds. To ensure the security of the compounds, the bungalows were positioned within what has been described as 'a series of nested boxes'.[49] The first outermost enclosure was provided by siting colonial settlements within the confines of their traditional groupings of civil lines, military cantonments and hill stations. The next layer of protection against the dirt, disease and otherness of the world outside was provided by the walled compound within which each dwelling sat. Further barriers were created through the planning and layout of the individual bungalow, as will be discussed below. The idea of grouping houses together in compounds or cantonments was thus transferred at New Delhi from its original military context to domestic architecture for an Indian middle class.

The size of houses in the New Delhi Bungalow Zone depended on the status of those who occupied them (Plate 4.27).[50] Hierarchical relations of class were linked to a particular colonial sociology of 'caste' as a signifier of status. The British notion of caste permeated Lutyens's original drawings, which were carefully marked with zones for 'rich whites', 'thin whites' and 'thin blacks', with 'thin' denoting lower status.[51] Such designations became another means of exerting colonial control; as Metcalf observes, 'caste was elaborated by the British into an intricate and rigid system of hierarchy, enforced by the courts and defined by the decennial censuses'.[52] At New Delhi, this system was further complicated by the growing number of Indians who were employed as civil servants, thereby cutting across the usual boundaries of class and race, and giving rise to a unique social structure, which can be seen as yet another expression of King's colonial 'third culture'. The new capital gave physical and spatial expression to this system of spatial apartheid, thereby accommodating (in King's words) 'the conceptual model of a twentieth-century colonial society'.[53] Five areas were demarcated: 1. for gazetted officers, who were mainly European; 2. for European clerks; 3. for Indian clerks and lower-ranking officials; 4. for Indian princes; 5. 'non-official' space for those with insufficient rank or without a position in the imperial city. This model excluded the mixed-race Anglo-Indians, who lived in their own quarter outside both the old and the new cities. The other key feature of the plan, as with New Delhi as a whole, was the generosity of its layout. The bungalows were conceived as mini-estates set in substantial grounds, the largest

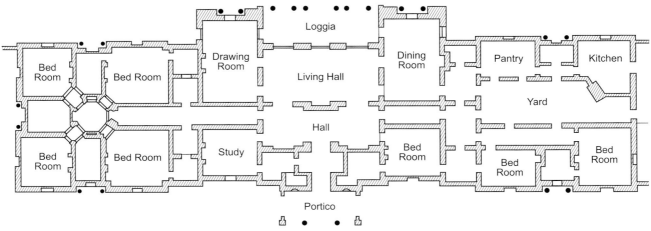

Plate 4.27 Edwin Lutyens, plan of bungalow for private secretary to the viceroy, New Delhi.

of which consisted of a 2.5 hectare plot for Members of Council, with 2 to 0.7 hectares allowed for military officers depending on rank.[54] The extreme spaciousness of the city spoke to a society both leisured and servanted, in which European notions of the domestic and the suburban green city predominated.

The government housing in New Delhi was designed by the office of Robert Tor Russell, chief architect to the Government of India (Plate 4.28). Russell and his team used a bungalow-type that had been established by the PWD, which had been responsible for official building since 1854. The PWD had created a masonry flat-roofed classical-style bungalow, which, though used for civilians and military alike, became known as the 'Military Board' style or 'engineering vernacular'. This austere approach stood in contrast to the more romantic style adopted for civilian bungalows, particularly in hill stations such as Simla, where gables and half-timbering abounded. Long term, however, the military style predominated. So entrenched did it become in official Indian architecture that it lasted long after colonial rule, forming the basis for the post-independence official housing zone at the modernist city of Chandigarh designed by the Swiss-born architect Le Corbusier.[55] At New Delhi, the PWD built 4000 such stuccoed brick residences for the full range of officials, as well as all the necessary municipal buildings such as hospitals, post offices and police stations. Baker and Lutyens also designed a few bungalows for the viceregal estate, principally for the staff quarters, and for high-ranking officials. The

austere military approach proved easily adaptable to a twentieth-century updating of the bungalow's form in a broadly classical idiom (Plate 4.29).

If we consider the typology of bungalows throughout India, they were generally planned along a horizontal axis with a covered entrance way, or *porte-cochère,* on one side and a veranda on the other (see Plate 4.26). The centre of the dwelling was occupied by a hall and living spaces, from which bedrooms led off to either side to create a three-bay plan. The open plan was adapted from indigenous structures to maximise the flow of air and provide shade through devices such as blinds and the sheltering veranda, which also kept the monsoon rains out of the interior. The veranda was used as a living and entertaining space, and also formed another important boundary within the controlled space of the compound. Indians, apart from house servants, were never permitted beyond this point. At New Delhi, as the bungalows were primarily intended for winter occupation, they, however, dispensed with the usual veranda (see Plate 4.27). The very permeability of the interior plan, in which bedrooms were situated next to living spaces, made the creation of a psychologically impenetrable threshold paramount in maintaining orderly inter-racial and gender relations. The inter-connectedness of the rooms, in conjunction with the presence of Indian servants, gave rise to what the revisionist historian Swati Chattopadhyay has characterised as an 'open-endedness of spatial meaning [that] unsettled dearly held ideas of public and private, self and Other, by denying colonisers a

Plate 4.28 Robert Tor Russell, Officers' bungalows, New Delhi, 1920, drawing. Photo: RIBA Collections.

Plate 4.29 Bungalow, 8 Hastings Road, New Delhi, 1921. Photo: RIBA Collections.

sense of safe confines'.[56] The large numbers of servants, who serviced the bungalow, lived in separate areas within the compound, which also contained extensive outhouses and stabling/garaging. As Chattopadhyay has argued, while giving the illusion of being spatially segregated areas, the white residential lines or housing zones can in fact be seen to contain both 'black' and 'white' landscapes co-existing in close proximity.[57] The bungalow and its compound can thus be seen as a contact zone and transcultural arena in which different spatial practices – Indian and English – ran alongside and interrelated with each other.[58]

Conclusion

New Delhi was inaugurated with great pomp in 1931 with a view to India becoming the fifth dominion in the empire. The British hoped that a new era of British-Indian governmental partnership would ensure the viability and stability of the new capital. At the time, however, as had also occurred with Webb's scheme in London, it was widely feared that it would soon seem outdated and defunct. Even Lutyens asked, 'Is it our swan song?', a question no doubt inspired in part by the fact that he was reading Edward Gibbon's *Decline and Fall of the Roman Empire* while designing New Delhi.[59] Johnson argues that New Delhi failed as a strategy for stabilising British India, not simply because it was a bold assertion of imperial power, but also because it represented a highly ambivalent space where forms of knowledge and visual languages were produced, shaped, consumed and ultimately contested in the longer term.[60] However, one could argue that it was this very permeability that allowed the city to be retained and reconceptualised in the post-independence era.

This chapter has argued that architectural remains, both ancient and modern, are one of the most widely recognised and evocative symbols of empire. For better or worse, therefore, the grand cities and monuments created by the British and other Western powers are one of the most conspicuous legacies of empire. Accommodating them within post-independence societies is, however, necessarily problematic and often controversial. In Delhi much of the memorial statuary, such as that commemorating George V and his parents, was taken down after 1947, with some of it being moved to Coronation Park, which became a 'monumental graveyard' for unwanted relics of the Raj.[61] The main buildings of the governmental centre, however, were absorbed into the post-independence nation; Viceroy's House was transformed into the President's residence or Rashtrapati Bhavan, while the Secretariat blocks retain their original name and purpose as the home of the Indian Civil Service. The inescapable physical presence of such massive architecture ensured that it constituted a fundamental part of negotiating post-colonial identities in India. The reappropriation of New Delhi is perhaps nowhere better demonstrated than in the annual India Day, which provides a contemporary counterpart to the durbar, when the ceremonial axial routes laid out by the Raj echo to the sounds and sights of the modern Indian state in yet another reworking of the ancient Mughal traditions. In the post-colonial period then, as Driver and Gilbert have argued, colonial spaces and buildings can be both imperial and anti-imperial simultaneously.[62] While still referencing an imposed Western legacy, they can, and sometimes do, simultaneously take on new meanings and usages. They are ambivalent spaces which, through their very survival, reveal layers of history and ideology in the city in a continuing and evolving dialogue between past and present, and between different places in the post-imperial world.

Notes

[1] Johnson, 2015.

[2] Howe, 2010; Bremner, 2016a, pp. 1–15.

[3] Bremner, 2004, p. 65.

[4] Cohn, 1983.

[5] Service, 1975.

[6] Bremner, 2016b, p. 98.

[7] Smith, 1999, pp. 21–2.

[8] Mace, 1976.

[9] Service, 1979.

[10] Hobsbawm and Ranger, 1983.

[11] Driver and Gilbert, 1998, p. 14.

[12] MacKenzie, 1984; Bremner, 2003.

[13] Driver and Gilbert, 1998, p. 23.

[14] Metcalf, 2005, p. 141.

[15] Irving, 1981, p. 278.

[16] Scriver, 2007b, p. 88.

[17] Chopra, 2016, p. 283.

[18] Davies, 1987, p. 68.

[19] Irving, 1981, p. 24.

[20] Scriver, 2007a, p. 36.

[21] Christensen, 1994.

[22] Metcalf, 2005, p. 149.

[23] Johnson, 2015, p. 136.

[24] Irving, 1981, p. 102.

[25] Irving, 1981, p. 167.

[26] Tillotson, 1989, p. 104.

[27] Mitter, 1992.

28 Tillotson, 1989, p. 109.

29 Tillotson, 1989, p. 105.

30 Baker, 1912.

31 Metcalf, 2005, p. 145.

32 Ridley, 2002, p. 181.

33 Irving, 1981, p. 102.

34 Irving, 1981, p. 98.

35 King, 1976.

36 Home and King, 2016, pp. 52–6.

37 Hosagrahar, 2007, p. 219; Hosagrahar, 2005.

38 Hosagrahar, 2007, pp. 229–30.

39 Stamp, 2001.

40 Irving, 1981, p. 186.

41 Johnson, 2015.

42 Johnson, 2015, p. 6.

43 Johnson, 2015, p. 186.

44 Hosagrahar, 1992.

45 King, 1976.

46 King, 2004, p. 171.

47 King, 2004, p. 71.

48 Metcalf, as quoted in Chopra, 2016, p. 294.

49 Metcalf, as quoted in Chopra, 2016, p. 294.

50 King, 1976, p. 248.

51 Ridley, 2002, p. 73.

52 Metcalf, 1984, p. 41.

53 King, 1976, p. 244.

54 King, 1976, p. 244.

55 King, 1995, p. 59.

56 Chattopadhyay, as quoted in Chopra, 2016, p. 296.

57 Chattopadhyay, 2000.

58 Pinney, 2012, p. 234.

59 Bremner, 2016b, p. 121.

60 Johnson, 2015, p. 195.

61 Bremner, 2016b, p. 123.

62 Driver and Gilbert, 1998, p. 26.

Bibliography

Baker, H. (1912) 'The New Delhi – Eastern and Western architecture – a problem of style', *The Times*, 3 October, pp. 7–8.

Bremner, G. A. (2003) '"Some Imperial Institute:" architecture, symbolism, and the ideal of empire in late Victorian Britain, 1887–93', *Journal of the Society of Architectural Historians*, vol. 62, no. 1, pp. 50–73.

Bremner, G. A. (2004) '"Imperial Peace Memorial": the second Anglo-Boer War and the origins of the Admiralty Arch, 1900–1905', *British Art Journal*, vol. 5, no. 3, pp. 62–6.

Bremner, G. A. (2016a) 'Introduction', in Bremner, G. A. (ed.) *Architecture and Urbanism in the British Empire*, Oxford, Oxford University Press, pp. 1–15.

Bremner, G. A. (2016b) 'Stones of empire: monuments, memorial, and manifest authority', in Bremner, G. A. (ed.) *Architecture and Urbanism in the British Empire*, Oxford, Oxford University Press, pp. 86–124.

Chattopadhyay, S. (2000) 'Blurring the boundaries: the limits of "White Town" in colonial Calcutta', *Journal of the Society of Architectural Historians*, vol. 59, no. 2, pp. 154–79.

Chopra, P. (2016) 'South and Southeast Asia', in Bremner, G. A. (ed.) *Architecture and Urbanism in the British Empire*, Oxford, Oxford University Press, pp. 278–317.

Christensen, E. (1994) *Government Architecture and British Imperialism: Patronage and Imperial Policy in London, Pretoria and New Delhi 1900–31*, unpublished PhD thesis, Evanston, IL, Northwestern University.

Cohn, B. S. (1983) 'Representing authority in Victorian India', in Hobsbawm, E. and Ranger, T. (eds) *The Invention of Tradition*, Cambridge, Cambridge University Press, pp. 165–209.

Davies, P. (1987) *Splendours of the Raj: British Architecture in India 1660–1947*, Harmondsworth, Penguin.

Driver, F. and Gilbert, D. (1998) 'Heart of empire? Landscape, space and performance in imperial London', *Environment and Planning D: Society and Space*, vol. 16, no. 1, pp. 11–28.

Hobsbawm, E. and Ranger, T. (eds) (1983) *The Invention of Tradition*, Cambridge, Cambridge University Press.

Home, R. and King, A. D. (2016) 'Urbanism and master planning: configuring the colonial city', in Bremner, G. A. (ed.) *Architecture and Urbanism in the British Empire*, Oxford, Oxford University Press, pp. 51–85.

Hosagrahar, J. (1992) 'City as durbar: theatre and power in Imperial Delhi', in AlSayyad, N. (ed.) *Forms of Dominance: on the Architecture and Urbanism of the Colonial Enterprise*, Aldershot, Ashgate Publishing, pp. 83–105.

Hosagrahar, J. (2005) *Indigenous Modernities: Negotiating Architecture, Urbanism and Colonialism*, New Delhi and New York, Routledge.

Hosagrahar, J. (2007) 'Negotiated modernities: symbolic terrains of housing in Delhi', in Scriver, P. and Prakash, V. (eds) *Colonial Modernities: Building, Dwelling and Architecture in British India and Ceylon*, Abingdon and New York, Routledge, pp. 219–40.

Howe, S. (ed.) (2010) *The New Imperial Histories Reader*, London and New York, Routledge.

Irving, R. G. (1981) *Indian Summer: Lutyens, Baker, and Imperial Delhi*, New Haven, CT and London, Yale University Press.

Johnson, D. A. (2015) *New Delhi: The Last Imperial City (Britain and the World)*, Basingstoke, Palgrave Macmillan.

King, A. D. (1976) *Colonial Urban Development: Culture, Social Power and Environment*, London, Routledge & Kegan Paul.

King, A. D. (1995) *The Bungalow: The Production of a Global Culture*, 2nd edn, Oxford, Oxford University Press.

King, A. D. (2004) *Spaces of Global Cultures: Architecture, Urbanism, Identity*, London and New York, Routledge.

Mace, R. (1976) *Trafalgar Square: Emblem of Empire*, London, Lawrence & Wishart.

MacKenzie, J. (1984) *Propaganda and Empire: The Manipulation of British Opinion, 1880–1960*, Manchester, Manchester University Press.

Metcalf, T. R. (1984) 'Architecture and the representation of empire: India, 1860–1910', *Representations,* no. 6, pp. 37–65.

Metcalf, T. R. (2005) *Forging the Raj: Essays on British India in the Heyday of Empire*, Oxford, Oxford University Press.

Mitter, P. (1992) *Art and Nationalism in Colonial India, 1850–1922*, Cambridge, Cambridge University Press.

Pinney, C. (2012) 'The material and visual culture of British India', in Peers, D. M. and Gooptu, N. (eds) *India and the British Empire*, Oxford, Oxford University Press, pp. 231–61.

Ridley, J. (2002) *The Architect and His Wife: A Life of Edwin Lutyens*, London, Chatto & Windus.

Scriver, P. (2007a) 'Stones and texts: the architectural historiography of colonial India and its colonial-modern contexts', in Scriver, P. and Prakash, V. (eds) *Colonial Modernities: Building, Dwelling and Architecture in British India and Ceylon*, Abingdon and New York, Routledge, pp. 27–50.

Scriver, P. (2007b) 'Empire-building and thinking in the Public Works Department of British India', in Scriver, P. and Prakash, V. (eds) *Colonial Modernities: Building, Dwelling and Architecture in British India and Ceylon*, Abingdon and New York, Routledge, pp. 69–92.

Service, A. (1975) *Edwardian Architecture and its Origins*, London, Architectural Press.

Service, A. (1979) *London, 1900*, St Albans, Crosby Lockwood Staples.

Smith, T. (1999) '"A grand work of noble conception": the Victoria Memorial and imperial London', in Driver, F. and Gilbert, D. (eds) *Imperial Cities: Landscape, Display and Identity*, Manchester, Manchester University Press, pp. 21–39.

Stamp, G. (2001) *Edwin Lutyens: Country Houses*, New York, Monacelli Press.

Tillotson, G. H. R. (1989) *The Tradition of Indian Architecture: Continuity, Controversy and Change since 1850*, New Haven, CT and London, Yale University Press.

Conclusion

Renate Dohmen

This book has sought to explore why the role that empire played in shaping British art has been so neglected. It has explored the artistic interactions between Britain and India that took place during the Raj, which have been overlooked because, in the nineteenth century when the discipline was founded, the history of art was conceived in terms of distinct national schools. To this end, the book has adopted a transcultural approach, emphasising that cultures are fundamentally intermeshed and constituted by exchange. Each of the four chapters has demonstrated the complexities, contradictions and denials that characterised Anglo-Indian transcultural encounters. They have offered an opportunity to compare how responses to the colonial encounter played out across the artistic media of painting, printmaking, design and display, as well as in architecture and photography, thereby bringing together histories that are usually considered separately, within the disciplinary boundaries of their respective media.

A crucial point that has emerged from the preceding chapters is the inherently contradictory character of British colonial ideology. As has been discussed, this ideology was based on essentialist Eurocentric conceptions of art and culture, which entailed a belief in India's inferiority and, moreover, became increasingly enmeshed with notions of race over the course of the nineteenth century. These attitudes shaped the encounter between Britain and India across all artistic media, albeit in different ways. They restricted, for example, the experimentation by British artists with Indian pictorial elements on the grounds that such experimentation undermined the integrity of Britain's own artistic traditions through admixtures of an inferior visual culture; cross-cultural appropriation and adaptation were therefore a predominantly Indian affair. In particular, the European medium of print became a popular means of visual expression with Indian artisans in urban centres, starting in Calcutta and gradually spreading across the subcontinent.

The same attitudes led, however, to an enthusiastic British engagement with the principles of Indian ornament, since it was generally believed that, while 'inferior' cultures were thought to lack the capacity for fine art, they instinctively excelled in matters of ornamentation. More 'developed' cultures needed therefore to regain their sense of design through the rational application of the 'right' principles gleaned from less advanced ones; in short, Britain had suffered a loss that contact with India could redeem. Thus, though colonial ideology primarily emphasised the supposed benefits that accrued to India as a result of being ruled by Britain, contact between the two was also thought to entail positives for the latter. For adherents of the Arts and Crafts Movement, for

example, India was characterised by a harmonious integration of art and life typical of less advanced societies, which they hoped would help to reform British society.

These attitudes also informed the representation of India in international exhibitions. Those held in London in 1851 and 1886, for example, focused on 'traditional crafts' associated with the 'timeless' Indian village, thereby highlighting the subcontinent's backwardness by contrast to the modernity of Britain. However, the examples of 'traditional' Indian art displayed at international exhibitions, such as the Gwalior and Jaipur Gates (see Chapter 2, Plates 2.11–2.13), were in fact shaped by the British applied arts curriculum, which had been exported to India to teach Indian students the 'right' kind of Indian 'tradition', based on principles laid out in Owen Jones's *Grammar of Ornament* (1865). The display of Indian art in international exhibitions thus embodies a chain of transcultural mediations that, ironically, originated in the British pursuit of 'cultural purity' and led to the invention of Indian 'traditions' by British art educators and designers.

Indian design was thus conceptualised in this period in a way that ignored market-driven developments such as the adoption and imitation of the Kashmir shawl by British consumers and manufacturers, which defied colonial efforts to curb such 'adulterations' of supposedly distinct cultural traditions. Such developments were far more significant, economically speaking, than the efforts of a small number of art schools dotted around the vast subcontinent. However, it was the image of traditional Indian crafts that prevailed in nineteenth-century Britain, largely on account of the influence of a handful of scholars and educators working in association with powerful institutions, most notably the South Kensington Museum. The pervasiveness of this image also owed much to a major publishing initiative on the part of the British authorities in the form of museum handbooks and exhibition catalogues, as well as the *Journal of Indian Art*, which together constituted a veritable propaganda machine. It is therefore crucial to subject to close scrutiny not just artworks and images, but also the histories of how they have been perceived, and the ideas that shaped these perspectives. Recent scholarship has begun to present a more nuanced account, one that also considers Indian craft practitioners' own

perspectives, and challenges the canonical story of decline promoted by British officials.[1]

A further area of artistic interaction between Britain and India is photography, which, however, followed a different trajectory. Introduced to India in the mid-nineteenth century, it was not directly implicated in the ideological debates over art, empire or nationhood that dominated discussions of other media at the time, because its recent invention meant that it lacked the artistic status of painting or sculpture. It primarily functioned to serve the imperial project by documenting the colony, providing the basis for illustrations in books, magazines and newspapers. British photographers such as Samuel Bourne, however, also deployed the medium in a more self-consciously artistic manner, applying British image conventions such as the picturesque to Indian subjects. The medium was also enthusiastically taken up by Indians, and while not every Indian photographer challenged colonial frameworks, photography did constitute a potent tool of counter-practice in the hands of some, who recorded and publicised events the colonial state would rather were ignored. Moreover, Indian traditions of miniature painting and photography soon merged into a decidedly Indian practice of 'tinting' photographs that more often than not covered the entire image in opaque colours, obscuring the photographic original.

Architecture, by contrast, was central to ideological debates around empire, and offered a rich terrain for transcultural negotiations. In this case, British fears of 'contamination' by 'inferior' cultural elements did not exclude the adoption of Indian elements in colonial buildings. Responses to the question of how best to mark the empire in stone ranged from the Indo-Gothic and Indo-Saracenic to the Neo-classicism of Lutyens's and Baker's New Delhi, all of which incorporated Indian elements. For the most part, these approaches drew on current architectural fashions in Britain that were adapted to India by including local features as British engineers or architects saw fit. The Indo-Saracenic style, however, was more closely modelled on Indian precedents, even if the underlying structure remained European. Irrespective of their chosen style, however, all of the buildings erected by the colonial authorities, showed the hand of the Indian workmen who

built them. British buildings in India, even when designed by British architects of high renown, as for example in Bombay, have for the most part been considered extraneous to British architectural history, however. The fact that architectural historians have only relatively recently begun to take note of these buildings suggests that the bias against art produced in the colonies also extended to architecture and was likely heightened by its adoption of Indian elements.[2]

The history of architectural interaction between Britain and India during the Raj also needs to take account of comparable practices on the part of Indian rulers (and the Indian landed classes more generally). In their case, the fusion of European and local styles of architecture reflected the Indian custom of aligning oneself with power through the adoption of select motifs from the most high-ranking style available.[3] British designers and architects derided these efforts for their 'incongruity' and 'bad taste', alleging a failure to apply principles of design correctly or indeed at all. Their objections, however, had little effect on Indian patrons, who, for the most part, did not engage with British design debates and continued to borrow European styles as a marker of status.[4] As intellectual paradigms have begun to shift, such long-denigrated Indian buildings are now likewise receiving scholarly attention. This new scholarship has also raised the possibility that such stylistic appropriations could, as discussed with regard to the Naya Mahal (see Chapter 2, Plate 2.20), also signal a nuanced defiance of colonial rule.[5]

The different ways in which the colonial encounter played out across different media reflected their respective places in colonial ideology. As already noted, the essentialist ideas of national identity on which this ideology rested accorded a central role to art and culture. The colonial encounter thus introduced European notions of fine art and of the artist as an original, creative figure to Indian culture. As Partha Mitter has pointed out, the Indian appropriation of the European notion of the artist had an immense impact, constituting a veritable revolution.[6] Here the adoption of European print technologies also played a key role, according artists nationwide popularity, as exemplified by the career of Ravi Varma.[7] By the early twentieth century, moreover, Indian notions of fine art had become

bound up with an essentialist understanding of culture, with the artist now seen as an authoritative figure who gave expression to the nation's cultural essence. It is therefore unsurprising that the Indian independence movement appropriated European ideas of nationhood and the figure of the artist for its own purposes. Indian nationalists also invoked the Orientalist binary of East versus West, declaring India to have a spiritual essence; this essence was, moreover, seen to be distinctly Hindu, in opposition to the colonial dictum of the religion's decadence. In so doing, however, the nationalists obscured the complex and diverse mixture of cultures and religions that historically co-existed in India.[8]

Indian art as it developed in the early twentieth century was thus deeply intertwined with the idea of the nation and with the independence struggle, not least because nationalists believed that asserting the nation's cultural identity was a precondition for the achievement of political independence.[9] The key development as regards fine art is the rise of the Bengal School of Art and, more especially, the shift in taste that saw Abanindranath Tagore acknowledged as the exemplary modern Indian artist in place of the now derided Varma. Whereas the former's work was considered to be an authentic expression of Indian nationhood by contrast to the supposedly 'colonial' and 'derivative' art of the latter, the practice of both artists can in fact be seen to be more complex than such a binary allows. It is also important to recognise that the appropriation of colonialist perceptions of Indian visual culture by the nationalists also had a more populist strand, one that repurposed the colonial notion of India as a craft nation to its own ends. The Indian craftsman thus became an icon of the anti-colonial Swadeshi movement, which campaigned for a boycott of British goods and promoted Indian craft enterprise. Exemplary in this respect (and highly effective, politically speaking) is Gandhi's adoption of spinning and the wearing of homespun cloth as forms of anti-colonial resistance.[10]

Notions of modern Indian art kept evolving, however, as a new generation of Indian artists challenged the nationalist models of Indian art in which they had been trained. Their growing familiarity with modern European art prompted a new phase of cultural exchange that extended beyond the

Plate 5.1 Fernand Léger, *The Great Parade*, mosaic. Les Abattoirs, Toulouse. Photo: Julian Worker/ Alamy. © ADAGP, Paris and DACS, London 2017.

colonial relationship. With older European artistic traditions now rejected because of their association with colonialism, modernism was seen to offer a means of creating an Indian art that participated in contemporary artistic debates on an international stage. In the 1920s, for example, the Bengali artist Jamini Roy, who had studied with Havell and Abanindranath Tagore, sought new sources of inspiration beyond Bengali models.[11] Drawing on the work of the French artist Fernand Léger, especially his use of heavy black outlines, Roy forged a new approach in modern Indian art that also looked to the linear emphasis of Kalighat *pats* and the schematic approach to drawing he admired in Byzantine icons (Plate 5.1). In his painting, *Saint Ann and the Blessed Virgin*, for example, Roy transforms the *pats'* satirical bent and social commentary into spiritual mythological scenes that suggest an idyllic village life (Plate 5.2). The work thus combines references to the international world of modern art with allusions to Indian folk culture that satisfied Indian nationalism's emphasis on the spiritual. In his use of the *pats*, Roy also offers an Indian version of European modernists' appropriation of the arts of Africa and Oceania, among other cultures, which were considered to be primitive

and hence authentic. In so doing, he successfully negotiated the double standard of modern art and the 'burden of representation' (see Introduction, p. 23) that it placed on artists of non-European backgrounds, whose work was considered inauthentic if it did not reflect their ethnic and cultural roots.

This expectation has continued to exercise its hold within the Western art world, even though the nineteenth-century essentialist understanding of culture as the expression of race and nation, on which it is based, has been abandoned. The double standard of modern art has, however, been subject to an increasingly urgent critique since the 'global turn' in the contemporary art world towards the end of the twentieth century, which saw the rise of large-scale international exhibitions across the globe. As a result, the visibility of artists from non-European backgrounds increased, but it soon came to be asked how much had actually changed, prompting widespread debate and calls for action. Critical scrutiny suggests that the art world continues to be characterised by what Monica Juneja has called the notion of 'exotic difference'. Juneja has also noted a tendency among artists from cultures outside of

Plate 5.2 Jamini Roy, *Saint Ann and the Blessed Virgin*, c.1945, opaque watercolour on canvas, 70 × 96 cm. Collection Samuel P. Harn Museum of Art, gift of Mr and Mrs Thomas J. Needham. Photo: Randy Batista.

Europe to 'self-orientalise', that is, to present both themselves and their work in terms of tropes of tradition, authenticity and otherness, much as artists in British India did.[12] Despite the contemporary art world's greater inclusivity, therefore, colonial legacies continue to linger, constraining the way that non-Western artists are able to position themselves within it. Thus, while the age of empire may be long over, the task of decolonisation has barely begun. For this reason studying the artistic interactions between Britain and India has a direct relevance today.

Notes

[1] McGowan, 2009; Roy, 1999.

[2] Bremner, 2016, p. 1; Chopra, 2011, pp. 39–41; Scriver, 2007, pp. 39–41.

[3] Kipling, 1886, pp. 3–4.

[4] Kipling, 1886, pp. 3–4.

[5] Prakash, 1994, pp. 99–102.

[6] Mitter, 1990, p. 364.

[7] Inglis, 1999, p. 124.

[8] Guha-Thakurta, 2004, p. 201; Chatterjee, 1993, pp.73–4.

[9] Chatterjee, 1993, pp. 6–7.

[10] Mathur, 2007, pp. 46–9.

[11] Chatterjee, 1987, pp. 6–8.

[12] Juneja, 2011, p. 277.

Bibliography

Bremner, G. A. (ed.) (2016) *Architecture and Urbanism in the British Empire*, Oxford, Oxford University Press.

Chatterjee, R. (1987) '"The original Jamini Roy": a study in the consumerism of art', *Social Scientist*, vol. 15, no. 1, pp. 3–18.

Chatterjee, P. (1993) *The Nation and its Fragments*, Princeton, NJ, Princeton University Press.

Chopra, P. (2011) *A Joint Enterprise: Indian Elites and the Making of British Bombay*, Minneapolis, MN, University of Minnesota Press.

Guha-Thakurta, T. (2004) *Monuments, Objects, Histories: Institutions of Art in Colonial and Post-Colonial India*, New Delhi, Permanent Black.

Inglis, S. R. (1999) 'Master, machines, and meaning: printed images in twentieth-century India', in Phillips, R. B. and Steiner, C. B. (eds) *Unpacking Culture: Art and Commodity in Colonial and Postcolonial Worlds*, Berkeley, CA, University of California Press, pp. 122–42.

Juneja, M. (2011) 'Global art history and the "burden of representation"', in Belting, H., Birken, J. and Buddensieg, A. (eds) *Global Studies: Mapping Contemporary Art and Culture*, Stuttgart, Hatje Cantz, pp. 274–97.

Kipling, J. L. (1886) 'Indian architecture of today', *Journal of Indian Art*, vol. 1, no. 3, pp. 1–5.

McGowan, A. (2009) *Crafting the Nation*, New York, Palgrave Macmillan.

Mathur, S. (2007) *India by Design: Colonial History and Cultural Display*, Berkeley, CA, University of California Press.

Mitter, P. (1990) 'Artistic responses to colonialism in India: an overview', in Bayly, C. A. (ed.) *The Raj: India and the British 1600–1947*, London, National Portrait Gallery, pp. 361–7.

Prakash, V. (1994) *Productions of Identity in (Post) Colonial 'Indian' Architecture: Hegemony and its Discontents in 19th Century Jaipur*, unpublished PhD thesis, Ithaca, NY, Cornell University.

Roy, T. (1999) *Traditional Industry in the Economy of Colonial India*, Cambridge, Cambridge University Press.

Scriver, P. (2007) 'Stones and text: the architectural historiography of colonial India and its colonial-modern contexts', in Scriver, P. and Prakash, V. (eds) *Colonial Modernities: Building, Dwelling and Architecture in British India and Ceylon*, London and New York, Routledge, pp. 27–50.

Index

Page numbers in **bold** refer to illustrations